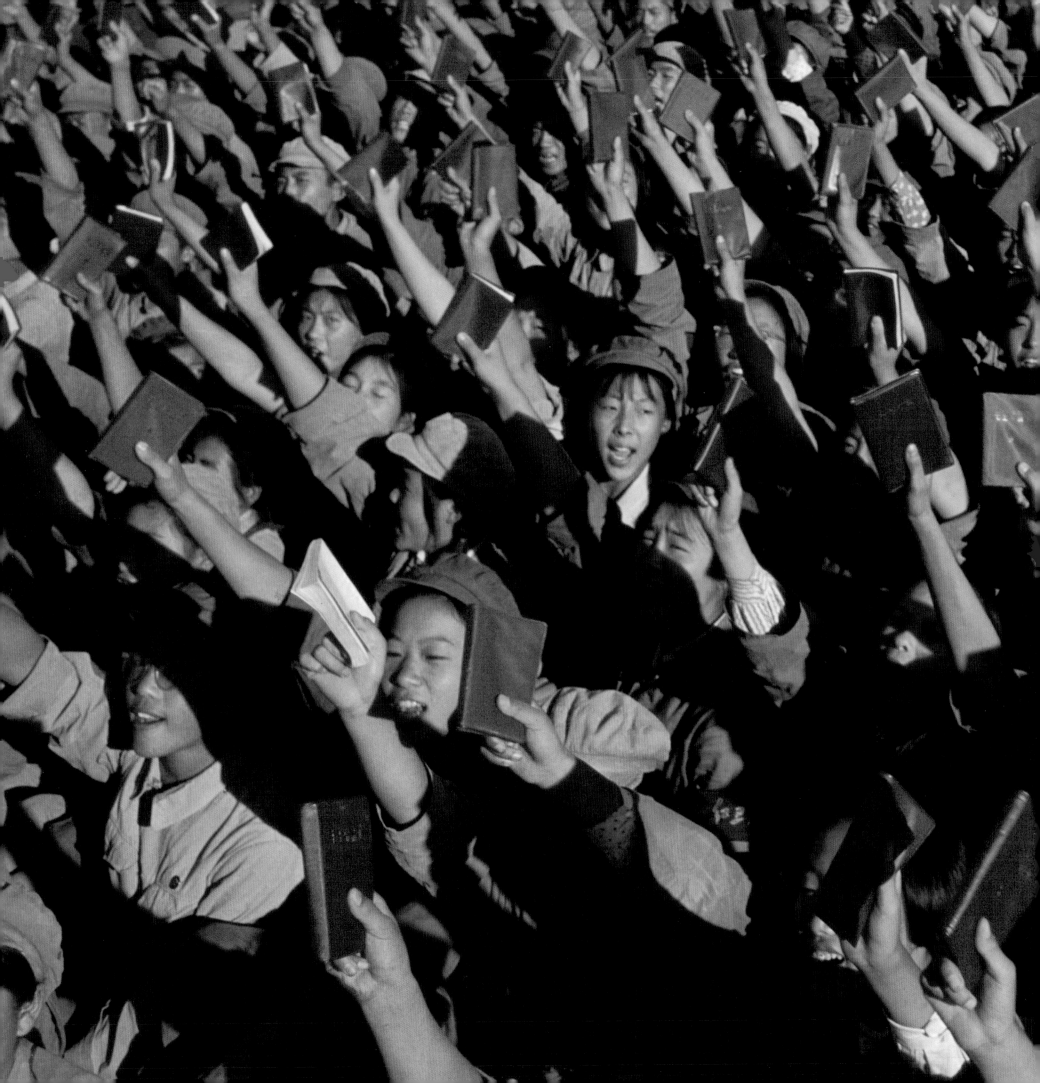

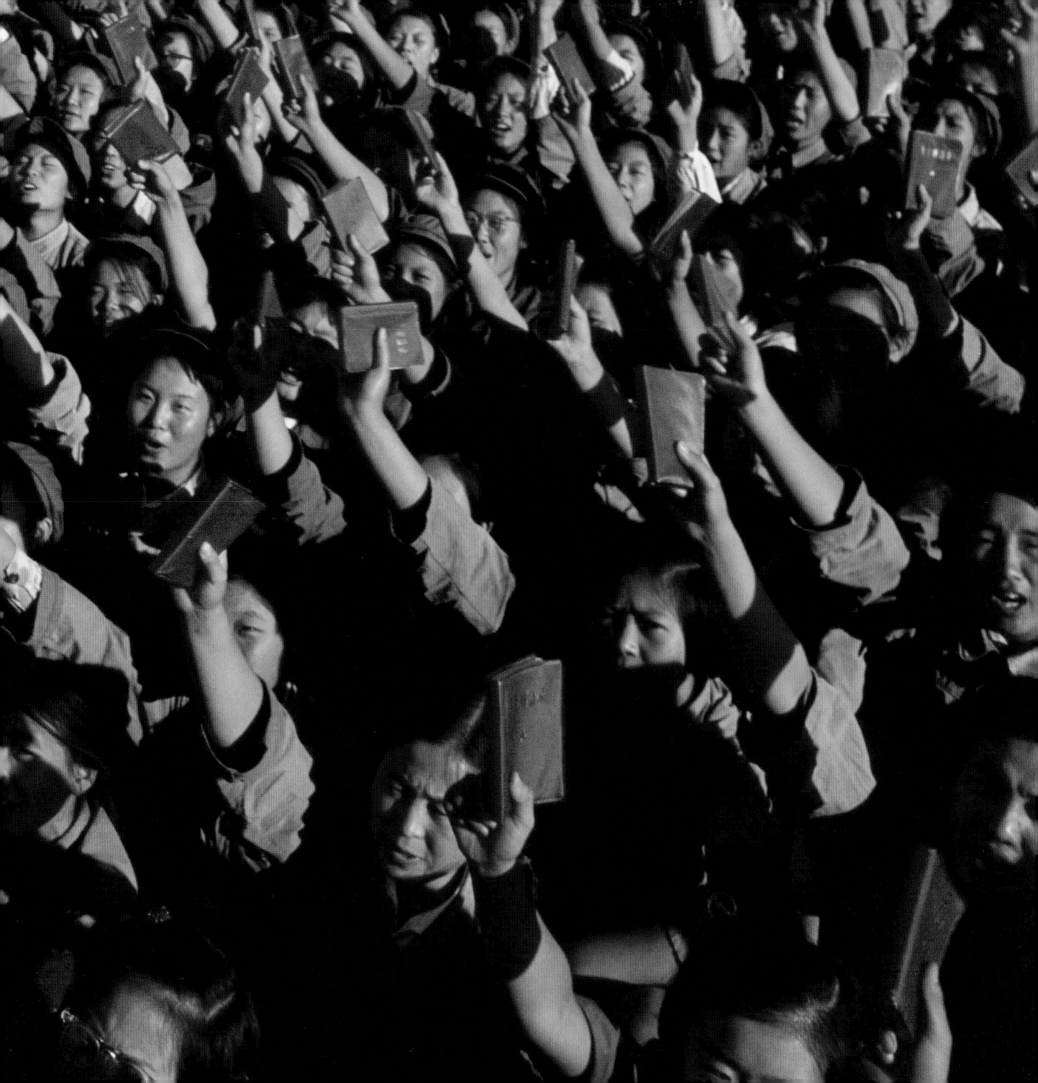

R
E
D

CHINA'S CULTURAL REVOLUTION
JIANG JIEHONG

JONATHAN CAPE LONDON

For my parents, and their generation

THE GREAT PROLETARIAN CULTURAL REVOLUTION IS A GREAT REVOLUTION THAT TOUCHES PEOPLE TO THEIR VERY SOULS. IT ALSO TOUCHES THE ESSENCE OF THE PEOPLE'S POLITICAL STANDPOINT AND THE DEEPEST POINT OF THEIR WORLD OUTLOOKS, TOUCHES THE ROADS ONE TRAVELLED AND THOSE ONE WILL EXPERIENCE IN THE FUTURE, AND TOUCHES THE ENTIRE HISTORY OF CHINA'S REVOLUTION.

MAO ZEDONG

INTRODUCTION

It is generally accepted that China's Great Proletarian Cultural Revolution (*Wuchan jieji wenhua dageming*) was launched under the guiding principles of the *May the Sixteenth Circular* (*Wu yiliu tongzhi*) by the Central Session of the Chinese Communist Party on May 16, 1966, and ended with the death of Mao Zedong in 1976. However, various views on the duration of the Cultural Revolution exist. For Mao, it was Yao Wenyuan's *The Criticism on the New Version of the Historical Play 'Hai Rui Dismissed from Office'* (*Ping xinbian lishiju 'Hai Rui baguan'*), published in Shanghai's *Wenhui bao* (*Wenhui Daily*) on November 10, 1965, that marked the start of the movement. Originally, the Chairman only expected his Cultural Revolution to last between a few months and a year. Most early scholars claimed that the Cultural Revolution proper lasted three and a half years, from late 1965 to April 1969, when the Ninth Session of the Chinese Communist Party announced its successful completion.[1] Again, at the Party's Eleventh Session in 1977, Mao's successor Hua Guofeng declared for the Party that the eleven-year Cultural Revolution was finally terminated along with the fall of the Gang of Four (*Siren bang*). In 1981, the *Resolution of Certain Questions in the History of Our Party Since the Founding of the People's Republic of China* officially assigned main responsibility to Mao and laid significant blame on the 'well-planned machination' by Lin Biao and the Gang of Four. The decade was then historically defined as a 'ten-year turbulence' (*shinian dongluan*).

The Cultural Revolution has been seen as a watershed, the defining period of the half-century of Communist rule in China. Studies on the Cultural Revolution offer more than historical insight; they are essential for a better understanding of China today.[2] The events based on official records and research in the sociological and political context have already been chronicled. But by looking at the Cultural Revolution through a visual perspective, we can revisit the extraordinary phenomenon created by a population of some 800 million people. The extreme visual changes in China's environment were most dramatic in the first two years of the Cultural Revolution, when the momentum of the mass movement was established.

The first visual sign of the Revolution was the appearance of the big-character poster (*dazi bao*) at two o'clock on the afternoon of May 25, 1966 on the eastern wall of the building that housed the main canteen of Beijing University (p. 13). Proclaiming 'What are Song Shuo, Lu Ping and Peng Peiyun up to in the Cultural Revolution?', the poster was produced by Nie Yuanzi and six colleagues from the Department of Philosophy as overt criticism of the University leaders. According to Yin Hongbiao, this first big-character poster was in no way, as officially explained, produced under instruction from any Central Cultural Revolution Small Group members, such as Kang Sheng, but was generated spontaneously.[3] Within just half a day, more than a thousand big-character posters appeared all over the campus. This can be seen as the genuine start of the mass movement, or indeed a visual announcement – in a public space – of the advent of the Cultural Revolution. Soon afterwards, under Mao's instruction to support the voice of the masses, the proclamation of the poster was broadcast nationwide on China National Radio on June 1, 1966 and was published on the title page of *Renmin ribao* (*People's Daily*) the next day.

Pages 2–3,
Weng Naiqiang,
Detail from *Red Guards in Tiananmen Square*, Beijing, 1966.

Anonymous photograph,
The big-character posters on the campus of Beijing University (Beijing, 1966), *China Pictorial*, Vol. 233, November 1967.

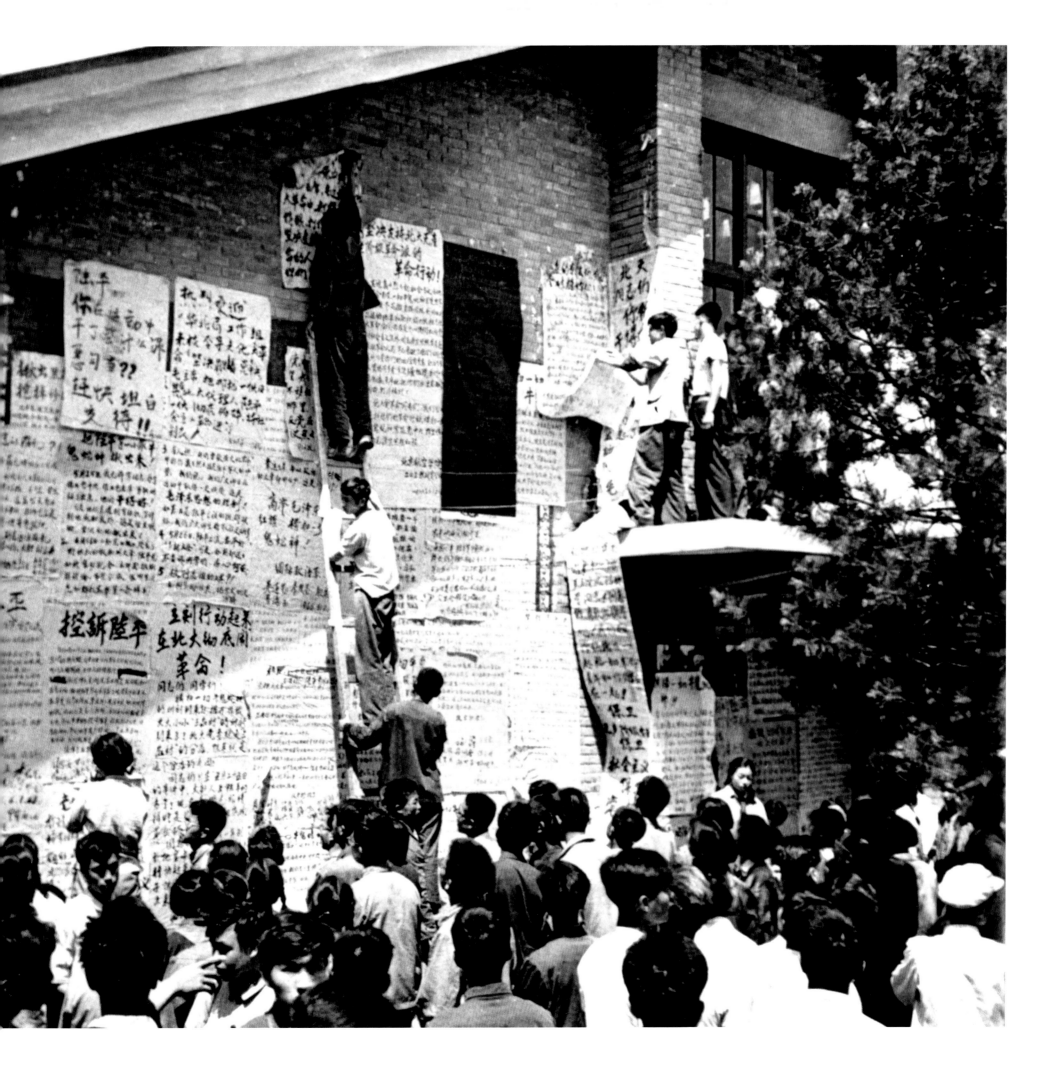

One could lay the responsibility for the 'why' of the Cultural Revolution on those named original protesters, but in reality there is no answer to explain the nationwide scale or the sustainability of such a movement. The definition of the Cultural Revolution in official terms as the 'turbulent decade' obscures the significance of the mass movement as an essential prerequisite, and conceals the intentions to shape a heroic identity for the new government, who were supposedly saving the people from catastrophe by exploring and defeating a hidden counter-revolutionary group. However, the dynamics of the mass movement, which in theory was terminated by the army in August 1968, still remain mysterious.

The Cultural Revolution offers a variety of memories and meanings to different generations. It can be viewed as a political struggle, a cultural disaster or a national humiliation, and sometimes, to younger ones, as the ultimate carnival. Belonging as I do to the generation born just after the peak of the movement, for me the Cultural Revolution exists in a realm of fantasy or, indeed, as a tale of red.

I started my primary school in Shanghai, when the Cultural Revolution had been officially declared finished and the open-door policy of China's economic reform was soon to be introduced. The world of my childhood memory lacked colour. Like other people on the streets, my mother always wore a faded grey coat. There was a common expression and the same simple haircuts. I could always see the tiredness, even in their smiles, like the signs of a low mood after excessive excitement. My mother was only cheered when I earned red flowers, pentagrams or flag signs as so-called 'spiritual rewards' (*jingshen jiangli*) at kindergarten. In the first lesson at

school I learned how to correctly draw a shining red sun, the symbol of Chairman Mao, and I expected to be named on the red board, the place of honour. I felt shame early on when I failed to join the Communist Young Pioneers as expected. I envied those who advanced with their dazzling red scarves, which represented an almost absolute superiority.

My earliest visual imagining of the Cultural Revolution unfolded through two disparate sources: the stories that I heard from my parents' generation, full of absurdity and terror, and the immediate legacies of Mao that I experienced directly. It seemed that the bizarre happenings in the stories were decades away. Yet I was having my 'normal' and 'promising' life: the red national flag was hoisted every morning while our league song *'We Are the Communist Successors'* was proudly sung; the loudspeakers' pet phrase was repeated endlessly–'*Mao zhuxi jiaodao women* (Chairman Mao teaches us)…' The frequently used big-character slogans, such as '*weida* (great)', 'Mao', '*wansui* (long live)' and large exclamation marks, remained as fragmented traces on the walls, but strikingly their faded red still represented the fanaticism, horror, glory and sorrow of the past. The most unforgettable image was Mao's unavoidable scrutiny from his portraits on the walls of classrooms, assembly halls and elsewhere. The great gaze was examining every single thought or action, at any time, anywhere.

Despite its title, the Revolution has been discussed less in terms of its cultural dimension than in its political implication. It could even be interpreted literally and positively as an attempt to re-establish the foundation of Chinese culture. Only a few recent publications have focused on the cultural and social development during the decade.[4] The first re-evaluations of

the art produced in the years of the Cultural Revolution have started to appear, yet the 'art' of the period has been generally ignored by the authorities. This absence in Chinese art history can be attributed to various causes. As soon as the Cultural Revolution was officially criticised in 1978, people were encouraged to forget the turbulent years, in which the leaders or the Party were considered to have made serious mistakes. It is also apparent that many people realised that they had been duped by the cult of Mao and the belief in the Communist ideal. For the generation who lived through the Cultural Revolution, the fact that the visual record provides more precise and richer evidence than the literature of the time makes it more difficult for the visual material to be considered objectively. It is too volatile. The visual products of the Cultural Revolution are difficult to contain within a conventional art-historical narrative, given their more complicated relationship with the social and political events and ideas. To understand the art of the time you cannot isolate studies of oil painting, printmaking, posters or opera from Mao's mass art movement as a whole.

This book starts with the 'Smashing the Four Olds' (*Po sijiu*) campaign, a prologue to the Cultural Revolution in a demonstration of practical anti-tradition, which prepared the whole country for a 'red show'. In these years of turmoil there was considerable visual continuity with the period from 1949 on. The redness of the Cultural Revolution is embedded in Chinese tradition. The popular slogan 'The whole country was awash with red (*quanguo shangxia yipian hong*)' epitomised the visual experience of the time and underlay the whole identity of twentieth-century China.

1. Fairbank, John King, *The Great Chinese Revolution 1800–1985*. London: Harper Perennial, 1987, p. 317.
2. MacFarquhar, Roderick and Schoenhals, Michael, *Mao's Last Revolution*. London: The Belknap Press of Harvard University Press, 2006, p. 1.
3. Yin Hongbiao, 'Wenge de diyizhang malie zhuyi dazi bao (The First Marx-Leninism Big-character Poster in the Cultural Revolution)', in Liu Qingfeng (ed.), *Wenhua da geming: shishi yu yanjiu (The Cultural Revolution: Historical Facts and Research)*. Hong Kong: The Chinese University Press, 1996, pp. 6–10.
4. For example, Wang Mingxian and Yan Shanchun, *Xin zhongguo meishu shi (The Art History of the People's Republic of China)*, 1966–1976. Beijing: Zhongguo qingnian chubanshe, 2000.

不懈不怠

NO DESTRUCTION NO CONSTRUCTION

The *May the Sixteenth Circular* is the earliest message indicating the battlefield of the Cultural Revolution. It reads,

> ...the ox-demons and snake-spirits (*niugui sheshen*) were released from the cages and permeated into our newspapers, broadcasting, journals, books, speeches, films, dramas, visual arts, music and dances, etc...

> The whole Party must follow the instructions of Comrade Mao Zedong, raise the great flag of the Proletarian Cultural Revolution on high; thoroughly expose those anti-Party and anti-socialist 'academic experts' with their counter-revolutionary standpoint of the bourgeoisie; thoroughly criticise the counter-revolutionary thought of the worlds of academia, education, journalism, art and publishing, and take charge of these cultural areas.[5]

On June 1, the editorial of *Renmin ribao* popularised the anti-revolutionary objects, Feudalism, Capitalism and Revisionism (*Feng zi xiu*), for the first time as the 'Four Olds'.

> The climax of the Proletarian Cultural Revolution is arising in Socialist China, a country that maintains one quarter of the world's population... It is going to thoroughly eliminate all the old ideas, old culture, old customs and old habits of the exploiting classes, which have corrupted the people for thousands of years, and to create and construct the proletarian new idea, new culture, new customs and new habits among the masses.[6]

After inspection by Mao in Tiananmen Square, Red Guards, who claimed themselves to be the 'critics of the old world',[7] started to smash the 'Four Olds' in practical expression of the establishment of a new world. Early on the morning of August 19, 1966, a crowd – mainly teenagers – rushed on to the streets to confiscate and eliminate all the 'Olds', by searching through barber shops, tailors, photo studios, book stores and private residences across Beijing. On August 23, all major newspapers published an editorial entitled 'The Tides of the Proletarian Cultural Revolution Swept Across the Streets of the Capital City', which further provoked destructive acts by Red Guards across the country. It became the darkest summer in the thousand-year history of Chinese culture.

China's public properties and cultural relics were attacked and numerous treasures were destroyed. Records indicate that, by the end of the Cultural Revolution in Beijing alone, 4,922 of the 6,843 officially designated 'places of cultural or historical interest' had been demolished, by far the greatest number of them in August and September 1966. During the height of the iconoclasm, all religious architecture, whether Buddhist, Islamic or Catholic, along with statues, frescos and books, was liable for destruction (p. 18). Crying, 'Smash, burn, fry and scorch', Red Guards pillaged and destroyed countless Buddhist temples with hundreds of years of history, namely, Biyun, Wofo, Baita and Jietai in Beijing, Jing'an in Shanghai, Jile in

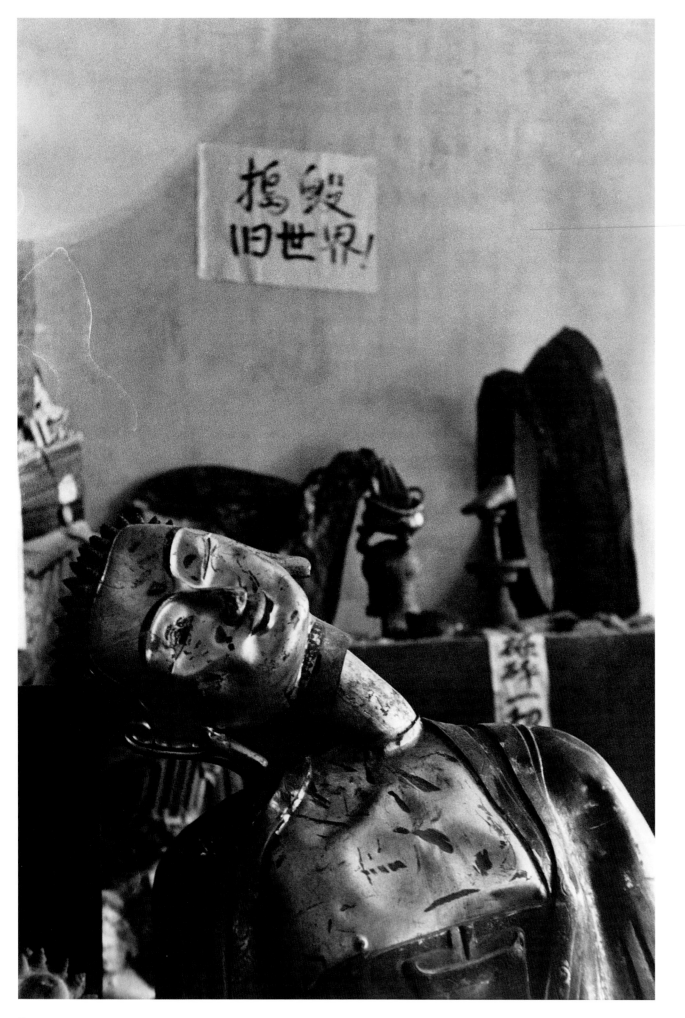

Li Zhensheng,
In the aftermath of the destruction of the Jile Temple, a sign
posted on the wall reads, 'Smash the old world' (Harbin, 1966),
Red-Colour News Soldier, p. 100.

Harbin, Baofeng in Jiangxi and some sixty temples on Mount Wutai in Shanxi province. They also trampled on the graves of Hai Rui in Haikou and Yue Fei in Hangzhou, and many other ancestral temples of those who had been respected as folk heroes or sages.[8] Even the Forbidden City (Palace Museum) would have been demolished, if the Premier Zhou Enlai had not urgently ordered the Beijing garrison to send troops to protect the world's largest imperial palace.[9]

Constructed in 1917 by French Jesuit missionaries, the Xikai Catholic Cathedral, featuring three massive green domes, forty-five metres in height, stands as the largest architectural landmark in Tianjin. In the summer of 1966, this Roman-styled building was seen as a symbol of imperialist and colonial power and was besieged by thousands of Red Guards. Believers were criticised publicly and church properties were assembled and burned in front of the cathedral. A couplet (*duilian*) was placed on both sides of the west façade, 'Smash the old thoughts, bomb the black church', while a portrait of Mao hung from the centre of its arch (pages 20–5).

In that same August of 1966 perhaps the most remarkable act of destruction of a priceless cultural relic centred on the Confucius Temple in Qufu, which was referred to as the 'Holy Land of the East' (*Dongfang shengdi*). Red Guards from most of Qufu's secondary schools first insulted the Confucians by burning old books and paintings, then smashing statues of deities.[10] When a Red Guard group of around 200 teachers and students from Beijing Normal University, called Mao Zedong's Thought Jinggangshan Regiment, led by a young cadre, Tan Houlan, arrived in Qufu in the autumn, the dignity of Confucius was further desecrated. On November 15,

these Red Guards paraded to announce their intention to 'thoroughly demolish the Confucius Family Shop' (*chedi daohui kongjia dian*) and gathered in front of the Confucius residence to pledge their mass effort (p. 27). Two weeks later, they joined forces with locals and like-minded students from the Qufu Teachers' Institute in an assembly of 100,000 people in the square of the Institute.[11] A local activist declared,

> To be 'nurtured' on the thoughts of Confucius never did anyone any good and only produced cowardly bastards who exploit, oppress, cruelly injure and bully other people. What those in favour of 'educating' people with the thoughts of Confucius want is to foster landlords, rich peasants, counter-revolutionaries, bad elements, rightists, monsters and freaks, foster counter-revolutionary revisionist elements, and hire men and buy horses for a capitalist restoration on behalf of the capitalists. Our response is to say no a thousand times over, to say no ten thousand times over![12]

Soon after, the statues of Confucius and others were 'humiliated' with obscene labels, pulled down and smashed (pp. 29–31); steles and memorial archways were shattered (pp. 32–7); and, tragically, the inscribed board of *wanshi shibiao* (the mentor for a myriad of ages), the honorary title for Confucius, fell to the ground in flames (p. 38). During their four-week stay in Qufu, Red Guards destroyed 6,618 registered cultural artefacts, including 929 paintings, more than 2,700 books, 1,000 stone steles and some 2,000 graves.[13]

Continued on page 40

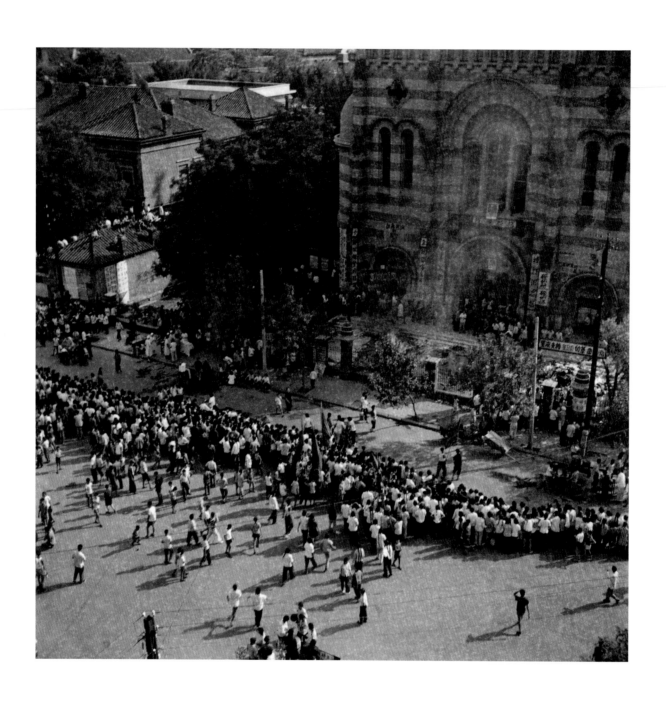

Wang Duanyang,
Smashing the Xikai Catholic Church No. 7, Tianjin, 1966.

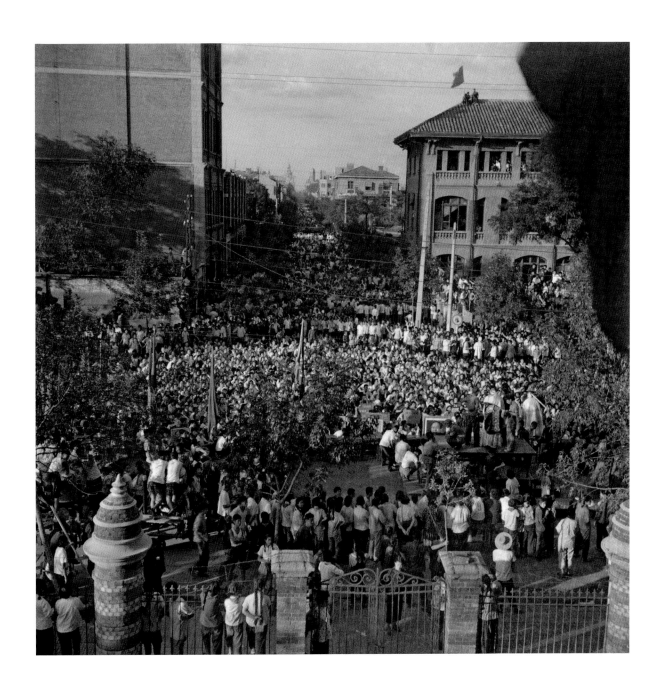

Wang Duanyang,
Smashing the Xikai Catholic Church No. 2, Tianjin, 1966.

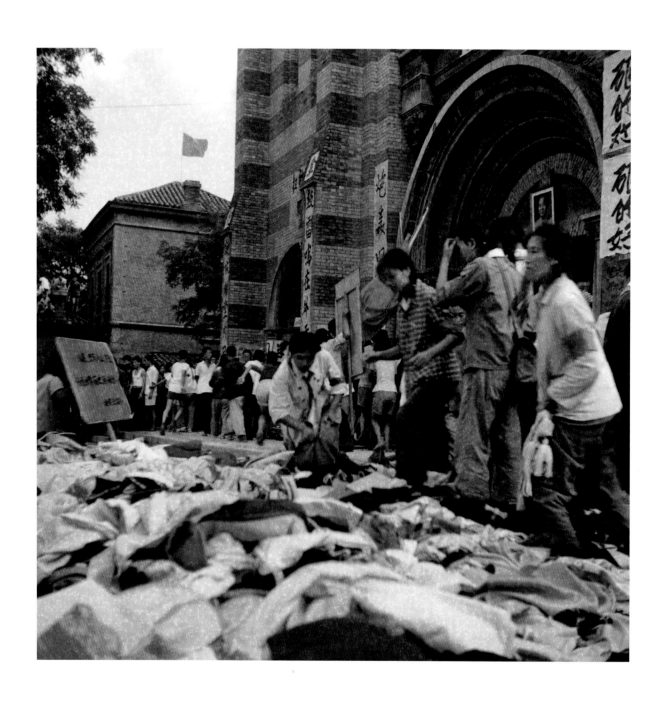

Wang Duanyang,
Smashing the Xikai Catholic Church No. 6, Tianjin, 1966.

Wang Duanyang,
Smashing the Xikai Catholic Church No. 4, Tianjin, 1966.

Wang Duanyang,
Smashing the Xikai Catholic Church No. 8, Tianjin, 1966.

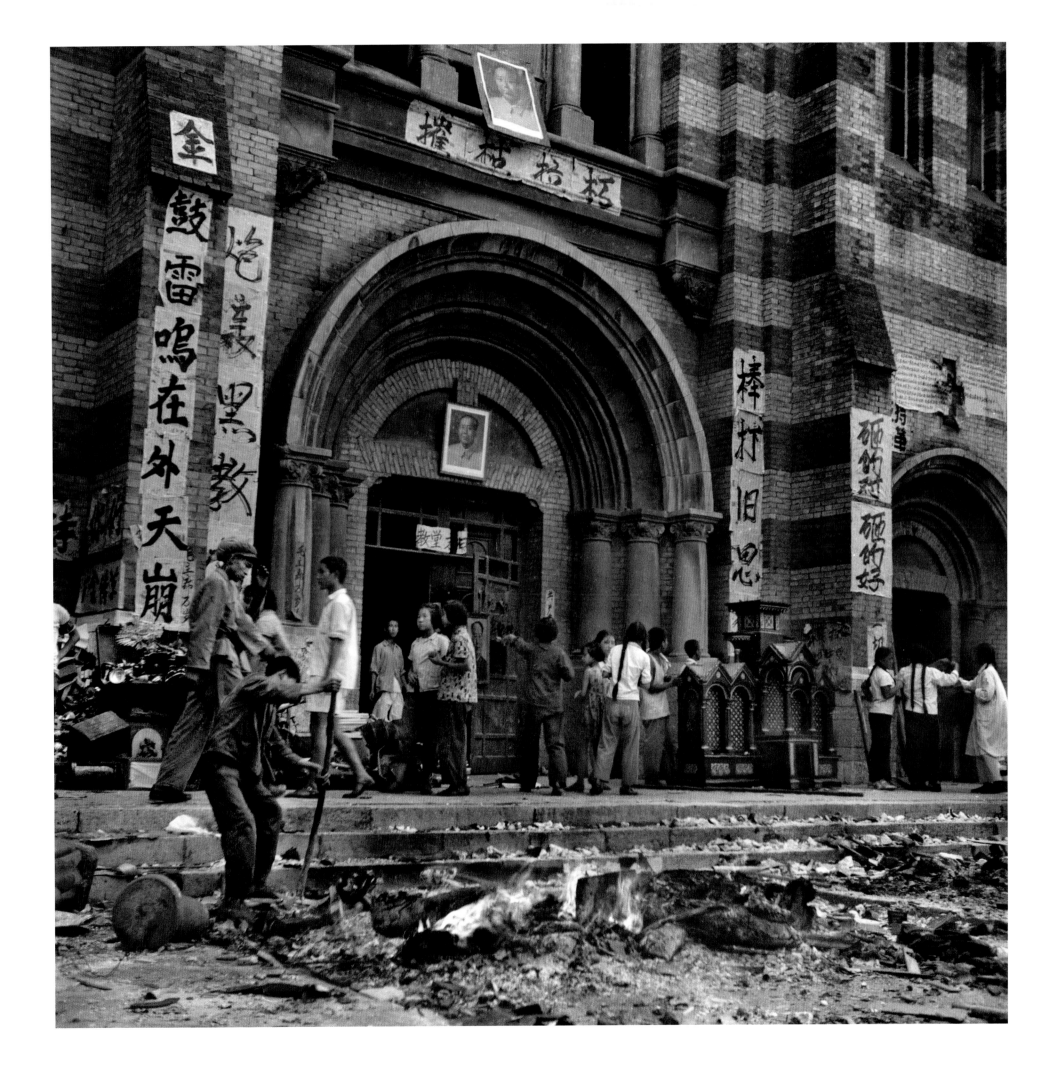

Anonymous photograph,
Red Guard Parade, Qufu, Shandong province, 1966, personal collection of Kong Hongyan.

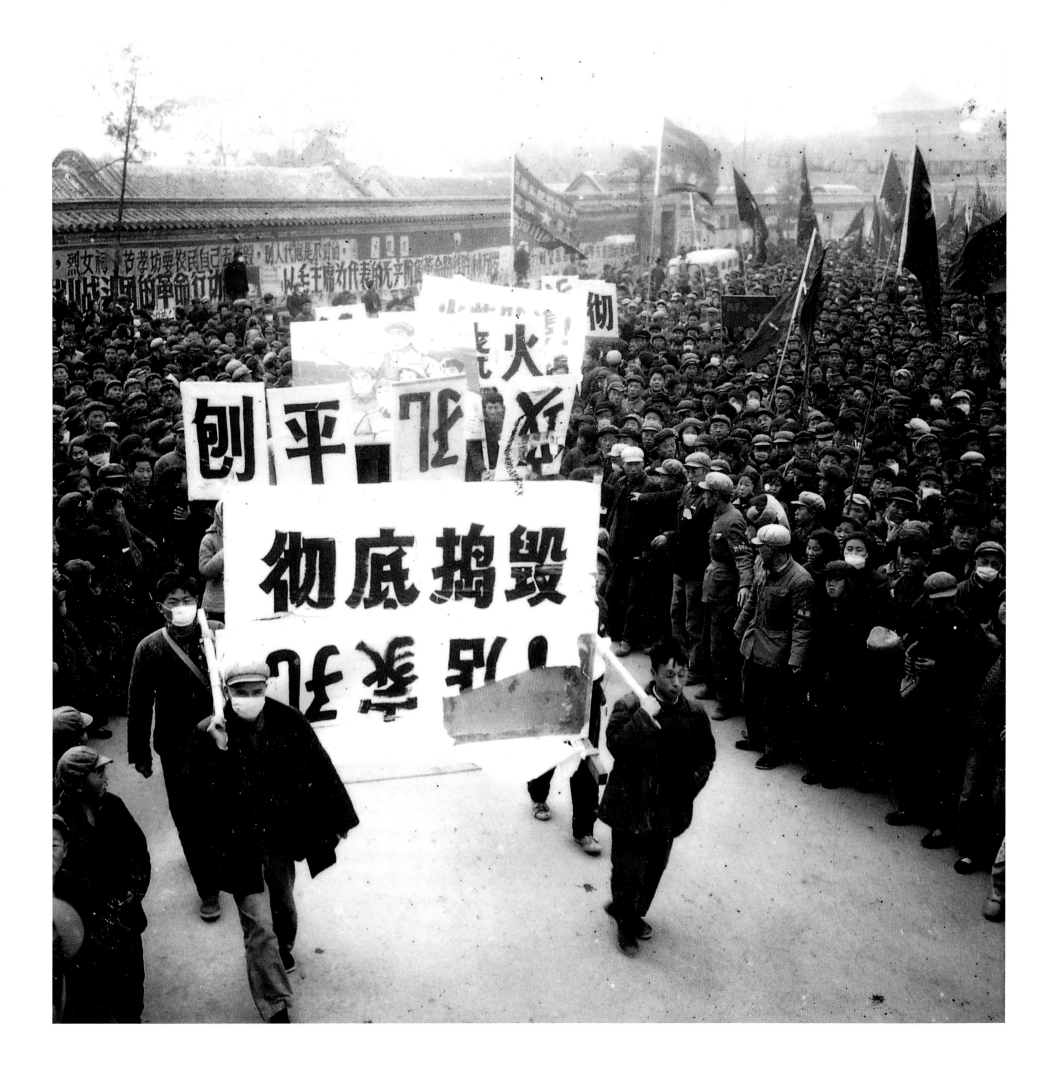

Anonymous photograph,
Humiliating the Ming Confucius Statue, Qufu, Shandong province, 1966, personal collection of Kong Hongyan.

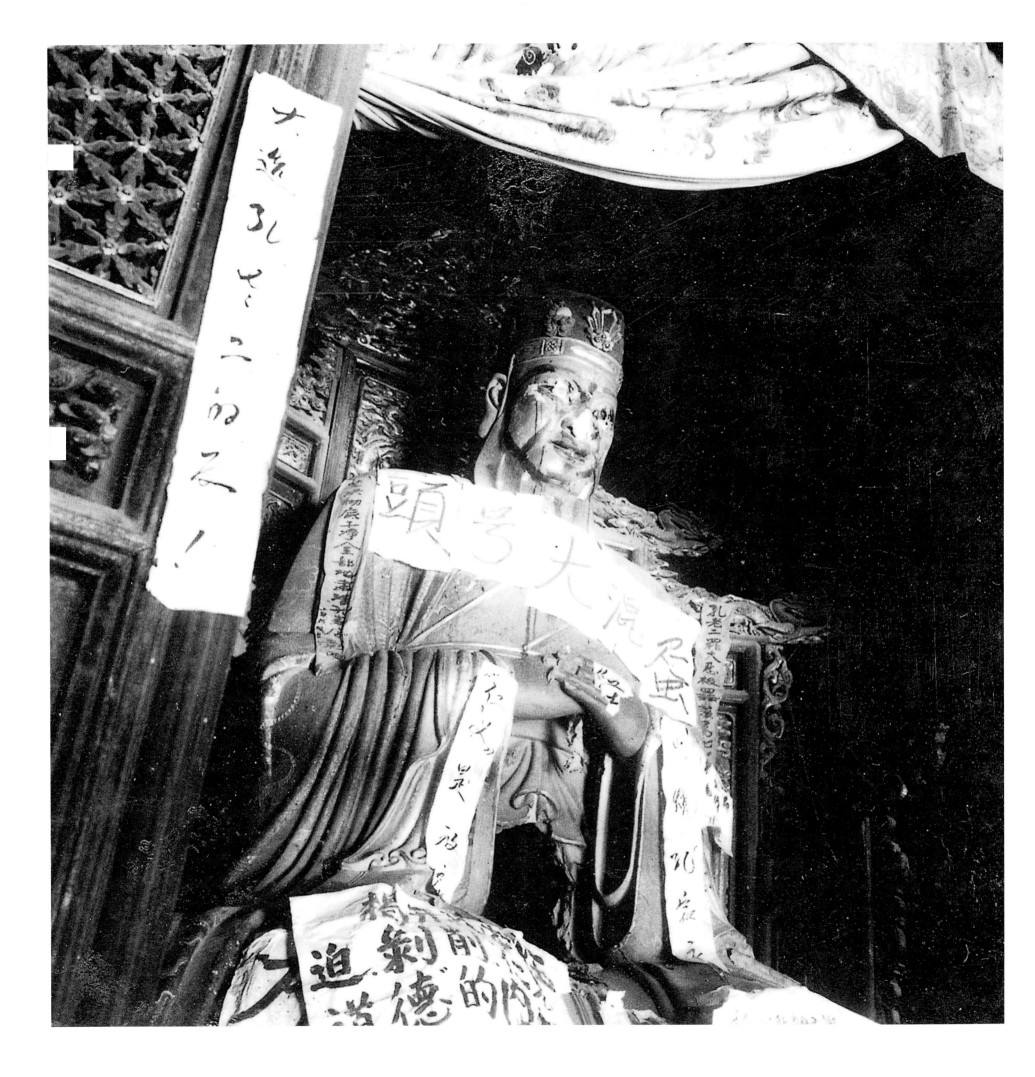

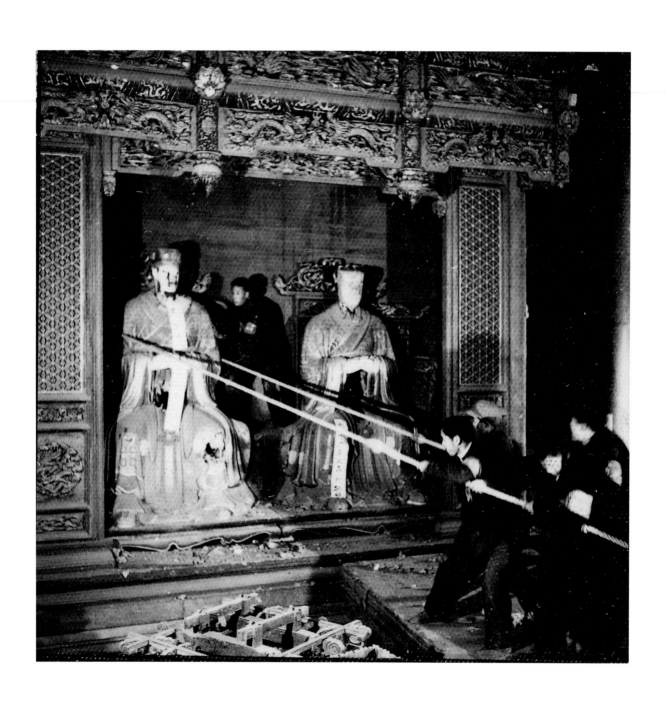

Anonymous photograph,
Pulling Down the Ming Statues, Qufu, Shandong province, 1966, personal collection of Kong Hongyan.

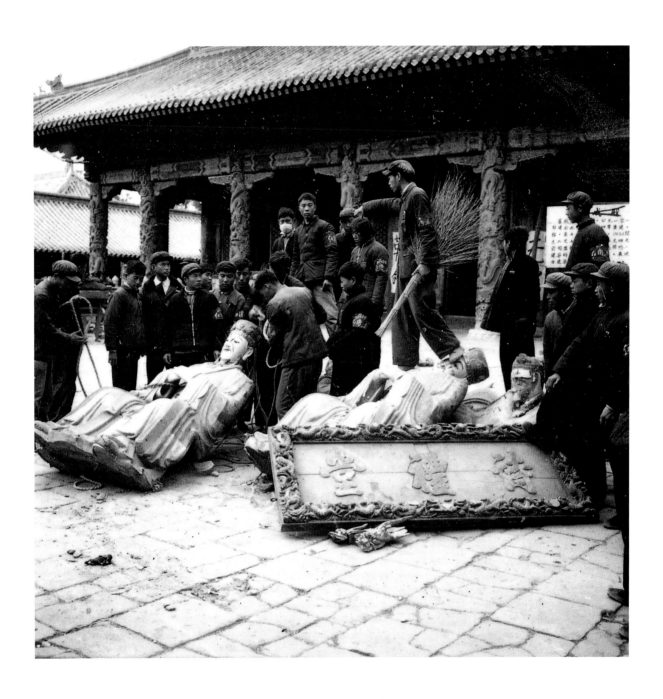

Anonymous photograph,
Smashing the Ming Statues, Qufu, Shandong province, 1966, personal collection of Kong Hongyan.

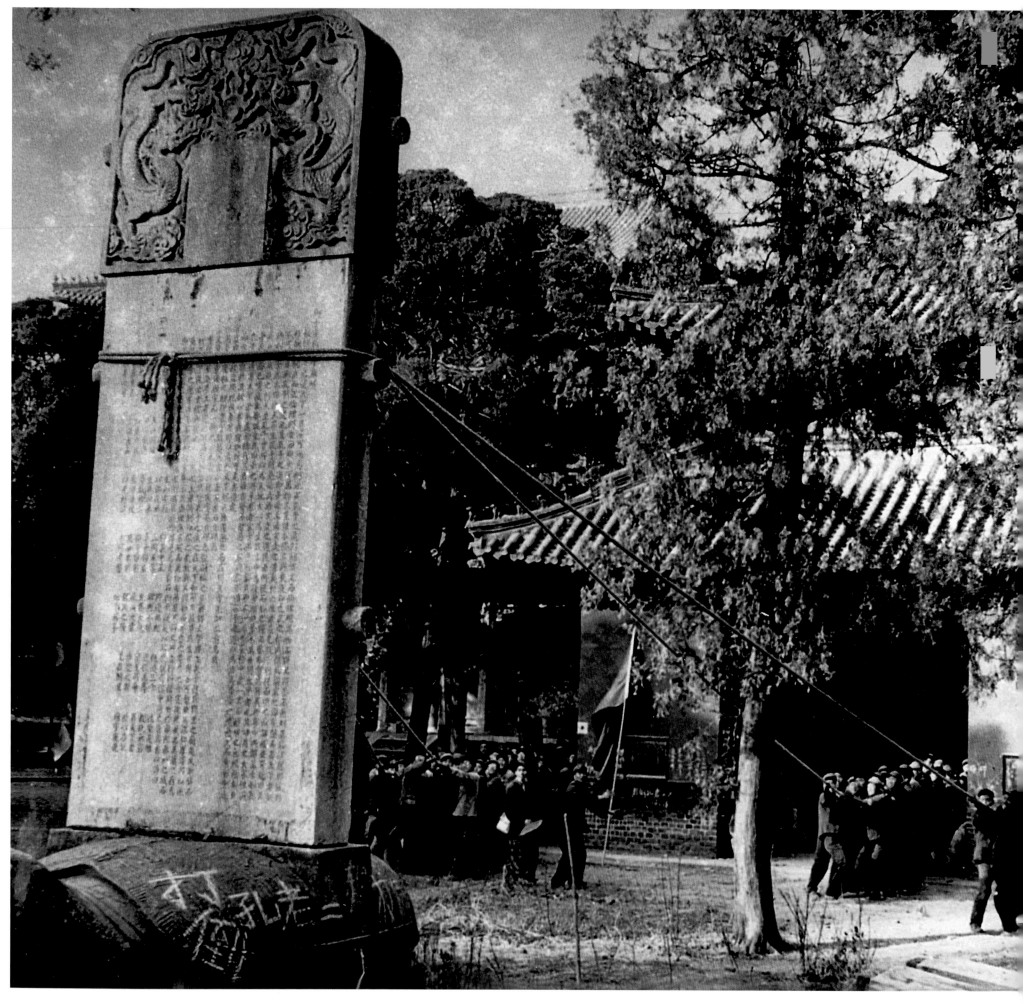

Anonymous photograph,
Pulling Down the Chenghua Stele of the Confucius Temple, Qufu, Shandong province, 1966, personal collection of Kong Hongyan.

Anonymous photograph,
Pulling Down the Memorial Archway, Qufu, Shandong province, 1966, personal collection of Kong Hongyan.

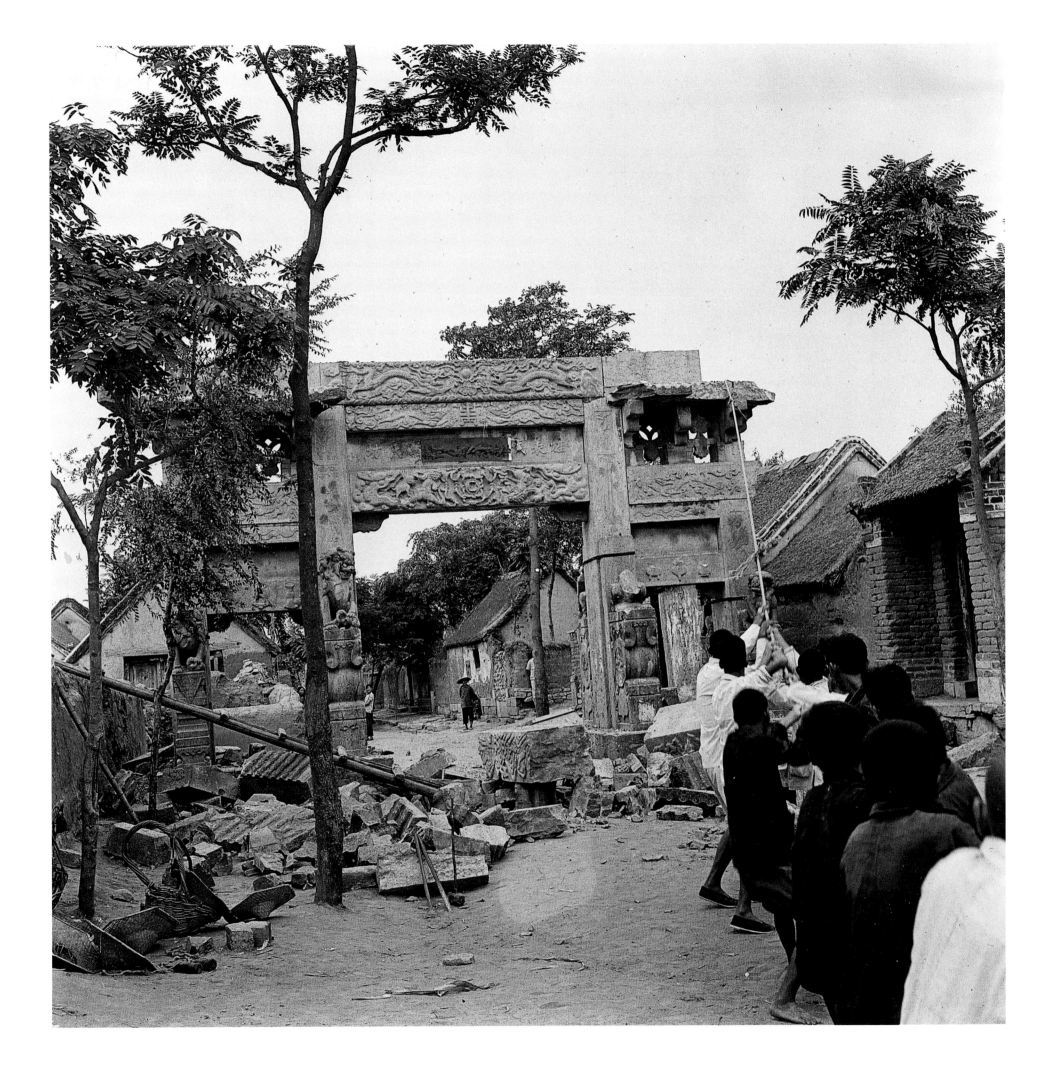

Anonymous photograph,
Photographing the 'Revolutionary Victory', Qufu, Shandong province, 1966, personal collection of Kong Hongyan.

Anonymous photograph,
The Inscribed Board of Wanshi Shibiao in Flames, Qufu, Shandong province, 1966, personal collection of Kong Hongyan.

Wang Shilong,
Setting the 'Four Olds' on Fire, Zhengzhou, 1966.

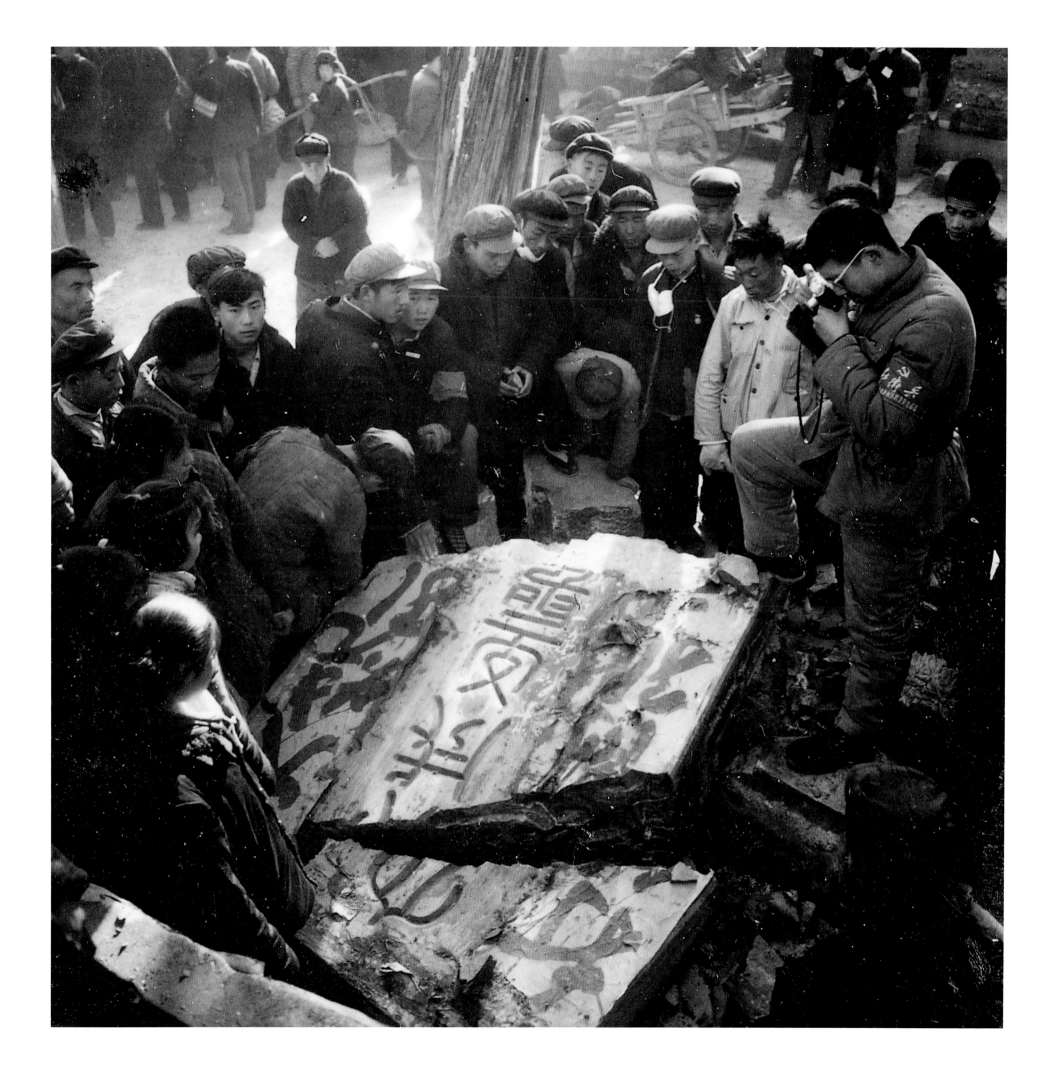

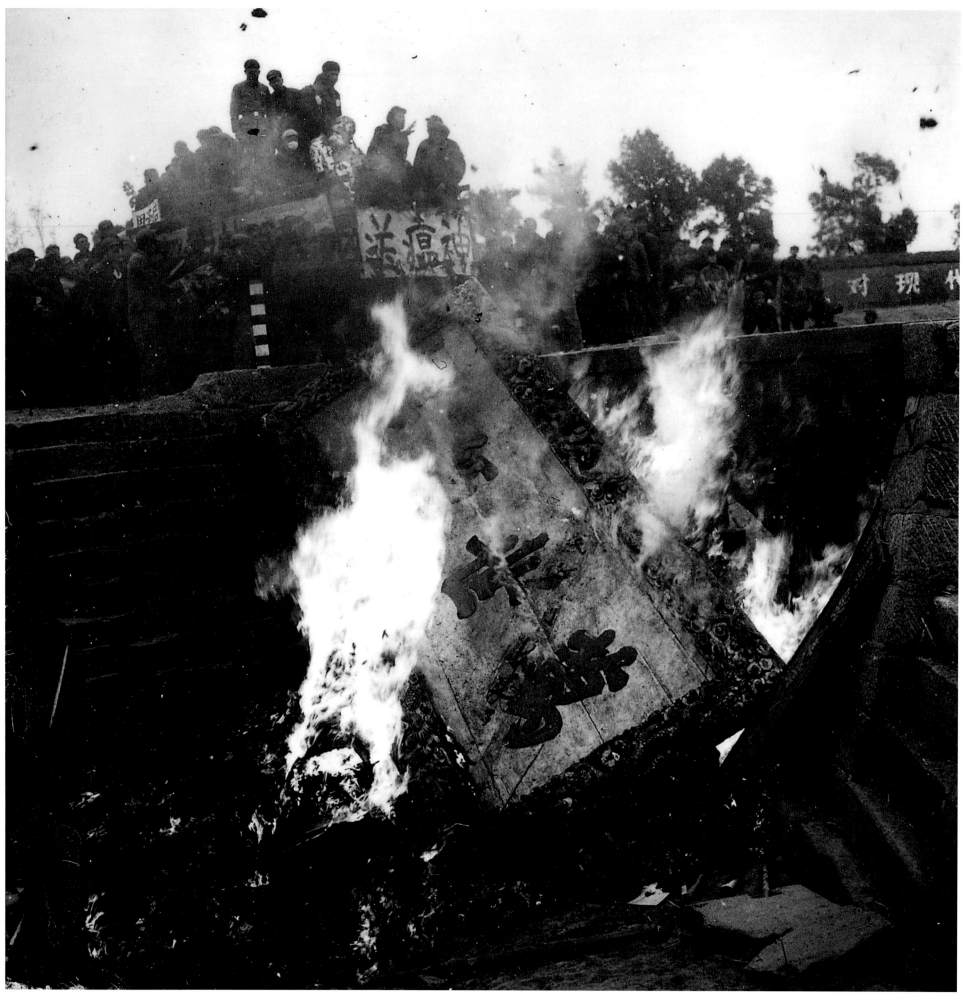

38

Across the country, over ten million homes were looted by Red Guards or people claiming to be Red Guards. Private properties were confiscated or set on fire. These houses would have contained copies of valuable literary classics, scrolls of calligraphy and paintings, artefacts and literary archives dating back to early dynasties (p. 39). In the city of Ningbo alone, more than eighty tonnes of books from the Ming (1368–1644) and Qing (1644–1911) dynasties were pulped. The actions of Red Guards soon turned into the 'red terror' (*hongse kongbu*), with which people of 'bad' class background, or owners of those 'Olds', were humiliated or worse.

The whole country was plunged into disarray during the summer months, while the 'old' was replaced with the 'new'. Beijing was even renamed 'The City of East Is Red' (*Dongfang hong*). Chang'an Boulevard became 'East is Red Road' (pp. 42–3) and West Chang'an Boulevard became 'Mao Zedong Road' (pp. 44–5). The stone lions and pillars in front of Tiananmen were replaced with bronze statues of Mao and some heroic figures from Chinese revolutionary history. Traditional names of famous old shops, restaurants and firms (*lao zihao*) were considered either feudalistic or capitalistic and were updated with revolutionary terms. The original seventy-year-old signboard of Quanjude, the famous roast-duck restaurant, was smashed into pieces and replaced with the newly painted 'Beijing Roast Duck Restaurant' (*Beijing kaoya dian*); Dong'an Bazaar was renamed Dongfeng (Eastern Wind) Bazaar. Even hospital names were changed: Tongren became Worker-Peasant-Soldier Hospital (*Gong nong bing*) and Xiehe was renamed Anti-Imperialism Hospital (*Fandi*). Some, who regarded themselves as revolutionaries or wished to prove themselves so, changed their names with any capitalist, feudal and

revisionist connotations to such revolutionary-sounding names as Hongyan (Red Cliff), Weidong (Defending the East, also meaning defending Mao Zedong), Jihong (Inheriting the Red), Yongge (Permanent Revolution), and so forth.[14] Similarly, in Shanghai, the walls of the entire Nanjing Road, the busiest commercial street in the centre, were covered with big-character posters, slogans and new shop signs (p. 46). These actions soon spread from the cities, reaching as far as the minority regions of Urumchi, Huhehot and Lhasa.

The movement also involved people's style in their daily lives. One's visual identity became an obvious measure of one's political standpoint or one's distance from the 'Four Olds'. As the Red Guards criticised,

> To stage a comeback, you (barbers) styled various eccentric hairdos such as 'Jet Style', 'Seamless Youth Style', 'Spiral Tower Style' or 'Youth Wave Style' with perfumes and pomades, which made the rogues over-pleased. To stage a comeback, you (tailors) styled plenty of nauseating dresses, such as jeans wear, which made these rogues self-satisfied.[15]

Those with haircuts considered eccentric or even with curly, long hair would be publicly subjected to disorderly or half-shaven (*yinyang tou*) haircuts in public. High-heeled shoes and winkle-pickers would be burned, and trousers that were either too tight or too wide, like flares, would be regarded as 'strange fashion' and torn up. A couplet hung out by a clothes shop read, 'The revolutionary suits should be made mostly, specially and promptly; the strange fashion should be abolished completely, particularly and immediately.'[16]

Chairman Mao said, 'a revolution is not a dinner party, or writing an essay, or painting a picture, or doing embroidery; it cannot be refined – so leisurely and gentle, so temperate, kind, courteous, restrained, and magnanimous.'[17] The Red Guard campaign 'Smashing the Four Olds', as a prelude, had two essential results. First, religion was obliterated, leaving Mao's Communism as the exclusive focus for belief. History does repeat itself, for centuries earlier the first Qin emperor had left commemorative inscriptions on sacred mountains, while reducing most of China's ancient manuscript and historical archives to ashes. Similarly, the destruction of millions of books during the Cultural Revolution led to the reverence for a single book, *Chairman Mao's Selected Words* (*Mao zhuxi yiilu*), and indeed the sole remaining icon, Mao Zedong. Second, the visual world of traditional China was substantially dismantled for restyling. The anti-traditionalist ideas were derived from the New Culture Movement at the beginning of the century, whilst the Cultural Revolution, as an extreme form of continuous struggle, intended to fundamentally eradicate the nation's historical legacy, which it found no longer useful. The Red Guards pioneered the radical mass movement by demolishing China's traditions in the visual arts, literature, music, performance and other folk cultures. The absence of cultural references then meant that the revolutionary methods could be devoted to 'creating', not 'reforming'. Mao taught that 'there is no construction without destruction' (*bupo buli*). The tragedy of the destruction of thousands of years of Chinese culture offered a free range for the construction of the new red world.

5. Although officially issued on May 16, 1966, the full version of the *May the Sixteenth Circular* was not published until May 16, 1967.

6. 'Hengsao yiqie niugui sheshen (Sweep Away All the Ox-demon and Snake-spirit)', *Renmin ribao*, June 1, 1966, p. 1.

7. 'Women shi jiu shijie de pipanzhe (We Are the Critics of the Old World)', *Renmin ribao*, June 8, 1966, p. 1. The rise of the Red Guards will be discussed in detail in Chapter Three.

8. Yan Jiaqi and Gao Gao, D. Kwok (trans. and ed.), *Turbulent Decade: A History of the Cultural Revolution*. Hawaii: University of Hawaii Press, 1996, pp. 70–4.

9. MacFarquhar and Schoenhals (2006), op. cit., p. 119.

10. Ho, Dahpon, 'To Protect and Preserve: Resisting the Destroy of the Four Olds Campaign, 1966–1967', in Joseph W. Esherick et al. (eds), *The Chinese Cultural Revolution as History*. Stanford: Stanford University Press, 2006.

11. Hou Xinmu and Kong Hongyan, *Bainian yingxiang: ershi shiji de kongfu (A Hundred Year Images: Confucius' Family in the Twentieth Century)*. Beijing: Zhongguo wenshi chubanshe, 2005.

12. Cited in MacFarquhar and Schoenhals (2006), op. cit., p. 120.

13. Ibid., p. 119.

14. Yan and Gao (1996), op. cit., pp. 66–7.

15. Cited in Mi Hedu, *Hong weibing zhe yidai (The Generation of Red Guard)*. Hong Kong: Sanlian chubanshe, 1993, p. 148.

16. Ibid.

17. Schoenhals, Michael (ed.), *China's Cultural Revolution, 1966–1969: Not a Dinner Party*. London: East Gate Books, 1996, p. 22.

Yu Jianying,
East Is Red Road, Beijing, 1966.

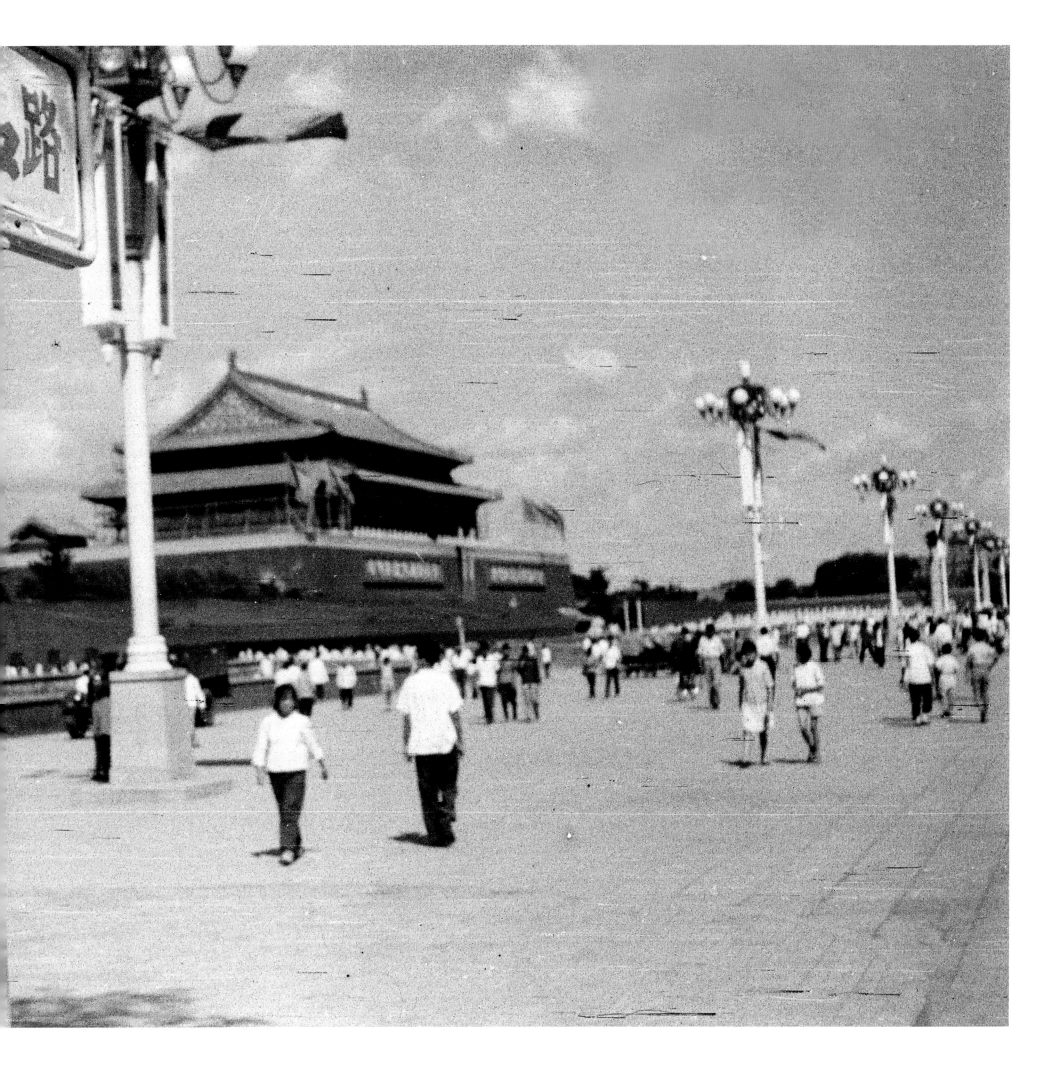

Yu Jianying,
Mao Zedong Road, Beijing, 1966.

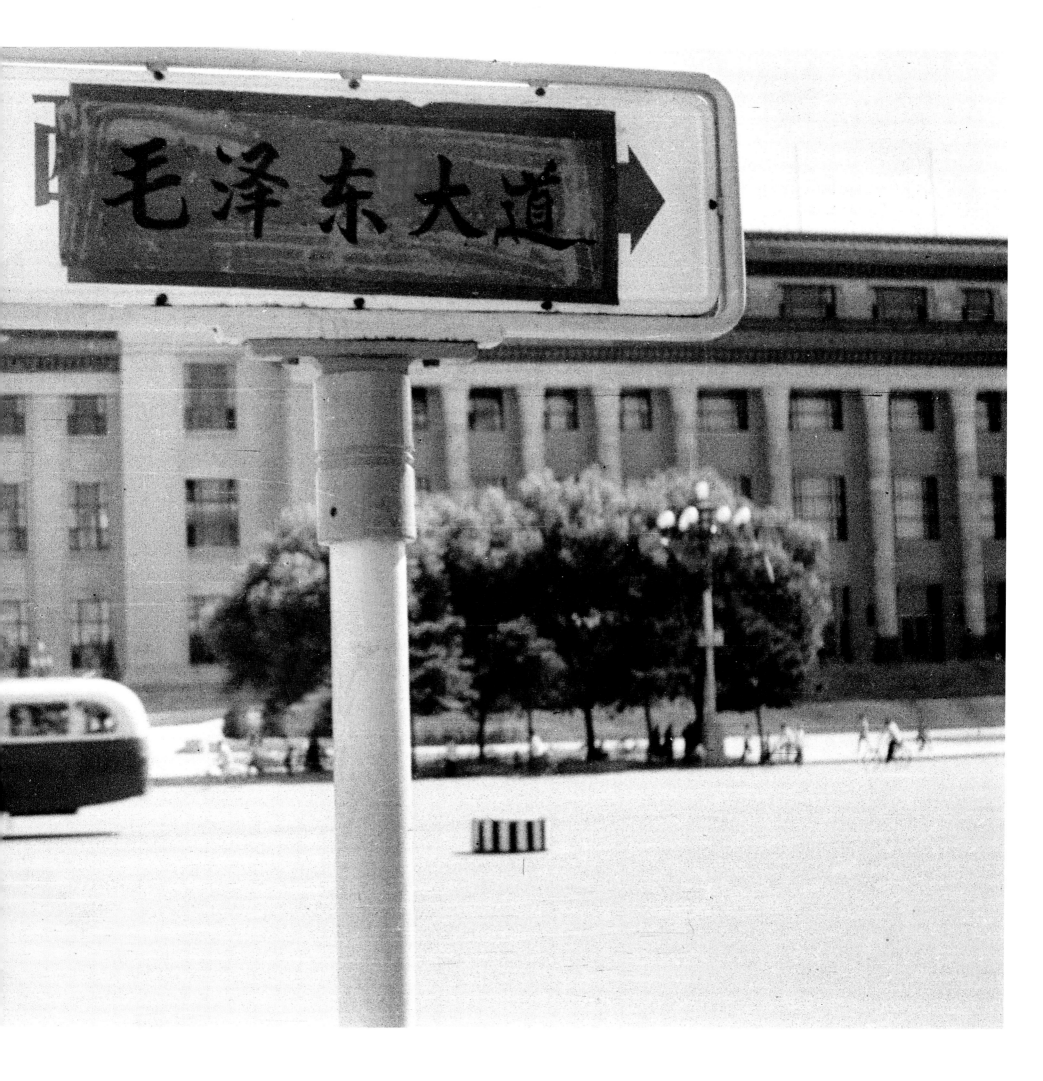

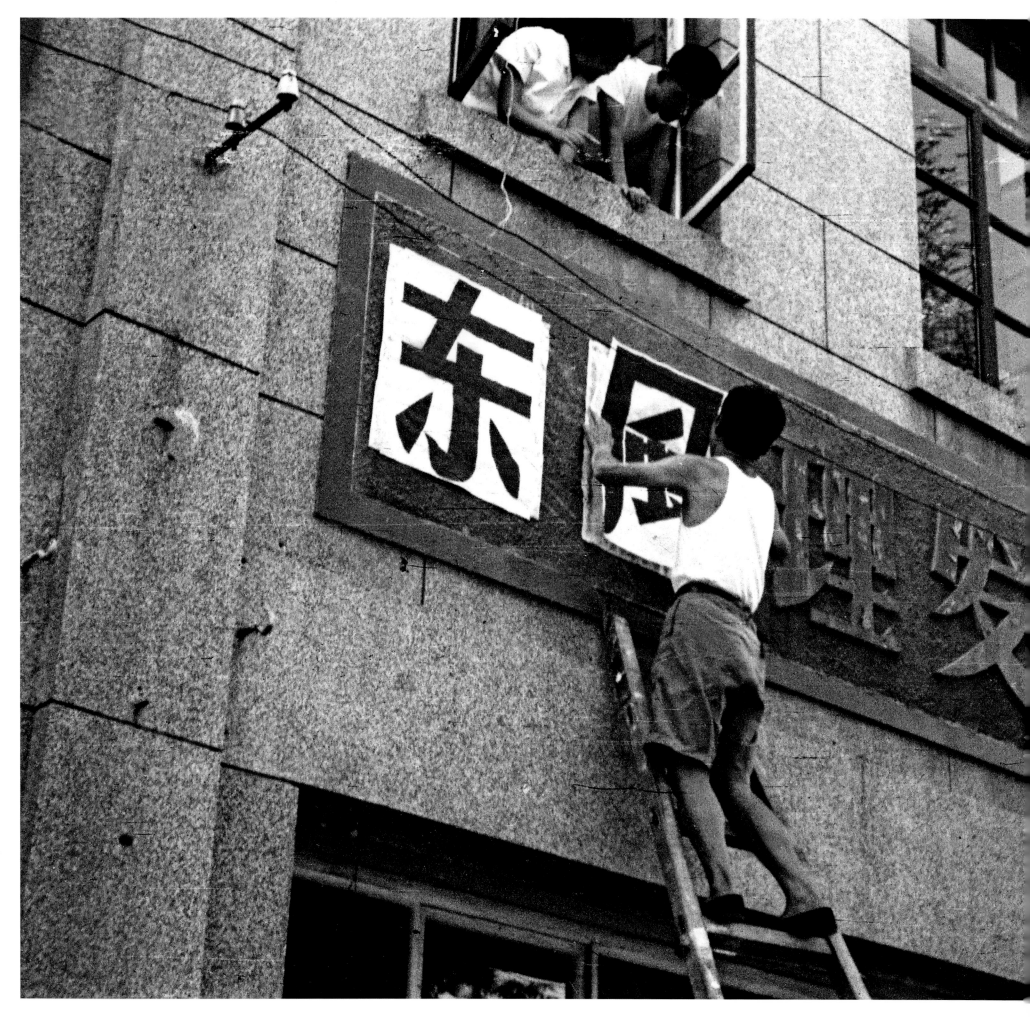

Yu Jianying,
Eastern Wind Barbershop, Beijing, 1966.

紅太陽

THE RED SUN

The personal cult (*geren chongbai*) of Mao was fostered from the moment Mao took charge of the Chinese Communist Party. In the early period of the Communist revolution, Mao advocated that people should give up their gods and he distanced himself from any cult of personality. However, Mao became more dominant following the founding of the People's Republic. Mao's reference to Joseph Stalin at the Session in Chengdu on March 10, 1958, after the Russian leader's death, was a warning that he intended to enjoy his own cult.

> Somebody is very keen on resisting the personality cults. However, there are two kinds of cults: one is correct, such as those correct ideas of Marx, Engels, Lenin and Stalin, we must worship, worship forever. Why don't we worship them, if they got the truth? Yet, the other is an incorrect cult, we should not blindly obey without any analysis.[18]

The image of Mao first appeared on postage stamps in 1944, as did Zhu De's in the liberated areas, replacing those of Sun Zhongshan (Sun Yat-Sen) and Jiang Jieshi (Chiang Kai-Shek).[19] On October 1, 1950, the first anniversary of the new China, Mao's image appeared on the front page of *Renmin ribao*, the state's principal newspaper. His small picture together with that of Sun Zhongshan implied that they were the figures of the 'inherited' revolution. On the tenth anniversary, the size of Mao's portrait grew to more than a quarter of the front page, juxtaposed with an image of Liu Shaoqi, who succeeded Mao as Government Chairman in 1958 and was publicly acknowledged as Mao's chosen successor later in 1961. By 1966, Mao's superiority had been fully developed during the political struggle, whereas Liu Shaoqi was descending in status and absent from public view. Then the Chairman occupied the entire front page, with his victorious smile appearing in all the newspapers, pictorials and magazines. Supported by his comrades, the cult of Mao reached its climax during the period of the Cultural Revolution. For example, in one of his letters to the Red Guards, Zhou Enlai wrote,

> In the course of this Great Proletarian Cultural Revolution of ours there can be only one criterion of truth, and that is to measure everything against Mao Zedong's Thought. Whatever accords with Mao Zedong's Thought is right, while that which does not accord with Mao Zedong's Thought is wrong. This is why Comrade Lin Biao tells us to 'read Chairman Mao's works, obey Chairman Mao's words, and act according to Chairman Mao's instructions'.[20]

On October 1, 1949, Mao Zedong had ascended Tiananmen, the Gate of Heavenly Peace, which was originally built during the Ming dynasty and reconstructed in the Qing dynasty. He declared the birth of the People's Republic of China to the thousands of citizens and soldiers gathered under Tiananmen: 'The Chinese people have finally stood up!' The appearance of Mao as a Communist leader must have added a new political dimension to the symbolism of the former imperial building, so marking a new era. At the same time, the gate instantly offered Mao the dual status of both Communist leader and feudalistic monarch.[21]

Lü Xiangyou,
Mao at the Tiananmen Balcony, Beijing, 1966, provided by China Photo Service.

人民日报

RENMIN RIBAO

庆祝中华人民共和国成立十周年

毛泽东主席　　　　刘少奇主席

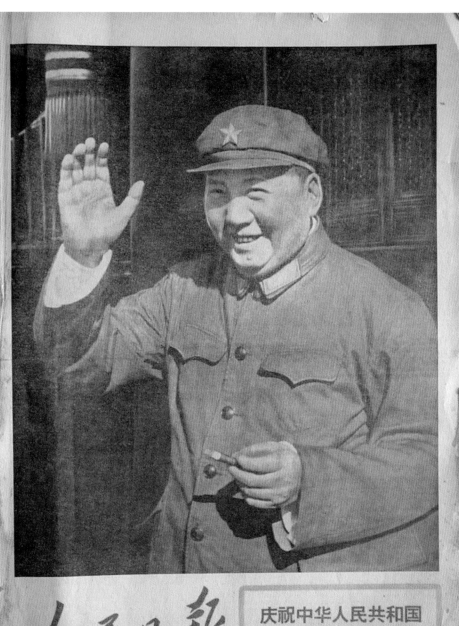

人民日报

庆祝中华人民共和国
成立十七周年！

According to Yan Jiaqi and Gao Gao, in the opening speech of Mao's first inspection of Red Guards, Chen Boda, the Politburo member and head of the Central Cultural Revolution Small Group, lauded Mao with three accolades – the Great Leader, the Great Teacher and the Great Helmsman. He was followed by Lin Biao, who declared, 'The highest commander of this Great Proletarian Cultural Revolution is Chairman Mao. Chairman Mao is the commander in chief.' With the Great Commander added, the combination of these accolades – commonly termed the 'Four Greats' (*Sige weida*) – was then used in every reference to the leader (p. 53).[22] To fill the religious and cultural void left by the Cultural Revolution, the use of the image of the red sun seemed accessible in the tradition of folk culture and became the ultimate symbol of Mao. A popular song extended the metaphors.

> A helmsman is needed for sailing on the sea;
> The sun is needed for all things to grow.
> Plants grow stronger when nourished by morning dew;
> Mao Zedong's Thought is needed for the revolutionary cause.
> Fish cannot live without water;
> Melons cannot live without vines.
> The revolutionary masses cannot survive without the
> Communist Party,
> Mao Zedong's Thought is the forever shining sun.[23]

As a former Red Guard recalls, 'I felt at that time our leader was not an ordinary man. Mao Zedong might have been born as a sun god. We even called him the red sun who arose from Shaoshan.'[24] Every Chinese of this generation would also remember another song by heart from childhood.

> I love Beijing's Tiananmen,
> The place where the sun rises.
> Our great leader Mao Zedong
> Guides us as we march forward!

In his autobiographical narrative, Wu Hung reflected,

> Owing more to its cheerful melody than to its unimaginative lyrics, this song became one of the most beloved children's songs in the country. While its lyrics were memorised by boys and girls even in kindergarten, Tiananmen was the seat of the Great Leader and immersed in Mao's sun-like brightness. In fact, for some years I actually believed that Mao lived in Tiananmen. At that time apparently I didn't understand the difference between metaphor and literal description, so whenever I drew Tiananmen I also circled it with radiating lines, a pattern of sunlight that I thought was a standard feature of the monument.[25]

Mao's image was literarily and ideologically fused with the identity of the sun and the colour red to create a complex image as a player with the role of people's new 'god'. Mao was affirmed as the great healer and saviour, who would be able to free people from agony, illness and a world full of evils,[26] and whose leadership must have been granted from heaven.

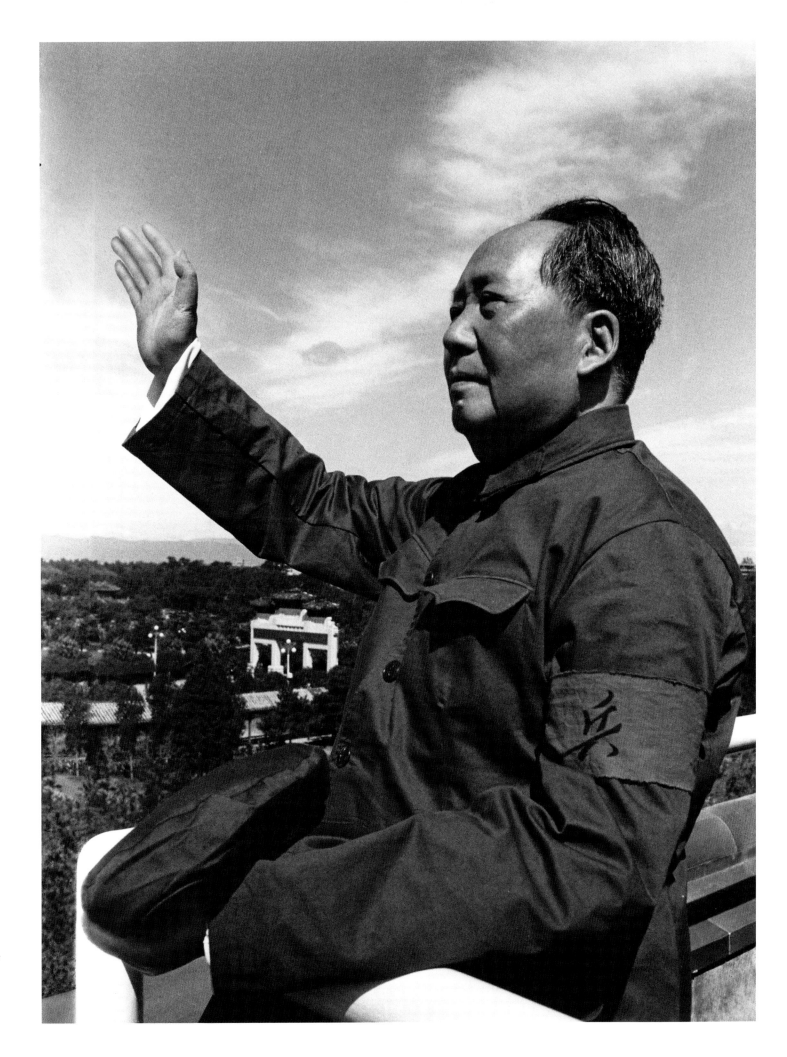

Lü Xiangyou,
Mao at the Tiananmen Balcony, Beijing, 1966,
provided by China Photo Service.

Weng Naiqiang,
Chairman Mao on Tiananmen, Beijing, 1966.

After attending the ceremony at the Tiananmen balcony eight times during the summer of 1966 to inspect his Red Guards, Mao disappeared. The Chairman, it seems, had recalled a famous passage from traditional Chinese political philosophy and was transformed into an 'invisible emperor', for in the third century BC the writer Han Fei had taught kings and emperors that power must be generated by secrecy.

> The way (of the ruler) lies in what cannot be seen, its function in what cannot be known. Be empty, still and idle, and from your place of darkness observe the defects of others, see but do not appear to see; listen but do not seem to listen; know but do not let it be known that you know… Hide your tracks, conceal your sources, so that your subordinates cannot trace the springs of your action. Discard wisdom, forswear ability, so that your subordinates cannot guess what you are about.[27]

Mao's increasing mystique during the Cultural Revolution was closely related to his withdrawal from public view. In comparison with China's other dynasties, paradoxically Mao could be seen as the most visible of 'invisible emperors'. It would have been impossible for him to launch such an unprecedented mass movement without a public presence, or to maintain his supreme power with a continuous presence that might impair his 'imperial aura'. In order to exercise power without physical presence, two visual languages were essential. On the one hand, Mao's calligraphy, the most widely known handwriting in China, inherited the visual power of written

language from Chinese tradition and signalled the dignity of the author. On the other hand, with the arrival of the culture of portraiture from the West, Mao was no longer dependent on the cultural legacy of literati and was in a position to manipulate that even more ubiquitous visual instrument, his own image.[28] The image of Mao was then reproduced and disseminated across the country by all possible means, including through the use of the most prevalent devices, the Chairman's portrait and the Mao badge.

When Mao, the son of a peasant, appeared as the leader of the Communist Party on the Tiananmen balcony, the invisible and mysterious power of the imperial tradition was transferred to the visible, popular and affable identity of the new government (p. 55). Mao's portrait on a huge scale was hung at the exact centre of the Tiananmen front wall as an integral element of the great system of imperial architecture. Wu described the effect of the presence of the Mao portrait on the building: 'the anonymity of the painters means the autonomy of the painting: it no longer seems a work created by a particular human hand, but an image that is always there and changes on its own'. Mao's middle-aged image in the 1952 portrait became older in the 1963 version, and even older again in the 1967 version, which is still on public view there today. This changing Tiananmen portrait magnified Mao's appearance when the subject himself was present on the balcony, yet at other times it substituted for the Chairman in his absence, and finally became 'an eternal presence of the Party and the country'.[29]

Mao had been a distant authority, but the proliferation of Mao portraits that permeated people's daily life created a sense of instant and direct access to the great leader. It is estimated that during the Cultural

Continued on page 60

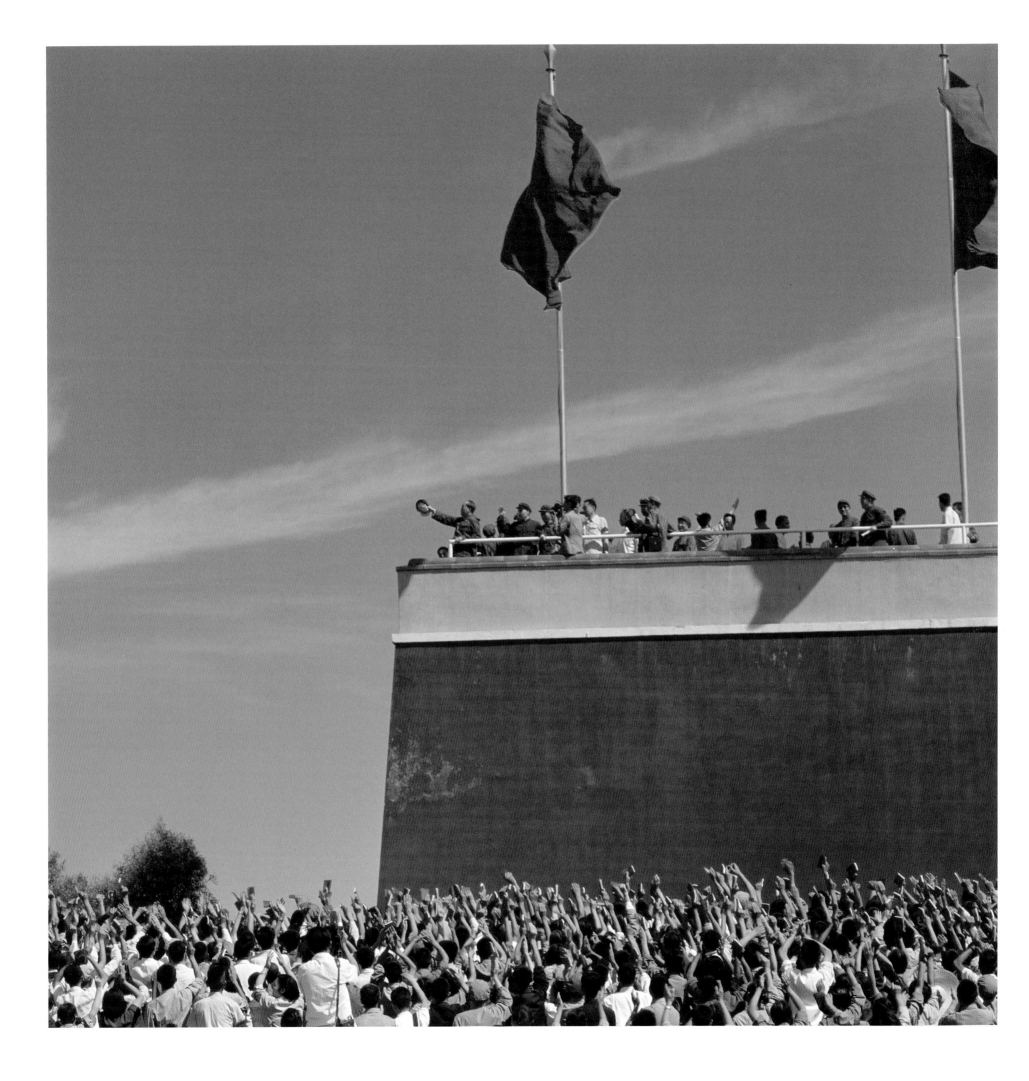

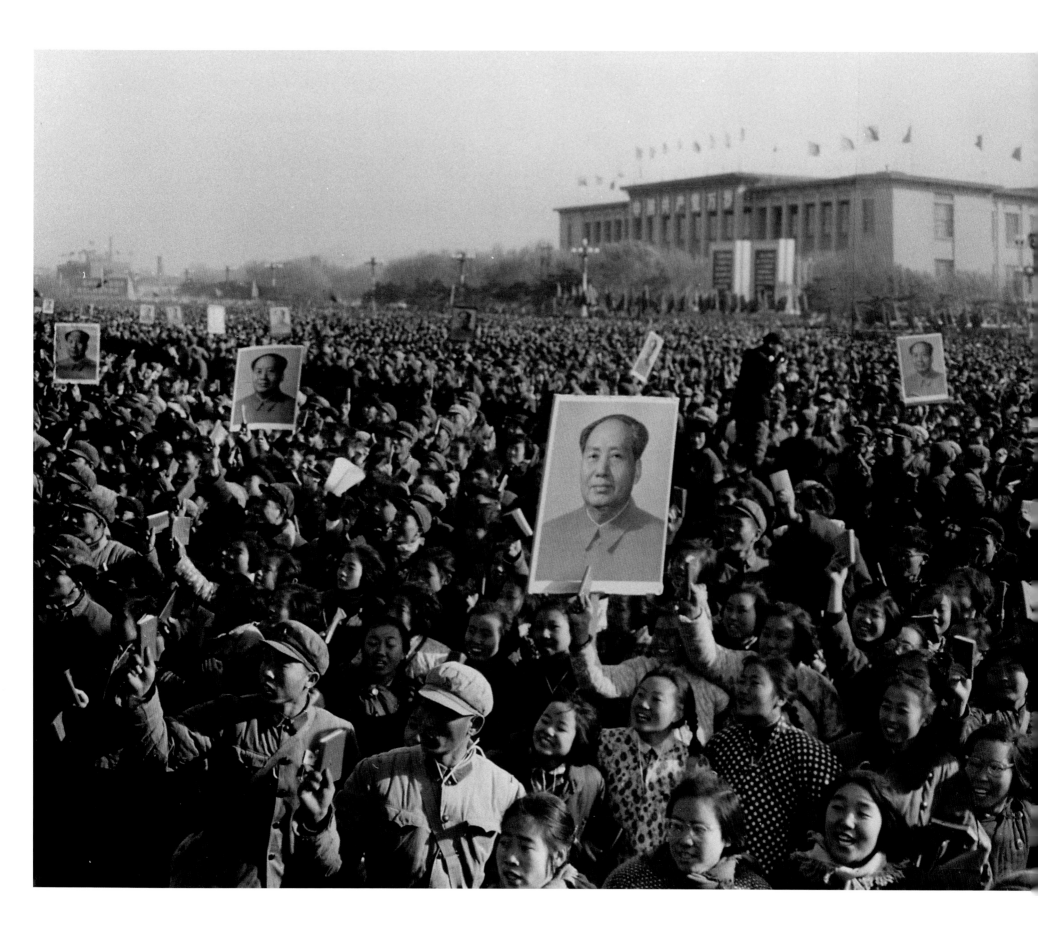

Anonymous photograph,
Red Guards Inspected by Mao in Tiananmen Square, Beijing, 1966, provided by China Photo Service.

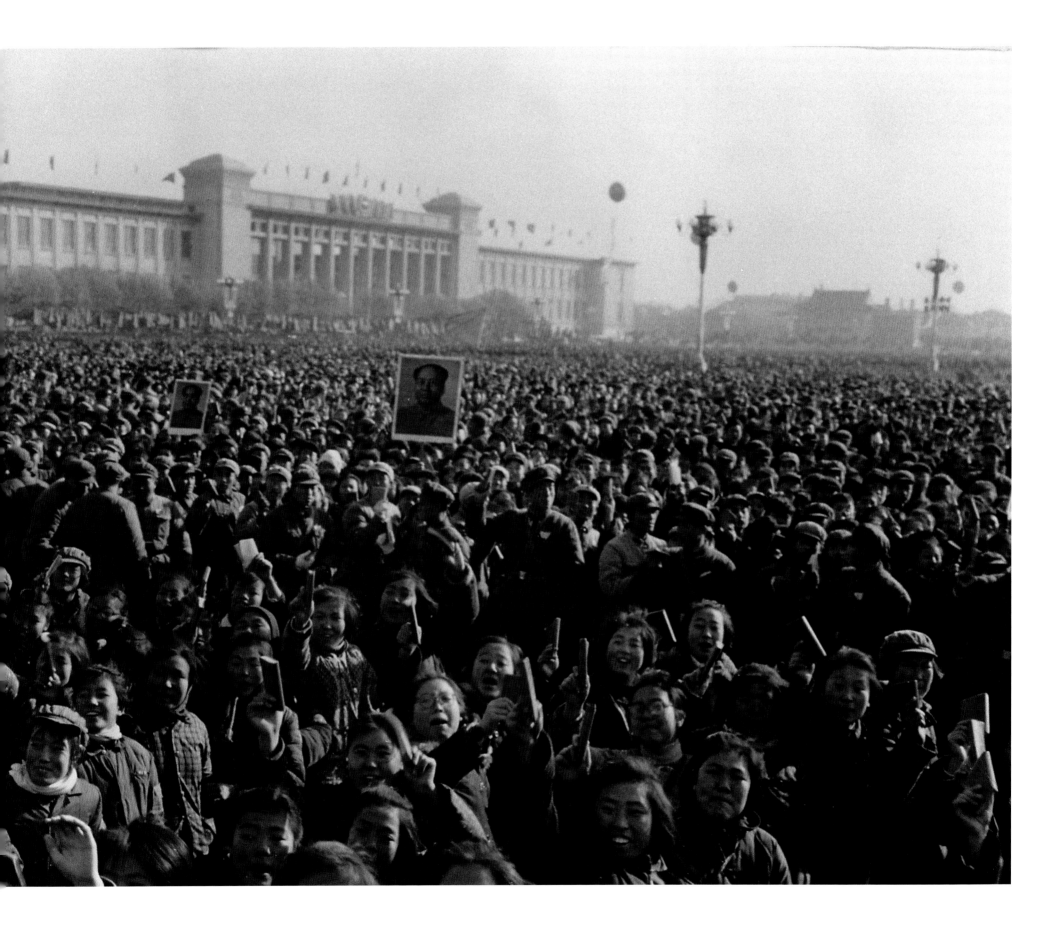

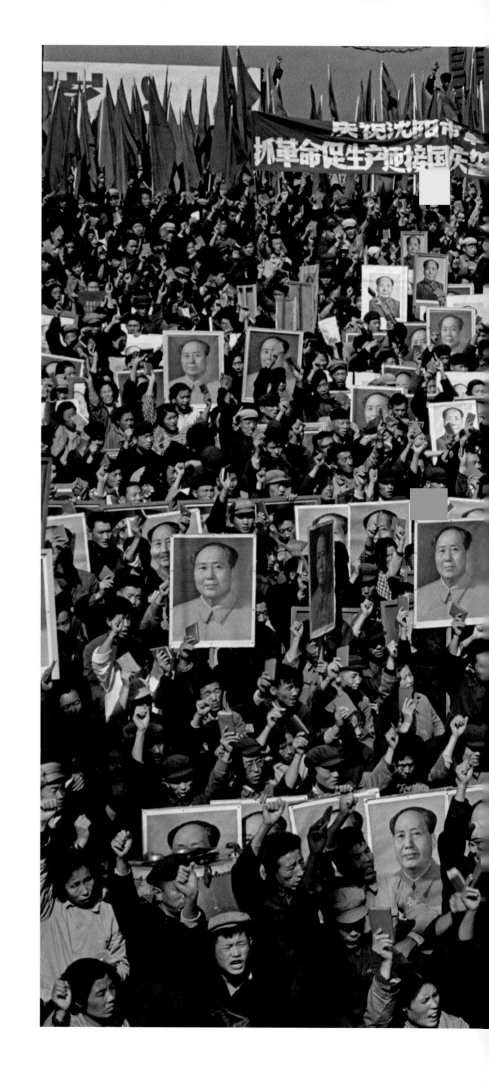

Jiang Shaowu,
Parade for Forthcoming National Day, Shenyang, Liaoning province, 1968.

Anonymous photograph,
Celebrating the Twentieth Anniversary of the People's Republic of China, Kunming, Yunnan province, 1969,
provided by China Photo Service.

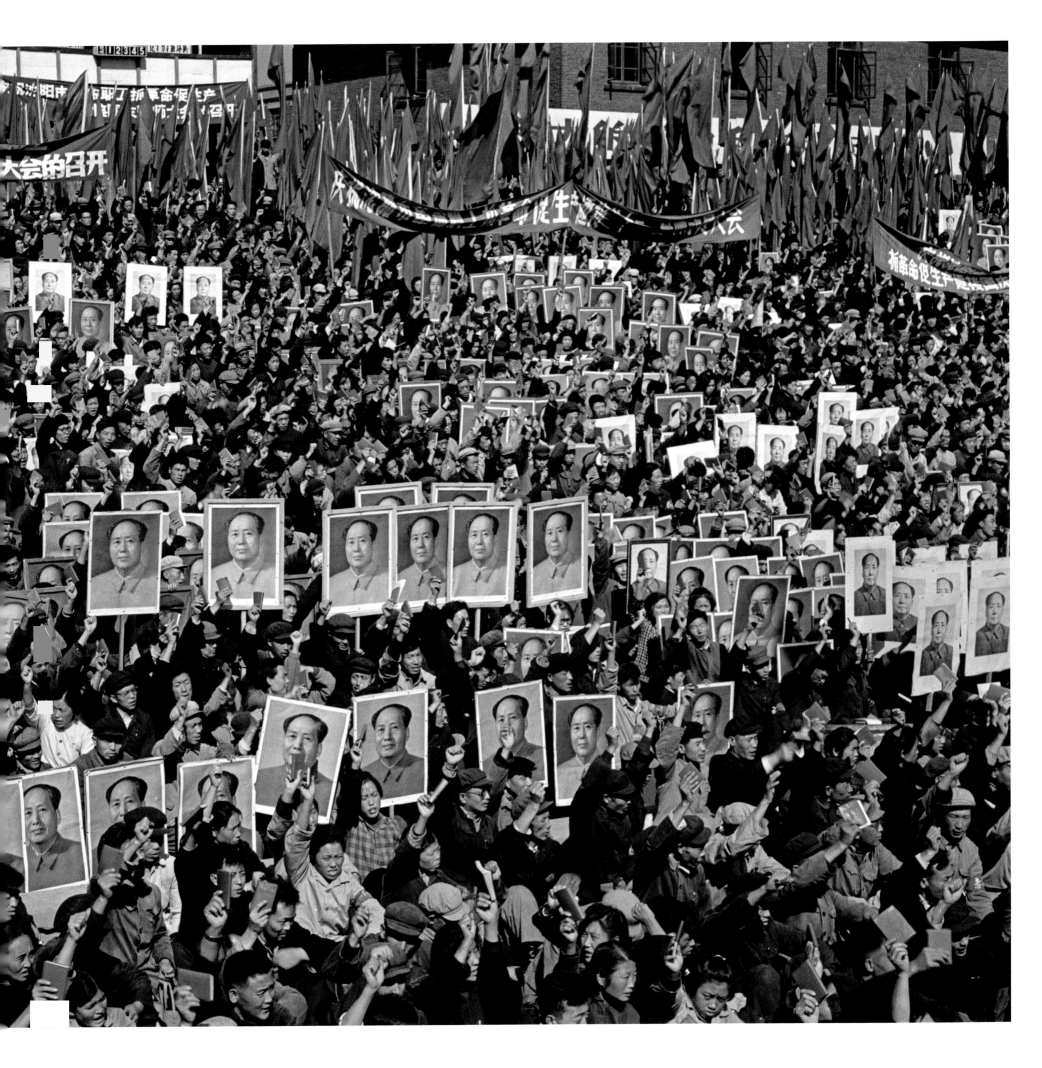

Revolution an astonishing 2.2 billion of the poster portraits, or the so-called 'standard portraits' (*biaozhun xiang*), of the Chairman were produced.[30] They appeared as Mao's substitute in factories, schools, shops, hospitals, museums, theatres, public transport stations and private residences, reinforcing his omnipresence. In a traditional residence, Mao's poster portrait replaced the *nianhua* (New Year pictures) or images of folk gods in the prominent position in the main room, with couplets on both sides. In other public interiors, the poster portrait was always placed high at the centre of a main wall, to provide a figurative image of the omniscient sun god for the daily forced cult practice, *zao qingshi wan huibao*, during which people asked for political instructions in the morning and reported at night. It was argued that the portraits in which 'Mao shared space, mainly with crowds, humanised, secularised and narrowed (but not closed) the distance between himself and the viewer. At the same time, the cult of his personality was projected and he added authority to the message.'[31] On other occasions, the divine image of the red sun also created an almost sacred presence that could be manipulated. During the 'Four Olds' campaign, some cultural treasures such as statues of Buddha and frescos that were covered with Mao's portraits and written slogans derived from his quotations had a better chance of surviving. One could also be criticised as the most atrocious counter-revolutionary and sentenced to death for carelessly sitting on a *Hongqi* (*Red Flag*), the Party journal, with a front cover bearing Mao's image.[32]

As well as the portraits distributed for public and private spaces, Mao's poster portraits became key instruments for people's assemblies and parades. During his inspections of the Red Guards in Tiananmen Square, images of Mao were always enthusiastically held up by the crowd (pp. 56–7). The poster portraits could be easily spotted in the heaving human ocean, because of the standardised size, their flat quality and the dignified silent smile on his lips. It seems that they were intended to reflect the Chairman's presence, either in the distance on the Tiananmen balcony or closer and on the move. More importantly, they represented his constant renewal and empowerment. Mao's poster portraits appeared in still greater numbers on National Days (pp. 58–9), or during celebrations for the success of Party Congresses. People holding the portraits lined up in formation and marched across the city under the slogan 'To continue the Great Proletarian Cultural Revolution to the end' (p. 61). The personal identities of thousands of the population were then physically overshadowed or metaphorically masked by the image of the individual. The parade became a mass collective advance, with one single face, that of Chairman Mao.

Mao's poster portraits were present as a silent command for the people's celebration on the publication of the *Selected Works of Mao Zedong*, and at the same time they legitimised the text for daily reading (pp. 62–3). To keep his 'imperial mystique', Mao issued his 'supreme instructions' (*zuigao zhishi*) from unknown places. When a new 'supreme instruction' was issued, people had to give up everything immediately to go to their *danwei* (work-units) for registration, and then gather for a celebratory parade, bearing Mao's portraits and slogans, even at midnight. Sometimes larger portraits of Mao would be carried in a sedan chair, which further transformed the two-dimensional image into something more solid and

Continued on page 69

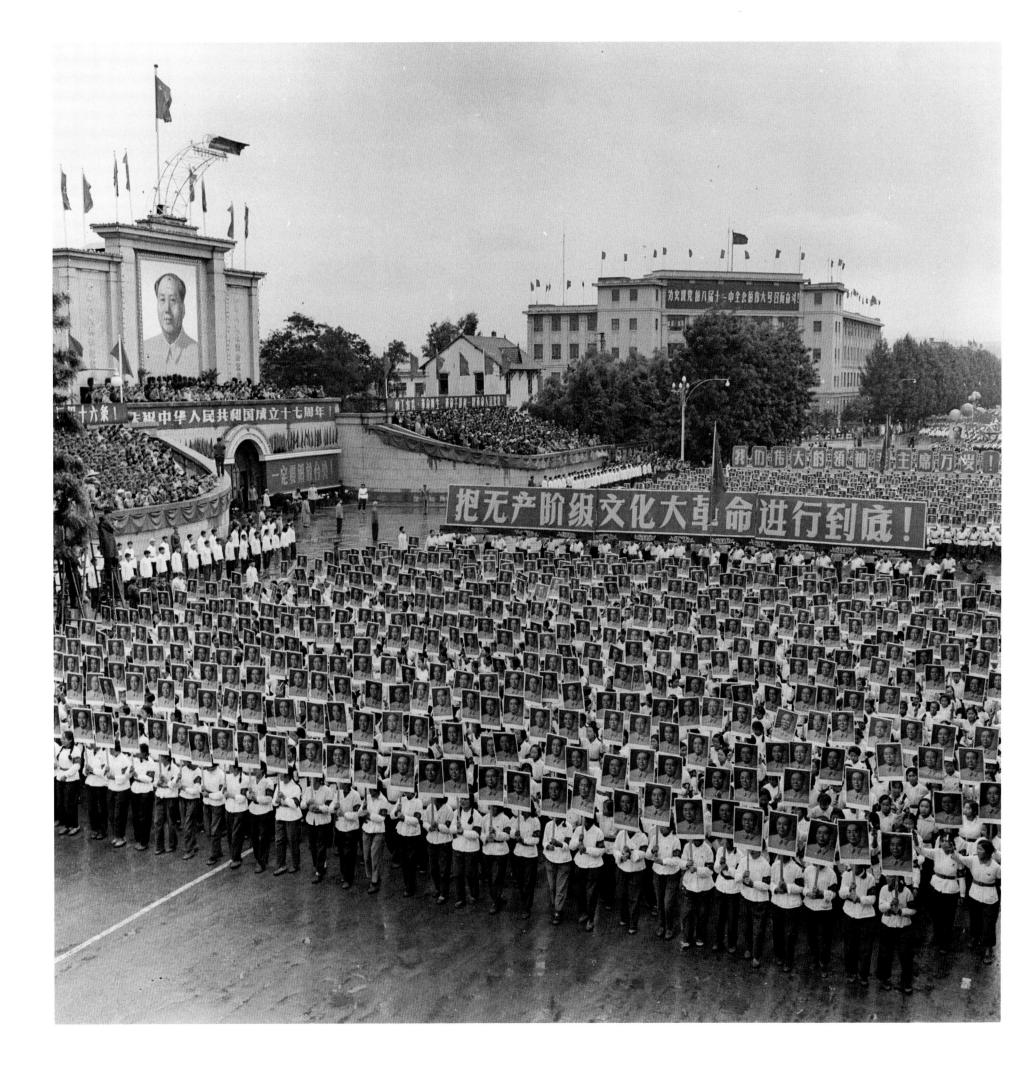

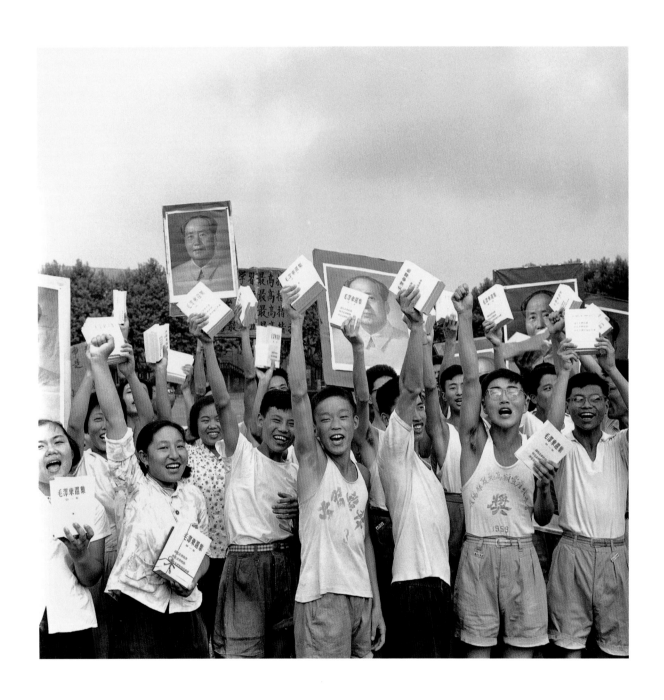

Xiao Zhuang,
Students and Staff from Nanjing Institute of Technology Receiving Selected Works of Mao Zedong, Nanjing, Jiangsu province, 1966.

Xiao Zhuang,
Students of Nanjing University Welcoming Selected Works of Mao Zedong, Nanjing, Jiangsu province, 1966, supplied by Xinhua Bookstore.

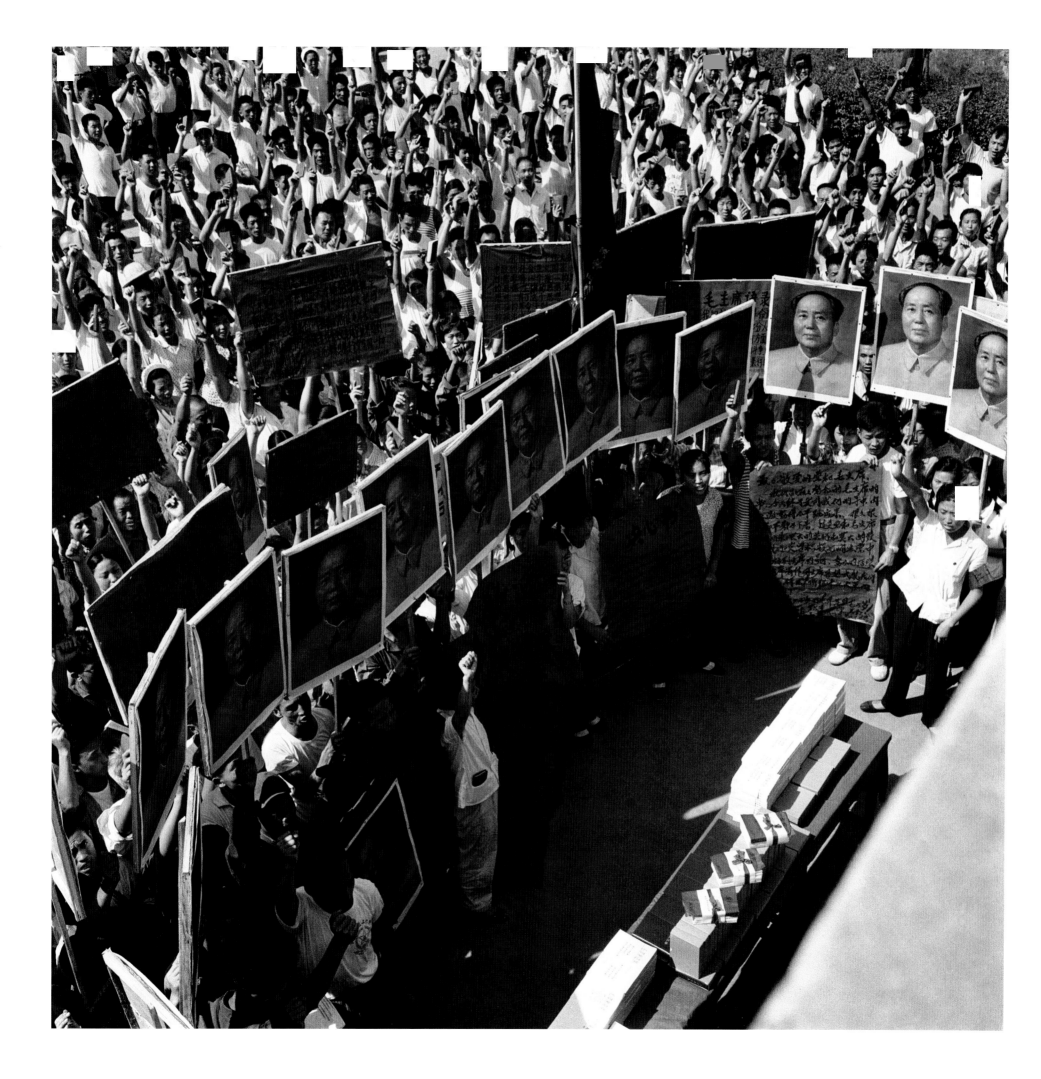

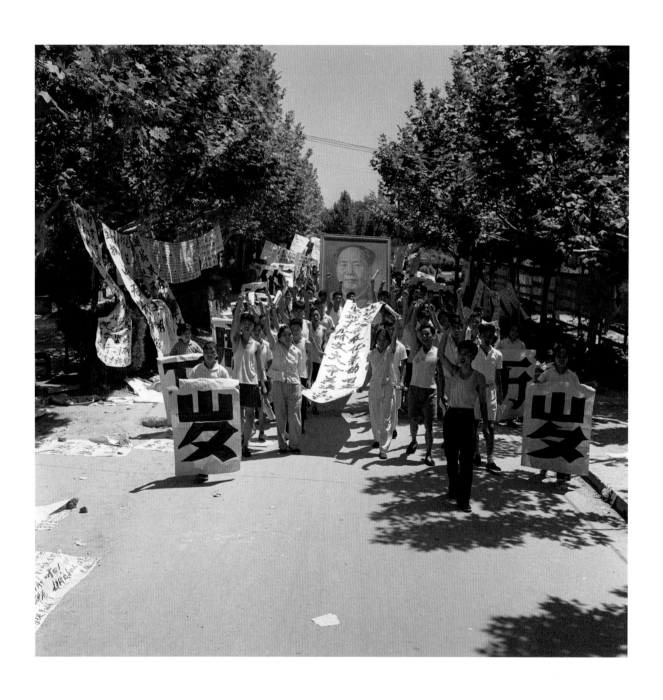

Wang Shilong,
Abandon Work and School to Parade, Zhengzhou, Henan province, 1966.

Xiao Zhuang,
Officials from Jiangsu Provincial Government in a Parade to Support the Cultural Revolution,
Nanjing, Jiangsu province, 1966.

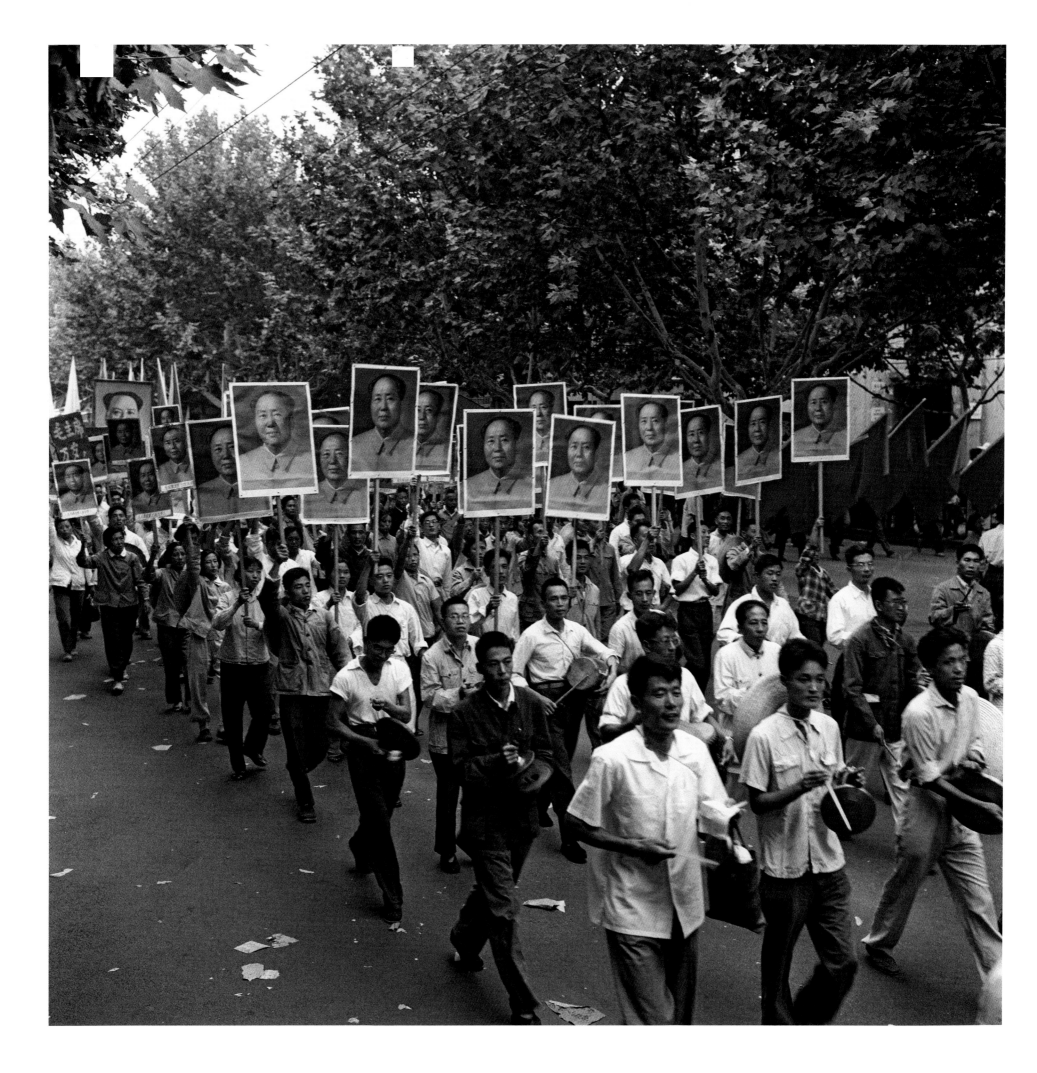

Weng Naiqiang,
Foreigners Participating in the Anti-Revisionism Parade, Beijing, 1966.

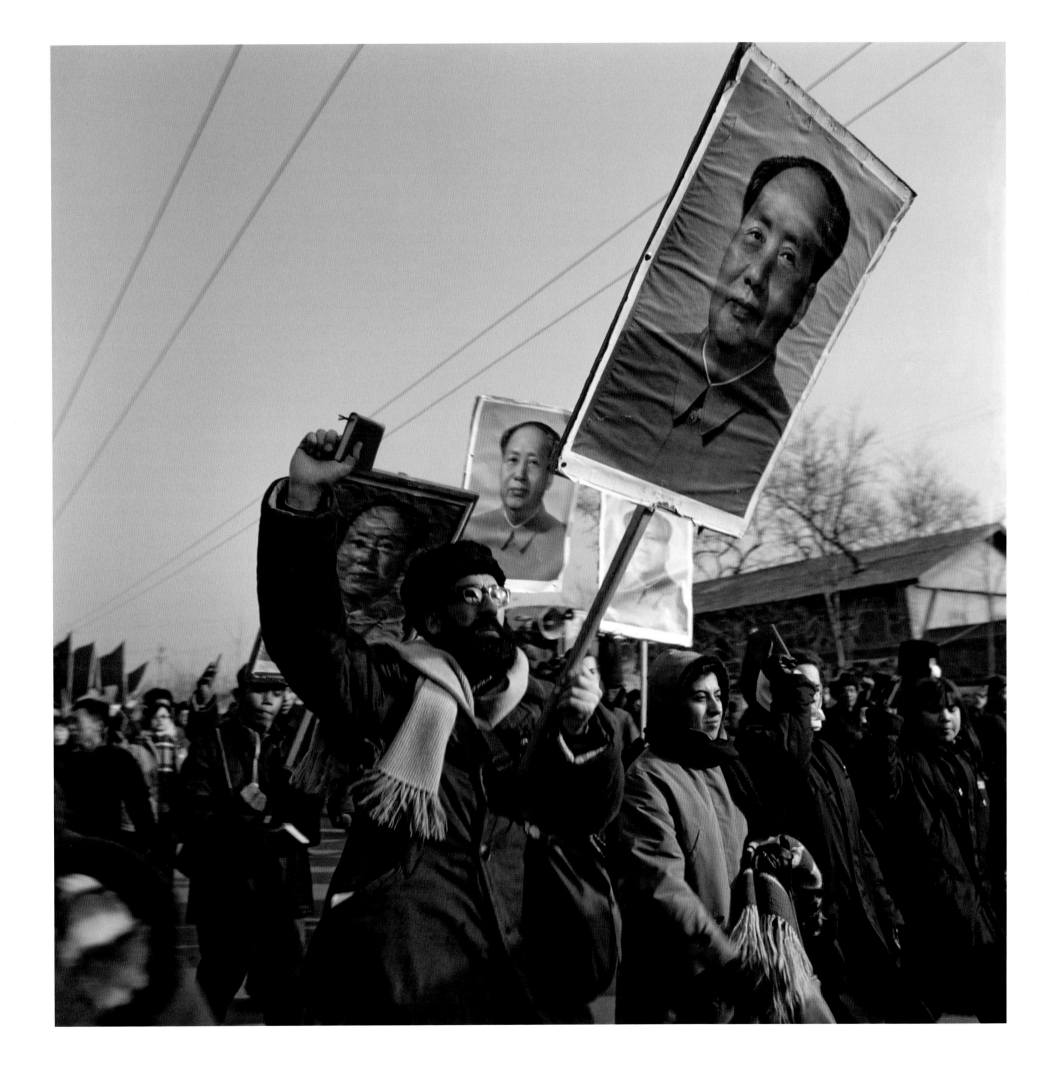

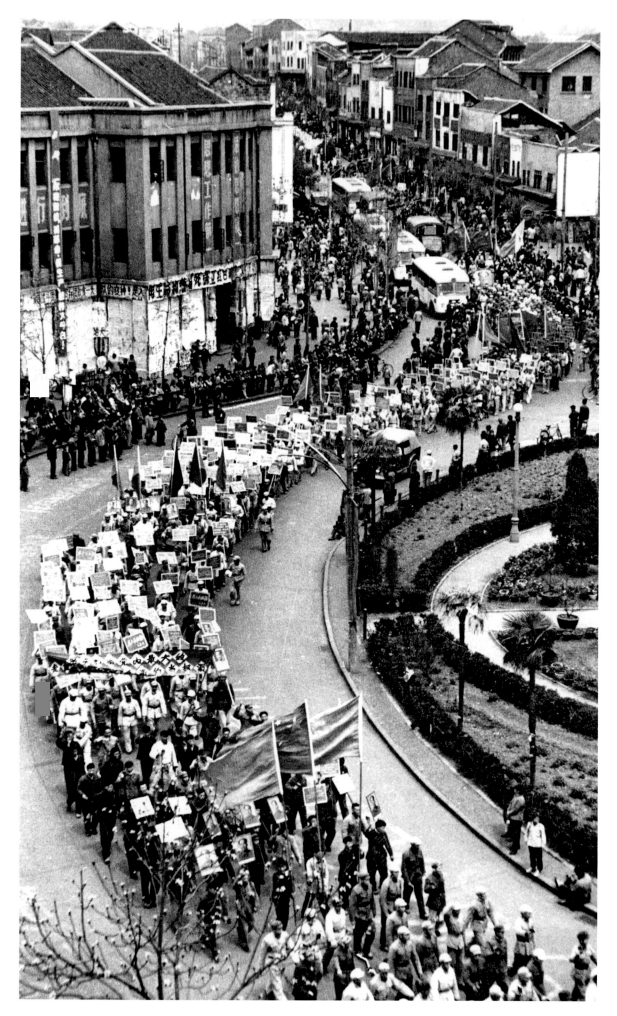

Anonymous photograph,
'Guizhou revolutionary people launched a general offensive against the prime
Capitalist Roader in the Party, and pledged their determination to carry out
the Great Proletarian Cultural Revolution to the end' (Guizhou province, 1966),
China Pictorial, Vol. 228, June 1967.

animated (pp. 64–8). Mao's poster portraits were substitutes of the Chairman, which were readily available to inspect the revolutionary mass, and objects of worship. His image became a virtual commander ready to escort the collective assemblies and lead the parades, or mount the campaign against the political enemies of the people, real or imagined.

Mao zhuxi qu An'yuan (*Chairman Mao Goes to An'yuan*), an oil painting by Liu Chunhua, a student from the Central Academy of Arts and Crafts, was another official portrait of comparable importance (p. 70). The painting shows Mao leaving for An'yuan to organise coal miners. It carries the caption, 'In autumn 1921 our great leader Chairman Mao went to An'yuan and personally kindled the flame of revolution there.'[33] The miners are completely absent. Mao remains heroically alone, 'gazing ahead over the road of revolutionary advance'.[34] In 1968, the year the *Renmin ribao* painting was distributed across the country for the first time, Liu's painting also appeared in poster format. Eventually 900 million copies of Liu's heroic image were printed (p. 71).[35] Mao's image in this latter painting was widely appropriated for the designs of Mao badges, calendar posters and postage stamps, which reconstructed the iconography of Mao to prove his primacy in guiding the Revolution. *Renmin ribao* commented that Liu's painting had caught the youthful image of the great teacher going on his own to An'yuan to launch the revolutionary movement.[36] In the editorial of *Wenhui bao*, the painting was acclaimed as 'the first art work which successfully depicted the image of the greatest contemporary Marxist and Leninist, our genius great leader Chairman Mao, and showed the struggle between Mao's proletarian revolutionary line and the bourgeoisie counter-revolutionary line of

"China's Khrushchev"'.[37] After the painting had been viewed by Jiang Qing and considered as a suitable model for Cultural Revolution art, its print reproductions were referred to as the '*hong baoxiang*' (red precious portrait).

The billions of Mao's poster portraits and *hong baoxiang* were still not sufficient for the needs of the propaganda machine. Handmade portraits of the Chairman were produced in large quantity, not only by professionals but by amateurs, who would imitate the work created by Red Guard students from the major art institutions, such as *Zhongyang meishu xueyuan* (Central Academy of Fine Arts), *Zhongyang gongyi meishu xueyuan* (Central Academy of Arts and Crafts),[38] *Zhejiang meishu xueyuan* (Zhejiang Academy of Fine Arts)[39] and *Sichuan meishu xueyuan* (Sichuan Academy of Fine Arts). In 1966, Shen Yaoyi, the author of many popular woodcut prints of Mao, was a final-year student in the Printmaking Department of the Central Academy of Fine Arts. Shen's woodcuts, drawing upon the legacy of the Woodcut Movement thirty years earlier, revealed his aesthetic ideals and academic training. His work, *Long Live Marx-Leninism and Mao Zedong's Thought* (pp. 72–3), juxtaposing Mao with the other four Communist leaders, demonstrated the role of the newly rising 'red sun' in the international arena. Soon Shen's woodcuts were printed as posters and used on the front cover of Red Guard pamphlets. His woodcut series of Mao portraits (pp. 74–5) recorded the image of the Chairman at different ages and were used extensively in publications, billboards and on other artefacts.

Monumental scenes of the entire visual history of China's Communist revolution were academically illustrated though woodcuts. The narratives

Continued on Page 76

Xiao Zhuang,
Chairman Mao Goes to An'yuan being printed, Nanjing, Jiangsu province, 1968.

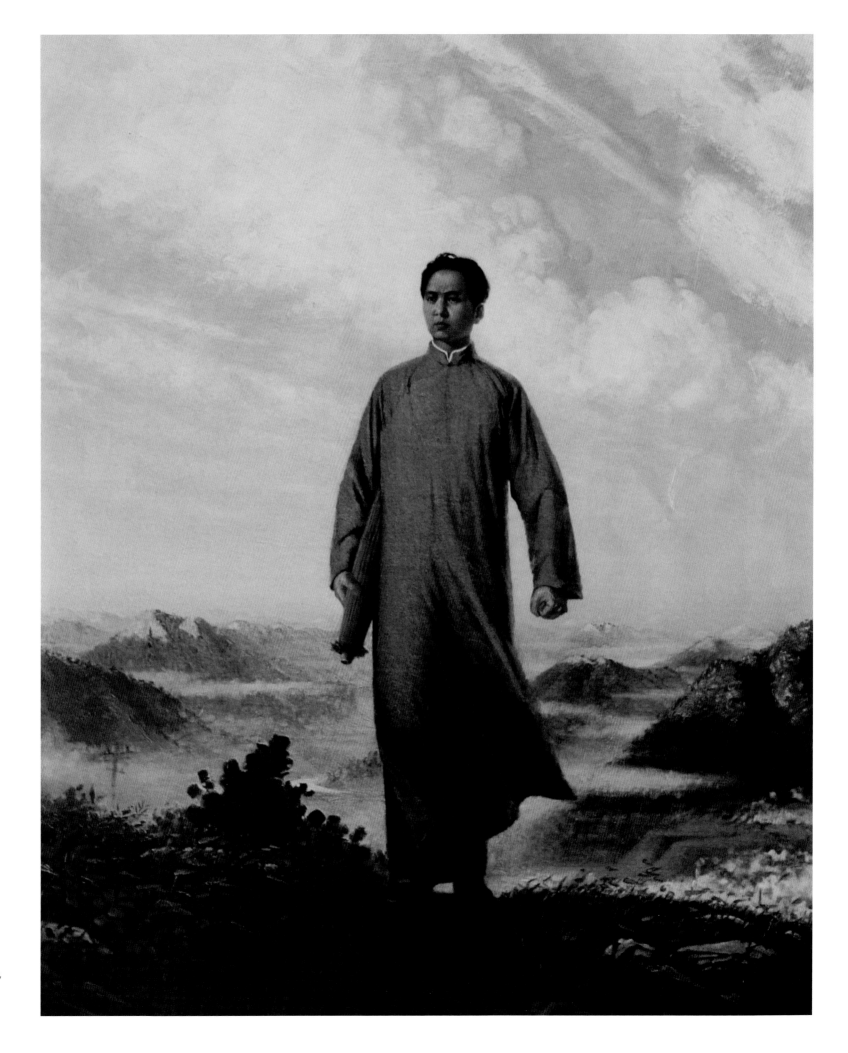

Liu Chunhua,
Chairman Mao Goes to An'yuan,
print reproduction of oil painting,
1967, personal collection of
Wang Mingxian.

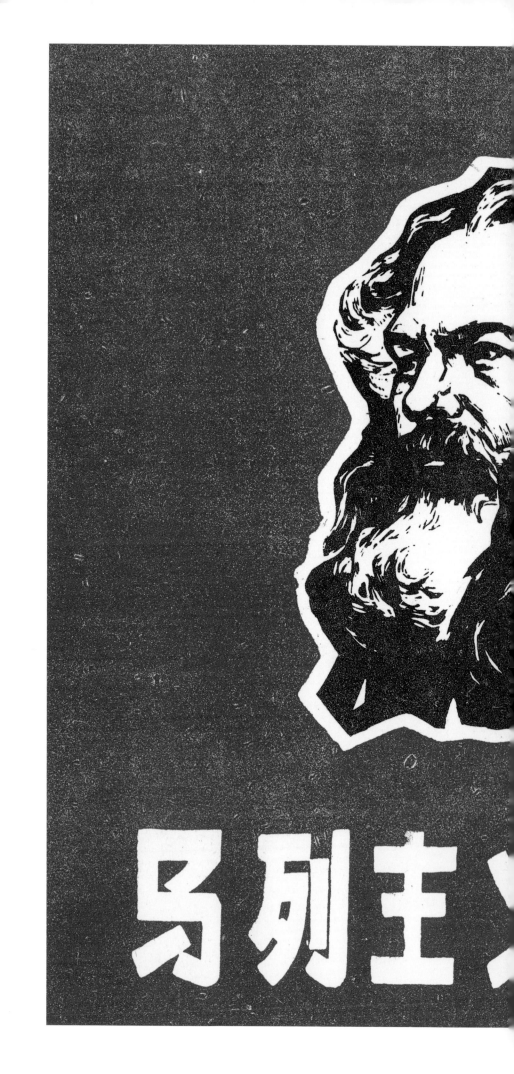

Shen Yaoyi,
Long Live Marx-Leninism and Mao Zedong's Thought, woodcut print, 1967, personal collection of Wang Mingxian.

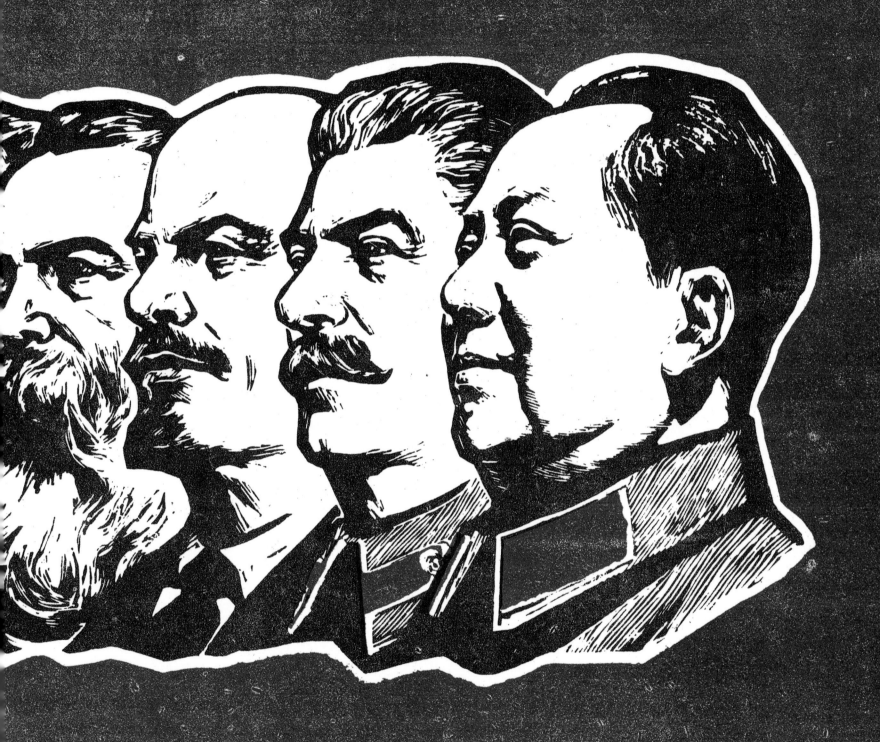

毛泽东思想万岁！

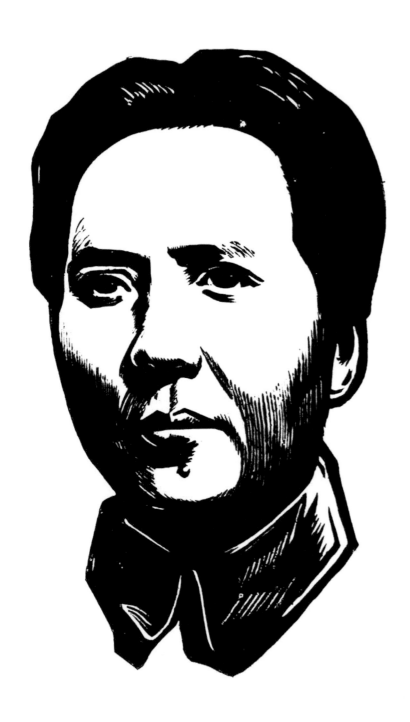

Shen Yaoyi,
Chairman Mao, woodcut print, 1966, personal collection of Wang Mingxian.

Anonymous,
Sailing on the Sea Relies on the Helmsman, woodcut prints, 1967, personal collection of Wang Mingxian.

that were described included the events at the Zunyi building, the site of the January 1935 meeting, which ended party domination by the so-called 'left opportunists' and established Mao's leadership; the Long March (*Changzheng*), when the Red Army (*Hongjun*) moved to Shanbei to evade the Kuomintang forces and successfully reversed the course of the Civil War; Mao's army crossing the Yangtze River during the final battle of the war; and the 'red sea' during the Cultural Revolution (p. 77). All were carefully designed in red to set off Mao's image, which stood in the foreground in an almost surrealistic manner. Because of the 'red sun' cult, these depictions of revolutionary successes were identified as the chronological history of Mao's personal achievements. These 'classic' images were widely imitated and people produced homemade portraits to express their loyalty to the Chairman (pp. 78–81). Even the landmark architecture of the Great World, one of Shanghai's oldest entertainment establishments and a favourite among the international set in the 1920s, was covered by a giant portrait of Mao with slogans and, most distinctly, by the three characters of 'East Is Red' (pp. 82–3).

Mao's portraits were also produced in the style of Soviet realism. The '*hong guang liang*' (red, smooth and luminescent) principle was considered aesthetically appropriate for painting Mao's image with realistic technique. Li Xianting recalls his propagandist life.

> When one painted a portrait of the Chairman, Mao's face would always be felt not red enough. Inspired by Chinese folk art, in particular the *nongmin hua* (peasant painting), where the figures'

faces could be painted with pure red pigment straight away, Mao's portraits were then painted redder and redder… I was always extremely cautious, almost frightened, when I painted Mao's portrait, worrying about either if the great head was not shaped perfectly, or in particular if the face had not been coloured red enough as expected. I had no choice but to paint his face in excessively dazzling red.[40]

When '*hong guang liang*' became definitive, the oil-painting conventions imported from the Soviet Union had to be abandoned (pp. 84–5) or, in other words, 'further developed'.

> Cool colours were to be avoided; Mao's flesh should be modelled in red and other warm tones. Conspicuous displays of brushwork should not be seen; Mao's face should be smooth in appearance. The entire composition should be bright, and should be illuminated in such a way as to imply that Mao himself was the primary source of [the sun] light. If Mao were in the centre of a group of people, all surfaces that faced him should appear to be illuminated. In this way, slogans such as 'Mao is the sun in our hearts' could be made tangible.[41]

Mao badges were a further step in the more private use of the portrait in the execution of political indoctrination. An initial monthly production of 30,000 badges quickly escalated to six million to satisfy demand. Local leaders expressed their loyalty by constantly producing more badges.

Continued on page 86

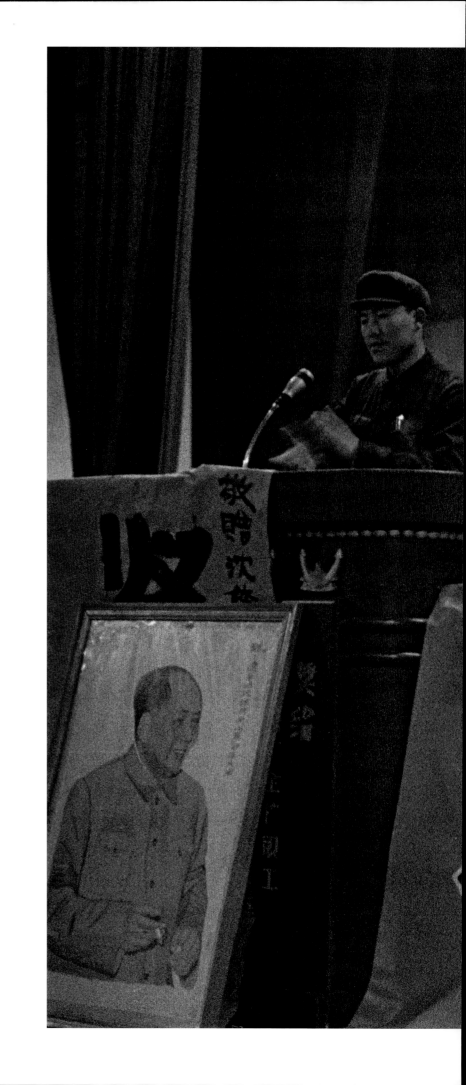

Jiang Shaowu,
Expressing the Loyalty to Mao, Shenyang, Liaoning province, 1967.

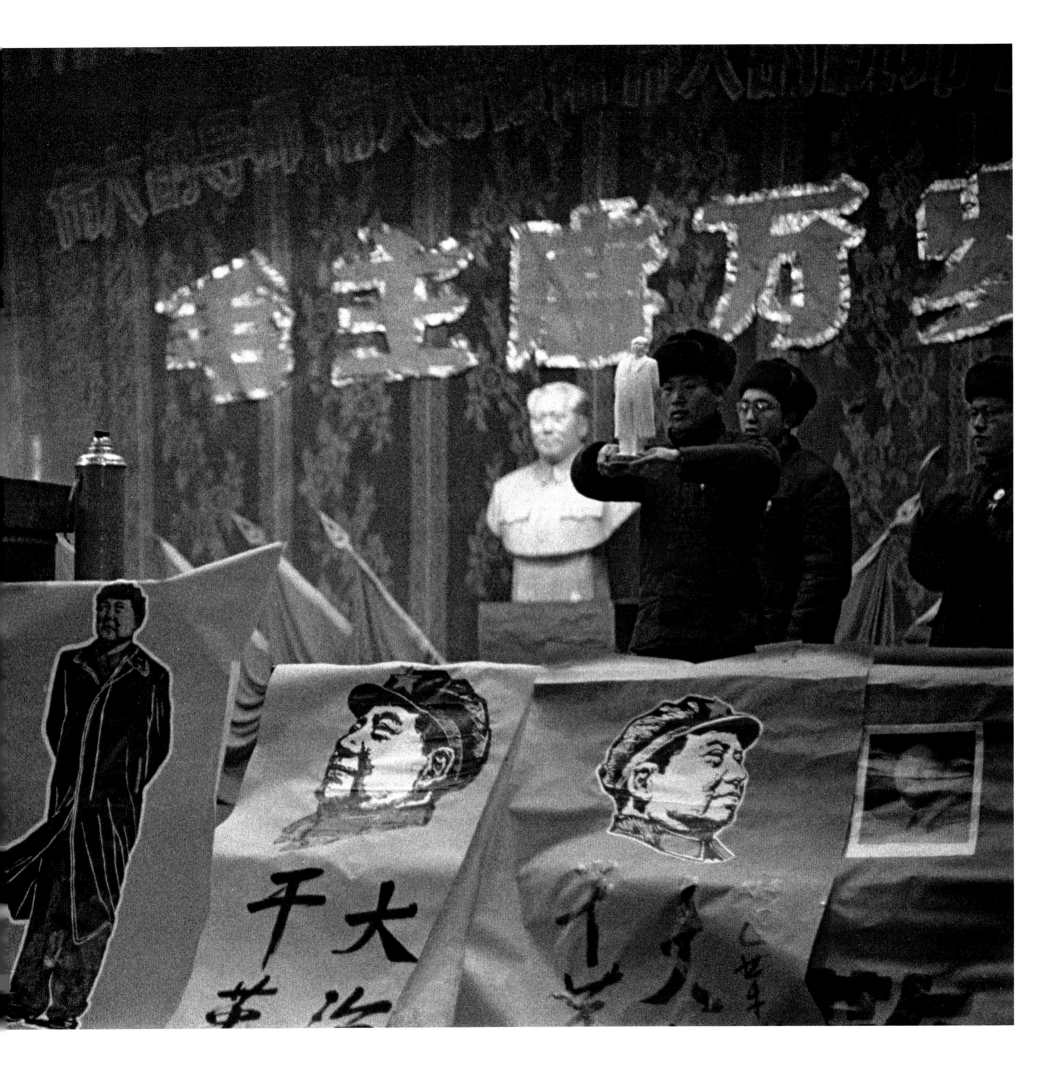

Li Zhensheng,
'Hundreds of thousands gather in front of the North Plaza Hotel carrying homemade portraits of Mao in a show of loyalty and support' (Harbin, 1968), *Red-Colour News Soldier*, pp. 218–19.

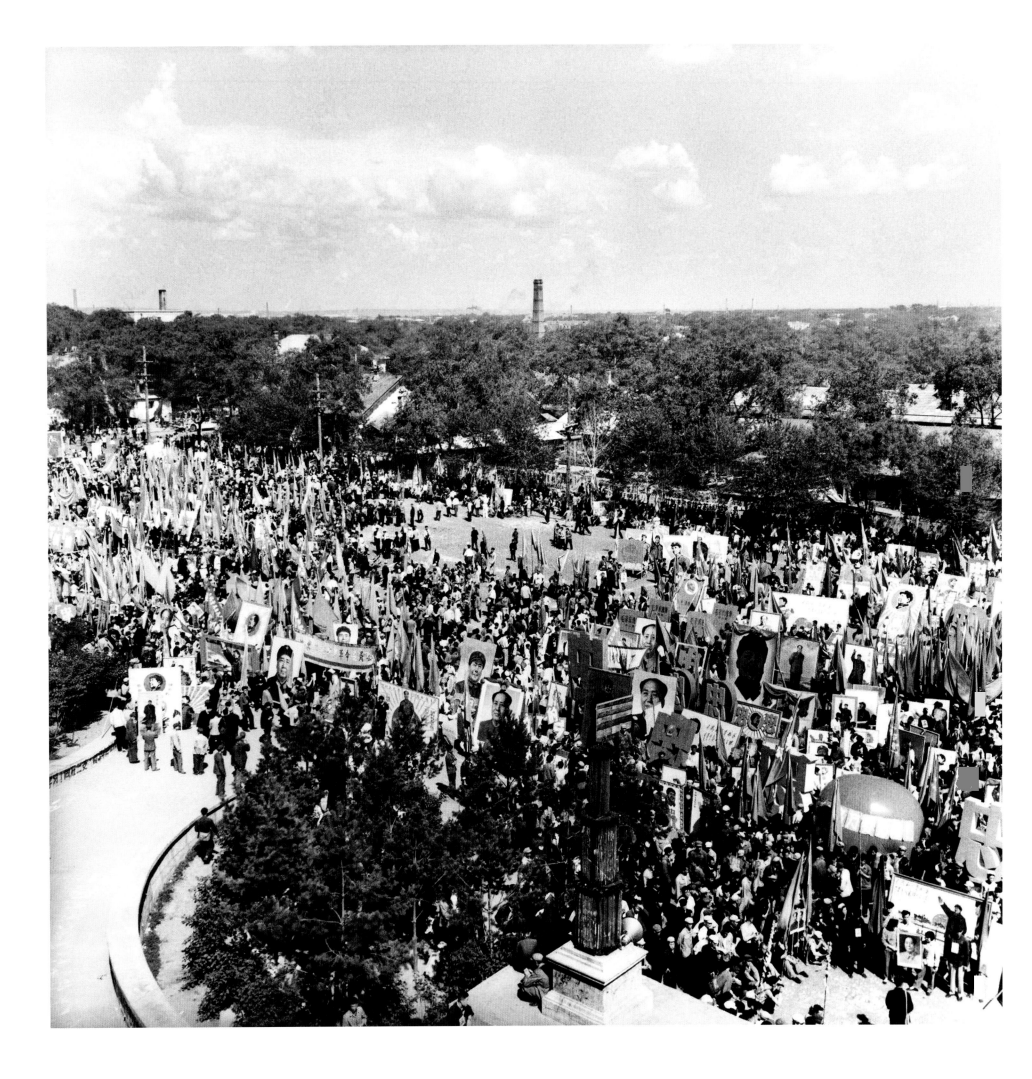

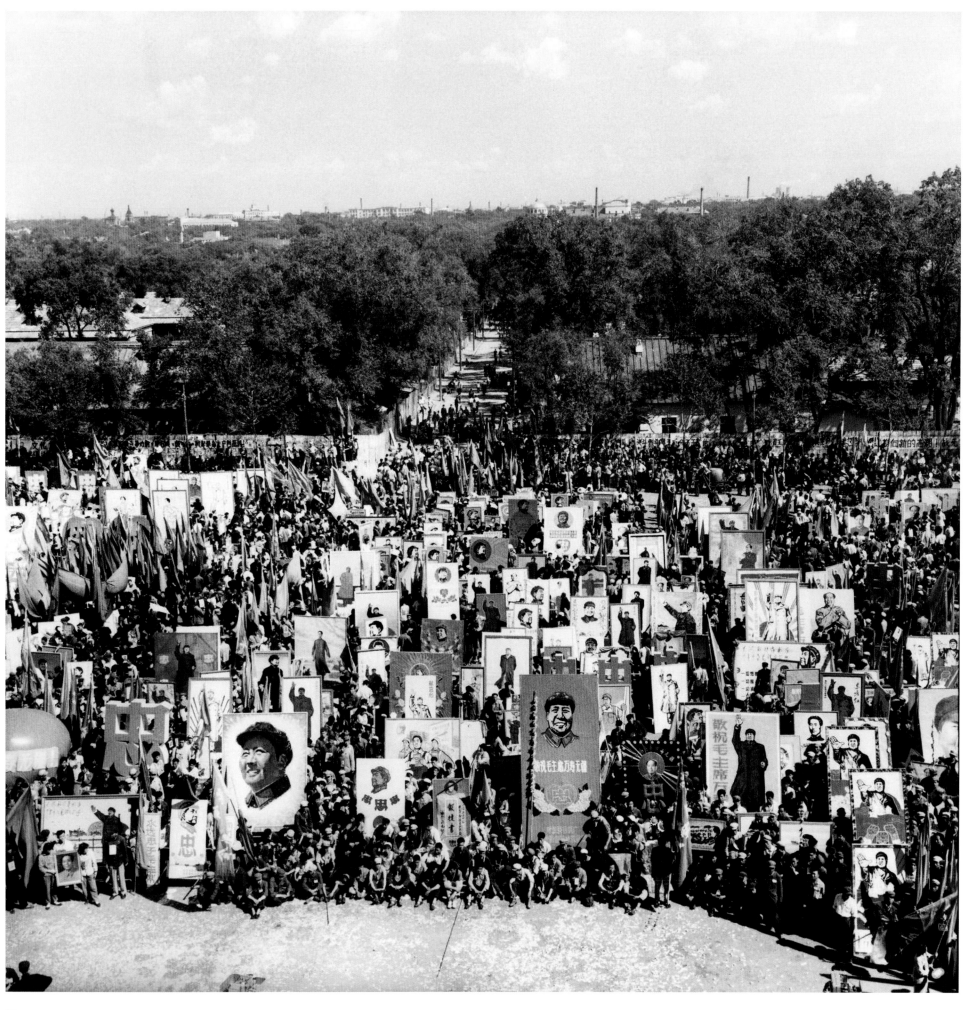

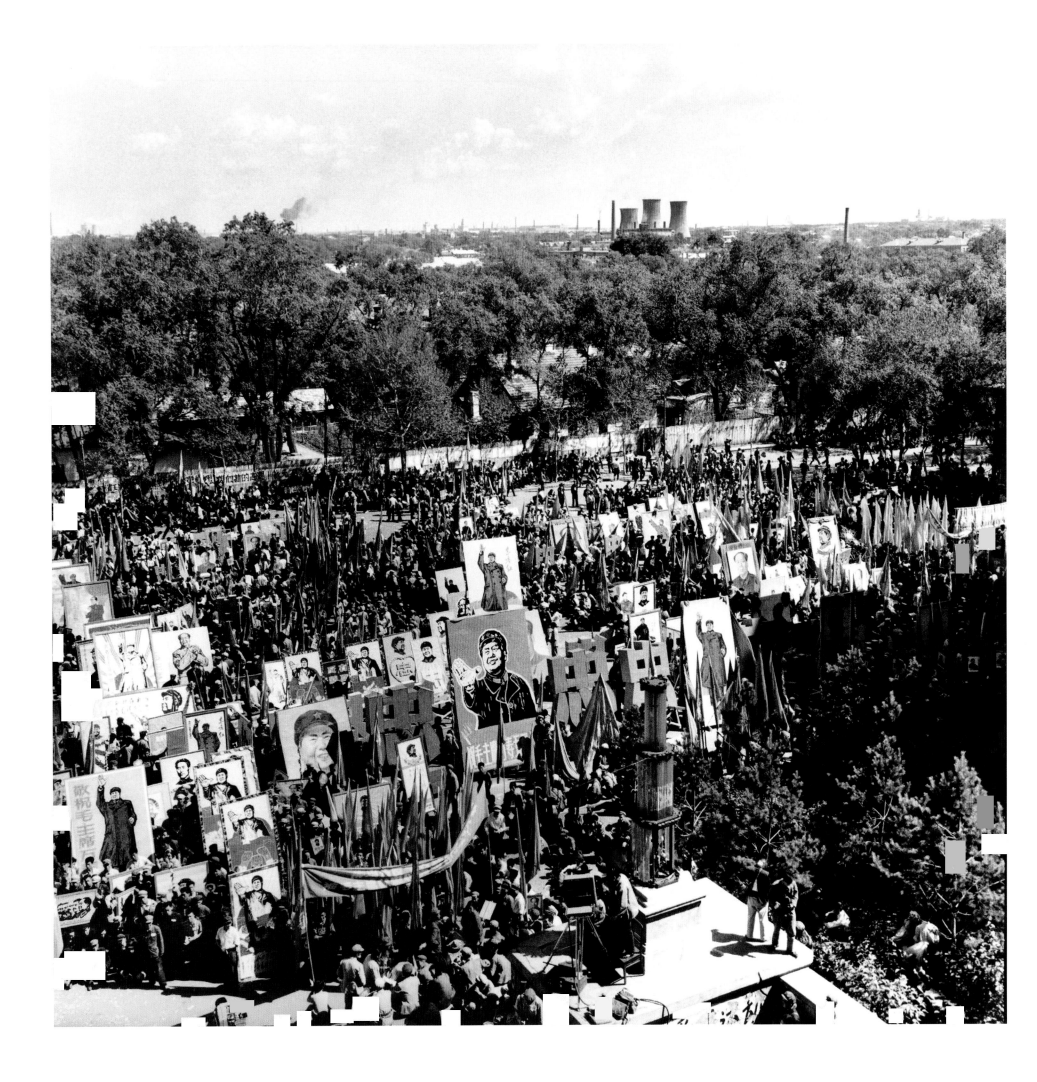

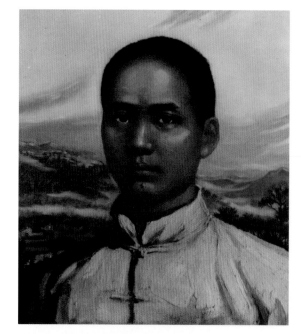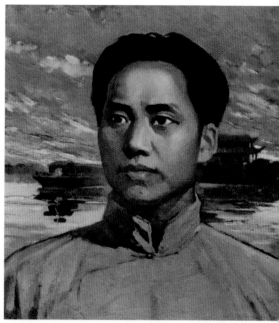

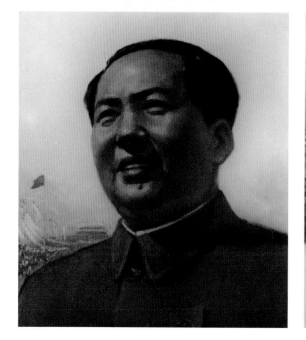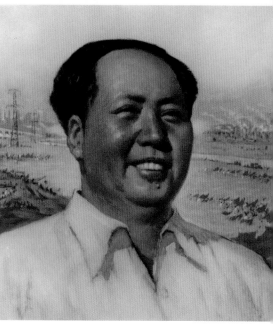

Staff and students of Zhejiang Academy of Fine Arts,
Mao's Portrait Series, print reproduction of oil painting, 1967,
personal collection of Wang Mingxian.

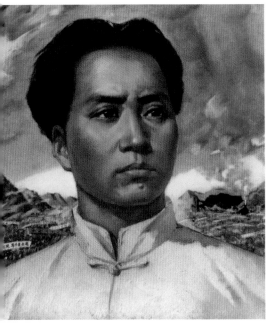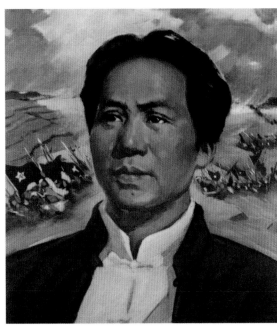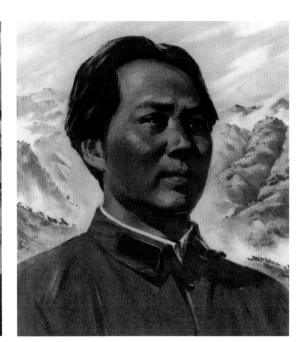
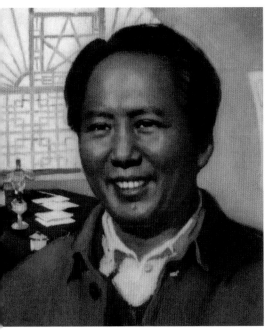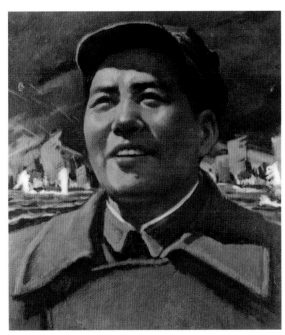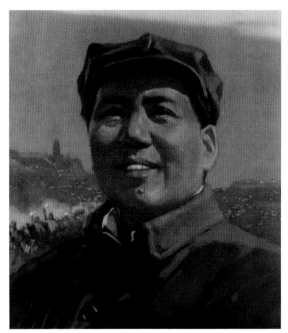
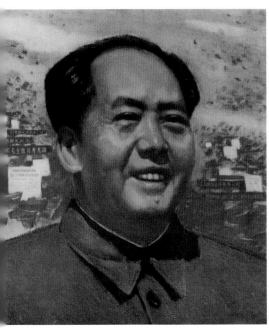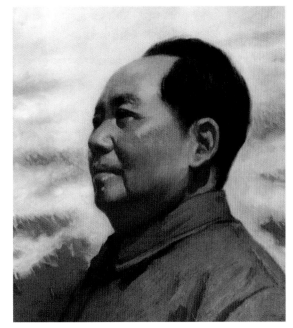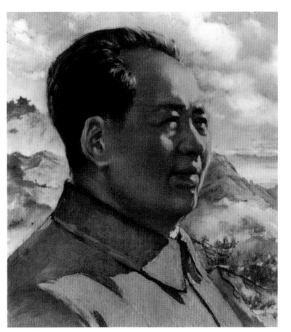

In March 1969, Zhou Enlai declared that 2.2 billion badges had been manufactured since the start of the Cultural Revolution. Although production was later restrained by the government, the total quantity of Mao badges is still estimated at more than 2.8 billion. Some private collections of Mao badges contain more than 10,000 different examples, and the total variety has been estimated at over 50,000.[42] Their dimensions ranged from one centimetre to more than half a metre across. They were usually made of aluminium, but iron, lead, silver, gold, porcelain, bamboo, wood and plastic were also used. Sometimes they were shaped as ellipses, pentagrams, lozenges and squares, but they were mostly circular to reflect the red sun (p. 87). Round badges carrying Mao's golden or silver portrait became the most common. Red was the essential colour for the background and was painted with 'glassified paint', which refracted the light through its uneven surface. Most of the designs have lines radiating at regular intervals to the edge of the disc. No matter where Mao was sited on the badge, in the middle or at the top, the rays were to emanate from his head. In some badges, his profile was positioned in a circle like a halo. In the more detailed badges, the undulating gaps of radiating lines created spiral-textured or net-textured rays. Mao was always prominently at the centre, from which the golden rays were spread (pp. 88–9).

As Mao became a more hybrid and complex iconic figure, sunflowers began to appear on the badges, in sets of either three or seven, signifying respectively the 'Three Loyalties' (San zhongyii)–loyalty to the Great Leader Chairman Mao, loyalty to Maoist Thought and loyalty to Mao's proletarian revolutionary line and the boundless loyalty of 700 million people towards Mao. Upon the middle flower, there was usually an embossed character zhong (loyalty), an important virtue for the people in deference to their emperors. The character zhong, or the slogan 'Long Live Chairman Mao', was combined with the pattern of sunflowers, or sometimes branded in a heart-shaped pattern on the badges, to express people's loyalty to and admiration of the Chairman.

The special places revered as China's geming shengdi (sacred revolutionary lands) were depicted on the badges. Their images were usually touched by Mao's rays. Sometimes a minimal slogan was carried on the reverse, such as 'the places where the red sun rose aloft'. There is a large badge, thirteen centimetres wide, which depicts all nine significant sites of the Long March, from Ruijin[43] and Zunyi, the snow mountains and the grass lands, to the heroic battlefields of Jinsha River, Lazi Kou, Luding Bridge and Liupan Mountain, and eventually Yan'an, the triumphal destination of the Long March.[44] Mao's other revolutionary achievements and actions, and important social and political commemorations, such as the celebrations of the founding of the Chinese Communist Party and the People's Republic, were recorded on anniversary badges. The international impact of Mao's leadership was illustrated on a badge with a globe encircled by red flags or by figures standing hand-in-hand on the planet with Mao's glittering countenance, and the slogan 'The Red Sun in the Hearts of the People in the Whole World' engraved on the back. The badge packs were endorsed with Lin Biao's handwriting of the popular motto 'Sailing on the Sea Relies on the Helmsman, Revolution Requires Mao Zedong's Thought', beside images of the rising sun (pp. 90–1).

Continued on page 92

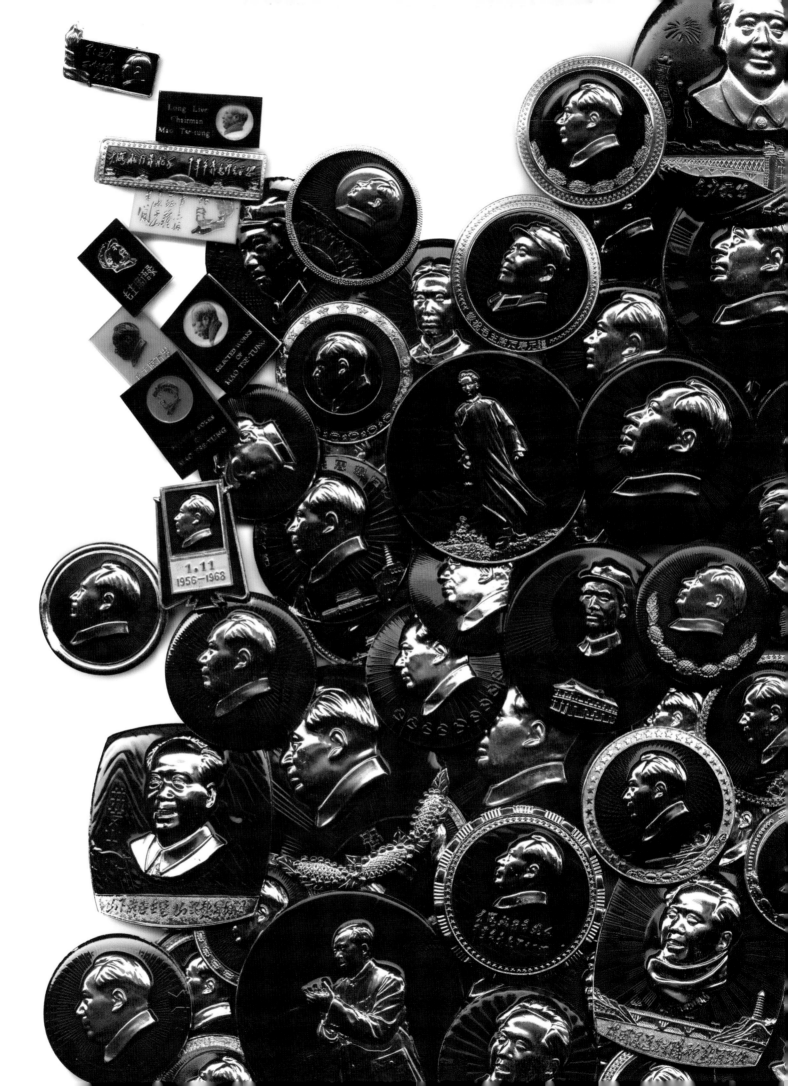

Mao badges,
1966–8, personal collection of the author.

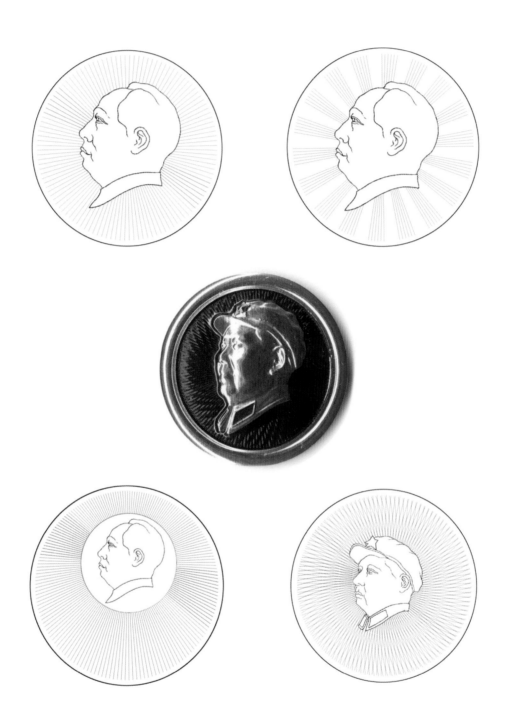

Mao badges,
personal collection of the author, illustrations by the author, 2000.

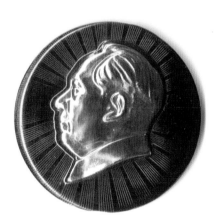

Mao badge packs,
1966–8, personal collection of the author.

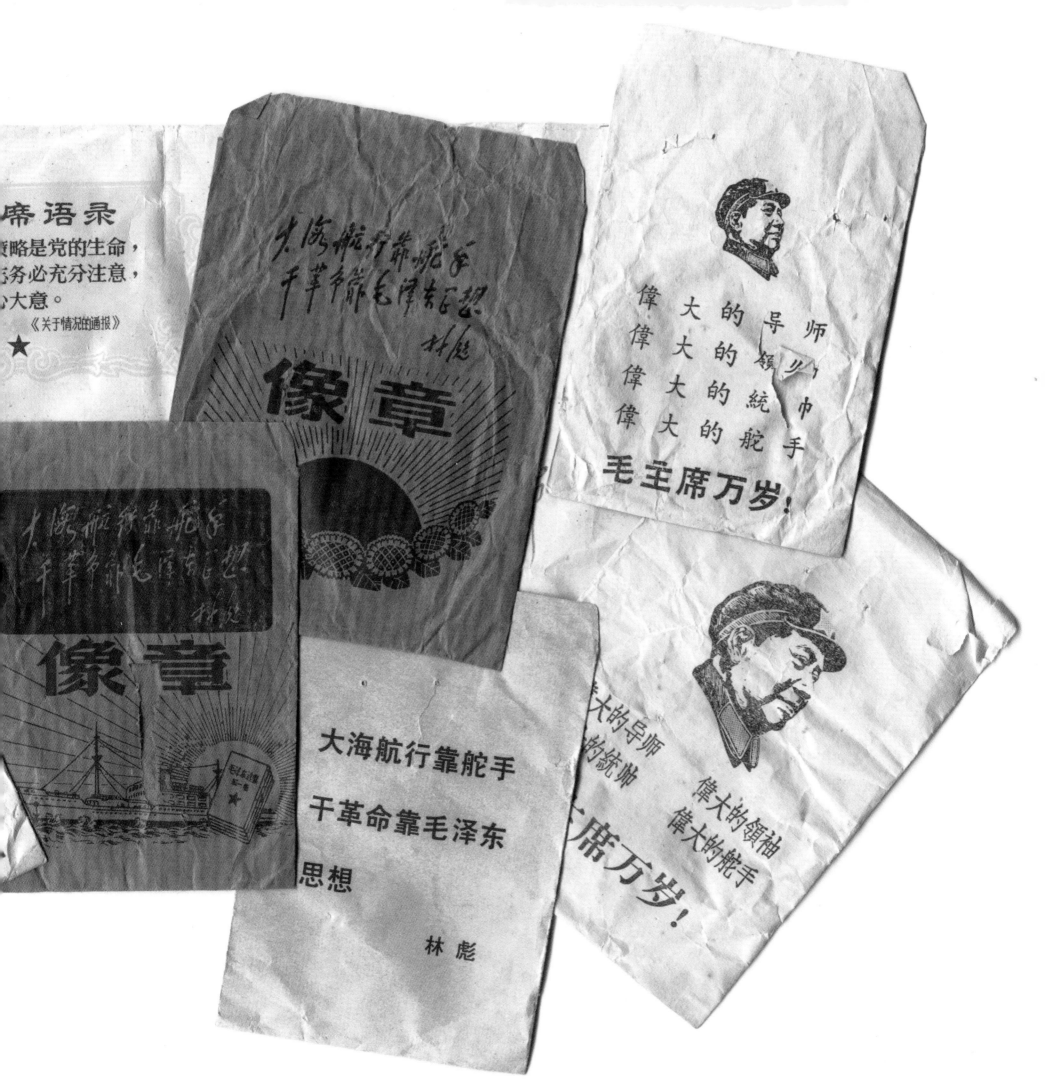

席语录

略是党的生命，
务必充分注意，
心大意。

《关于情况的通报》

★

大海航行靠舵手
干革命靠毛泽东思想

林彪

像章

大海航行靠舵手
干革命靠毛泽东思想

林彪

像章

大海航行靠舵手

干革命靠毛泽东

思想

林彪

伟大的导师
伟大的领袖
伟大的统帅
伟大的舵手

毛主席万岁！

大的导师
的统帅

伟大的领袖
伟大的舵手

主席万岁！

A former Red Guard recalls, 'In order to exhibit one's unlimited, steadfast and absolute loyalty to Chairman Mao, the entire population was obliged to wear a loyalty badge when going outside. Otherwise, one might be exposed as one who had problems in his ideology.'[45] In line with the phrase 'loyal or disloyal, watch one's actions' (*zhongbuzhong kan xingdong*), wearing or not wearing a badge signified one's attitude towards Mao, thereby distinguishing proletariat and bourgeoisie. To some, the number and size of badges they wore were measures of their political record and social standing (p. 94). Competition to produce larger varieties and greater quantities of badges emerged among the factories and work units (pp. 95–7). Mao badges began to be collected and admired purely for their design, and rare examples were much prized. Badges were even given as expressions of friendship. Those worn by young children were sometimes stolen. Some were even used as a kind of currency. A new badge could bring much more pride or jealousy than anything fashionable today. A Red Guard memoir describes the exchange of badges.

Among the trees, we discovered a brisk trade in Chairman Mao badges… I inquired whether anyone would sell me a badge. 'We are not speculators,' said one boy. 'We only trade. Two small ones for a big one.' 'What if I did not have any badges to trade?' 'You can use Chairman Mao photos instead. Ten photos for one badge.' I had seen youths on the sidewalk selling photos of Chairman Mao receiving the first group of Red Guards. A pack of ten cost eight *mao*, which seemed rather expensive… I ran off to find a photo dealer, came back with two packs, and bartered them for two small badges. I pinned one on my chest and the other inside my pocket. I was sure I could feel Chairman Mao's radiance burning into me.[46]

The culture of badges extended far beyond the original intention as an ideological symbol to provide a kind of separate realm, a strange aesthetic currency accessible to all.

Badges represented an alternative discourse, not necessarily in terms of dissent, but as symbols of individuation and as objects that took on 'lives' that were not necessarily intended by the Chinese government. Due to their simplicity and their ability to personalise and activate the Revolution, Mao badges offered peasants, workers and intellectuals alike the opportunity to learn about, conform to and define themselves in the Revolution.[47]

The badge was worn not merely for encouraging and sharing the revolutionary spirit, but as the ornament of Mao's people, expressing their new aesthetics. It was a valuable tool for constructing the collective identity during the mass movement. Images of Mao and the red sun were integrated into an indissoluble unit that recurred at every level of people's daily lives, bringing the aura of this god-like being with all its eternal perfection and blessings.

18. Cited in Wang Ruoshui, '*Mao Zedong weishenme yao fadong wenge* (Why did Mao Zedong Launch the Cultural Revolution)', in Song Yongyi (ed.), *Wenhua da geming: lishi zhenxiang he jiti jiyi (The Great Cultural Revolution: Historical Truth and Collective Memories)*. Hong Kong: Tianyuan shuwu, 2006, Part 1, p. 191.

19. Benewick, Robert, 'Icons of Power: Mao Zedong and the Cultural Revolution', in Harriet Evans and Stephanie Donald (eds), *Picturing Power in the People's Republic of China: Posters of the Cultural Revolution*. Maryland: Rowman & Littlefield Publishers, 1999, p. 123.

20. Schoenhals (1996), op. cit., p. 27.

21. Jiang Jiehong (ed.), *Burden or Legacy: From the Chinese Cultural Revolution to Contemporary Art*. Hong Kong: Hong Kong University Press, 2007, p. 15.

22. Yan and Gao (1996), op. cit., p. 63.

23. *Guowuyuan wenhuazu geming gequ zhengji xiaozu* (The Revolutionary Songs Collecting Group in the Culture Department of the State Council) (eds), *Zhandi xinge (The New Songs of the Battle Field)*. Beijing: Renmin wenxue chubanshe, 1972, p. 5.

24. Bennett, Gordon A. and Montaperto, Ronald N., *Red Guard: The Political Biography of Dai Hsiai-ai*. New York: Anchor Books, 1972, p. 96.

25. Wu Hung, *Remaking Beijing: Tiananmen Square and the Creation of a Political Space*. London: Reaktion Books, 2005, p. 53.

26. Wang Yi, '"*Wanwu shengzhang kao taiyang*" *yu yuanshi chongbai* ("The Universe Growing Relies on the Sun" and the Primary Worships)', in Liu (ed.) (1996), op. cit., p. 128.

27. Cited in Wu Hung, *Transience: Chinese Experimental Art at the End of the Twentieth Century*. Chicago: The David and Alfred Smart Museum of Art and The University of Chicago, 1999, p. 43.

28. See further discussions on the two visual languages of power in Chang Tsong-zung, 'Mesmerized by Power', in Jiang (ed.) (2007), op. cit., pp. 57–70.

29. See the detailed discussion on Mao's Tiananmen portrait in Wu (2005), op. cit., pp. 68–84.

30. Barmé, Geremie R., *Shades of Mao*. London: East Gate Books, 1996, p. 8.

31. Benewick (1999), op. cit., p. 126.

32. Feng Jicai, *Yibai ge ren de shinian (The Ten Years of One Hundred People)*. Nanjing: Jiangsu wenyi chubanshe, 1997, p. 108.

33. The An'yuan miners' union was the first important union led exclusively by the Chinese Communist Party and was one of the strongest sources to support the Party prior to 1949. In fact, Liu Shaoqi played a more important role in organising the strikes in An'yuan. Hou Yiming's *Liu Shaoqi tongzhi he An'yuan kuanggong (Comrade Liu Shaoqi and the An'yuan Miners)*, which was painted seven years earlier, shows the young Liu Shaoqi leading the strike in An'yuan among the coal miners. Because of the political struggle between Mao and Liu, who by then was being referred to as China's Khrushchev and died in disgrace in prison in 1969, this painting was denounced as an attempt to falsify history and was labelled a 'poisonous weed'. See further details in Benewick (1999), op. cit., p. 132.

34. Official review of *Chairman Mao Goes to An'yuan*, Renmin huabao, Vol. 243, September 1968, p. 13.

35. Andrews, Julia F., *Painters and Politics in the People's Republic of China: 1949–1979*. London: University of California Press, 1994, p. 339.

36. '*Wuchan jieji wenhua da geming kaichu canlan de yishu zhi hua* (The Glorious Art Blossom of the Great Proletarian Cultural Revolution)', *Renmin ribao*, July 9, 1968.

37. '*You yiduo da xianghua* (Another Big Fragrant Flower)', *Wenhui bao*, July 6, 1968, p. 1.

38. Former name of *Qinghua meishu xueyuan* (Qinghua Institute of Art and Design) in Beijing.

39. Former name of *Zhongguo meishu xueyuan* (China Academy of Art) in Hangzhou.

40. Interview with Li Xianting on February 24, 2001, Tong County, Beijing.

41. Andrews, (1994), op. cit., p. 360.

42. Lu Na, *Mao Zedong xiangzhang shoucang yu jianshang (The Collection and Appreciation of Mao Zedong Badges)*. Beijing: Guoji wenhua chubanshe, 1993, p. 14.

43. The site where the First National Soviet Congress was held on November 7, 1931, and from which the Red Army departed for the Long March on October 10, 1934.

44. White, Robert A., 'Mao Badges of the Cultural Revolution: Political Image and Social Upheaval', in *International Social Science Review*, 1994, 69 (3–4), pp. 61–2.

45. Cited in White (1994), op. cit., p. 58.

46. Cited in Gao Yuan, *Born Red: A Chronicle of the Cultural Revolution*. Palo Alto: Stanford University Press, 1987, pp. 119–20.

47. Schrift, Melissa and Pilkey, Keith, 'Revolution Remembered: Chairman Mao Badges and Chinese Nationalist Ideology', in *Journal of Popular Culture*, Vol. 30, 1996, pp. 169–97.

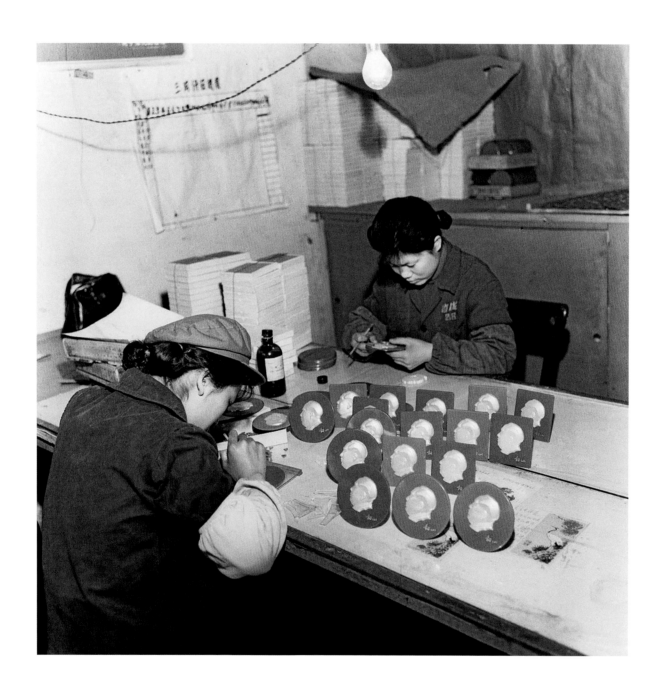

Li Zhensheng,
'Workers in the Harbin Art and Crafts Factory make Mao plaques' (Harbin, 1968), *Red-Colour News Soldier*, p. 220.

Li Zhensheng,
'During a three-week-long Conference of Learning and Applying Mao Zedong Thought, Wang Guoxiang, a model PLA soldier, shares his experiences from a meeting in Xinfa commune just outside Harbin, where the audience pinned some 170 Mao badges on his cap and uniform to express their admiration' (Harbin, 1968), *Red-Colour News Soldier*, p. 215.

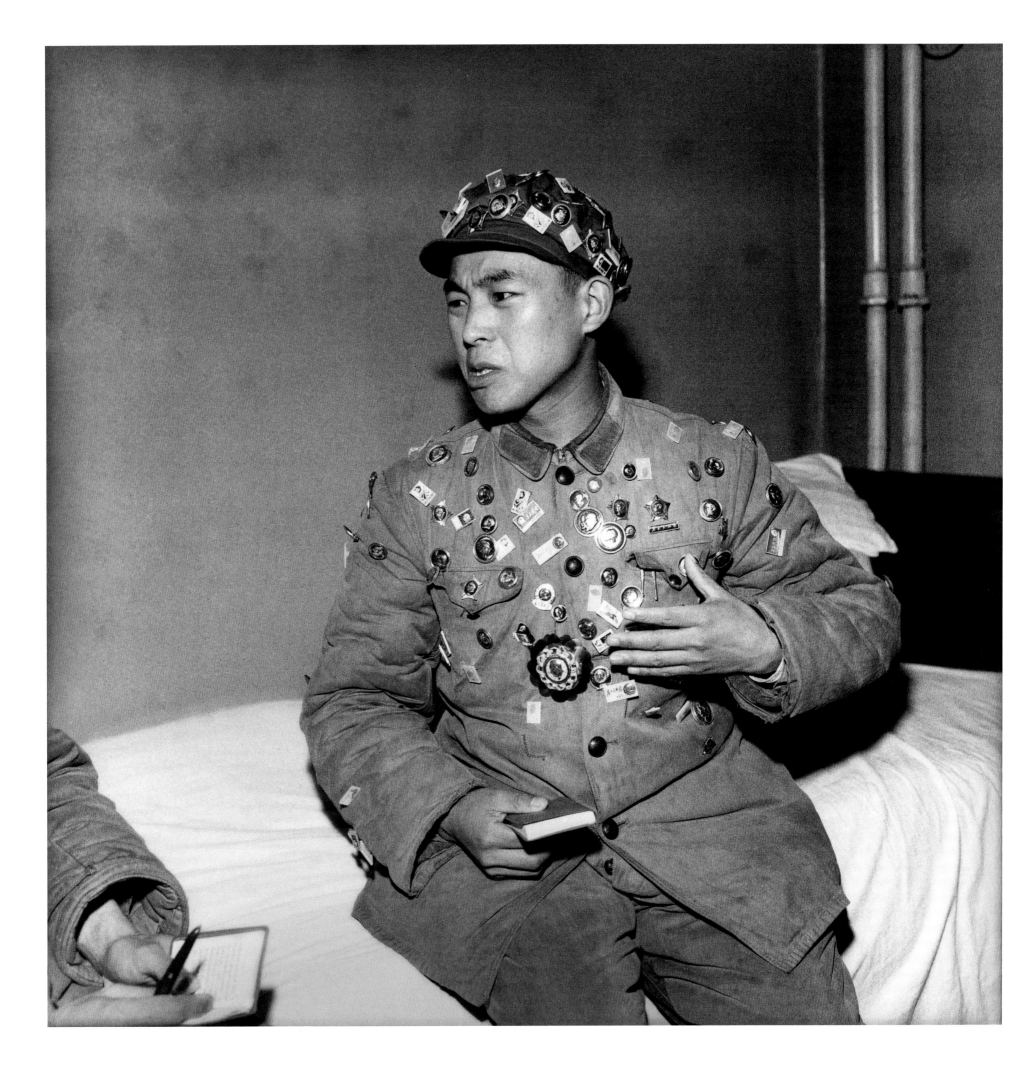

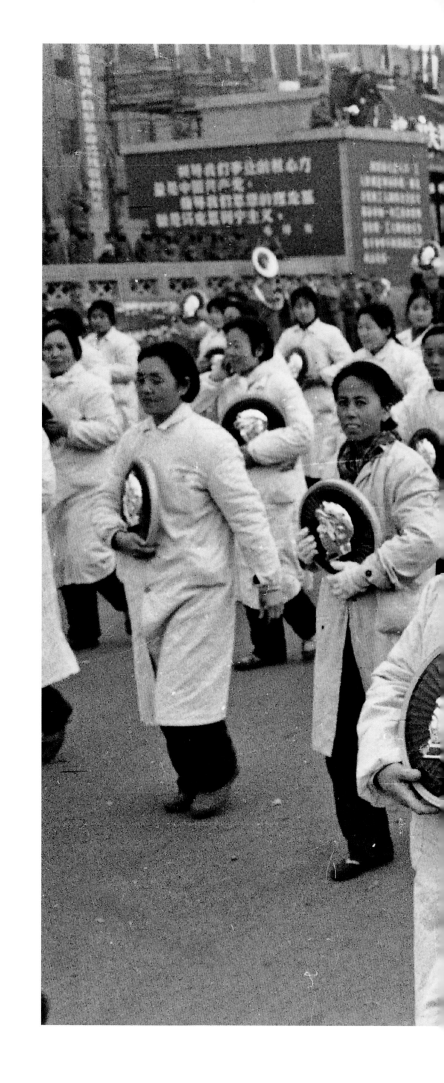

Jiang Shaowu,
Parade of Women with Homemade Metal Mao Badges to Celebrate the Success of the Ninth National Congress of the Communist Party of China, Shenyang, Liaoning province, 1968.

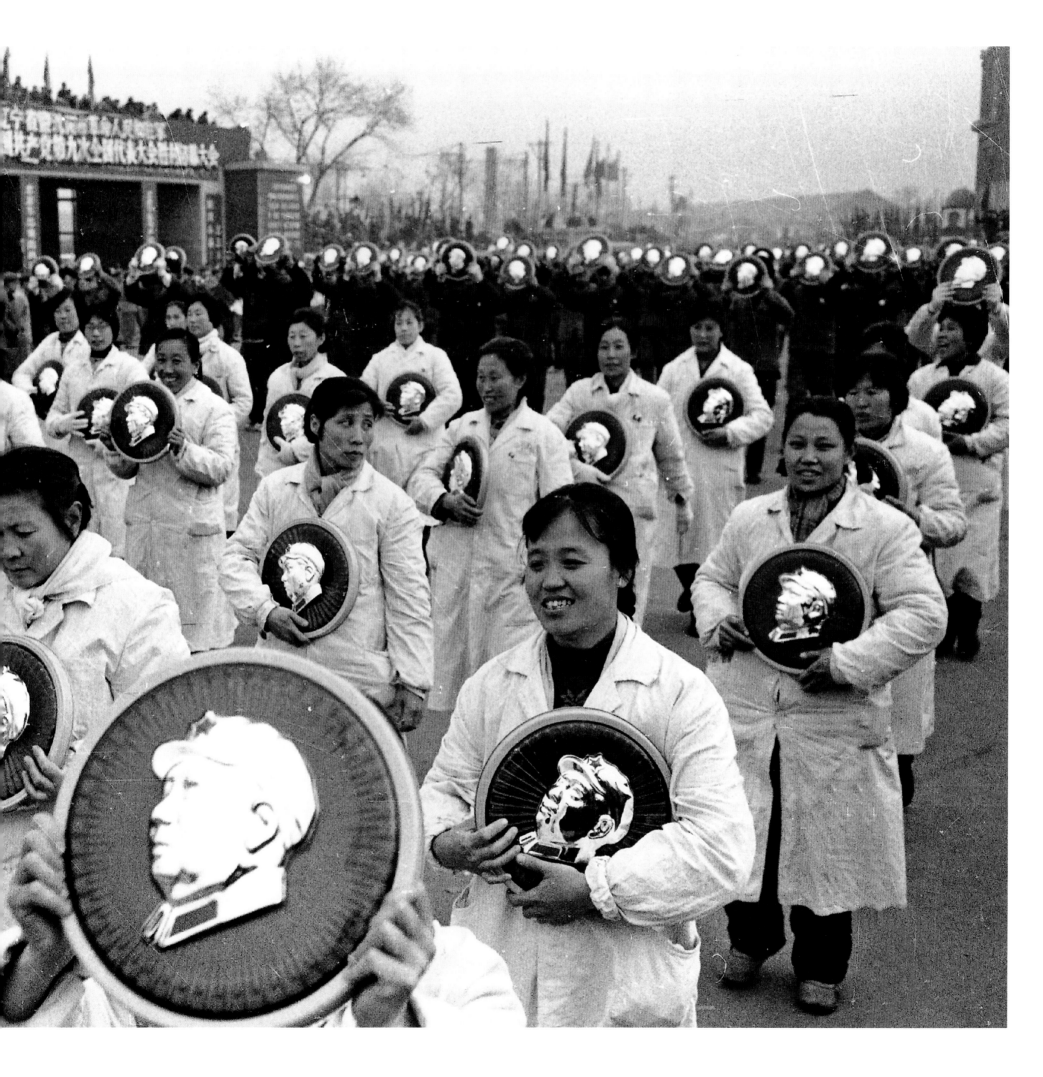

THE RED SEA

If the personal cult of Mao was at the core of the Cultural Revolution, then the Red Guard, perhaps one of the most infamous organisations in history, pioneered the mass movement. 'The whole country being awash with red' (p. 101) has become an image lodged in the collective memory for generations.

The birth of the Red Guard organisation was neither a strategic conspiracy nor a political mystery. The name was spontaneously created by a group of teenage students at the elite middle school attached to Qinghua University, who had gathered together after their evening study session on May 29, 1966 in the adjacent Yuanmingyuan Park. According to one of the participants at the founding meeting, the choice of title emerged after only a brief discussion. The student Zhang Chengzhi suggested, 'Just call it Red Guard, which means that we are the revolutionary guards of Chairman Mao, and we are going to defend the Chairman and his Thought, and to struggle against class enemies, counter-revolutionaries and revisionists till the end.' The others responded, 'The powerful guard of the red regime, or the honourable guard of the red country, so be it – the Red Guard!'[48] Red Guards first appeared as the signatories to big-character posters on June 2, then other middle-school students in Beijing followed and began to establish their own Red Guard organisations. Their oath reads,

> We are the guards of red power. Chairman Mao of the Party Central is our mountain of support. Liberation of all mankind is our righteous responsibility; Mao Zedong's Thought is the highest guiding principle for all our actions. We swear to protect the Party Central and to protect our great leader Chairman Mao. We resolutely shed our last drop of blood![49]

Everybody was classified politically either into the 'Red Five-category' (*Hong wulei*), which included workers, peasants, soldiers, revolutionary cadres and martyrs, or the 'Black Five-category' (*Hei wulei*), namely, landlords, rich peasants, counter-revolutionaries, bad elements and rightists. At the beginning of the Red Guard movement, individuals would need a revolutionary family background from the 'Red Five-category' to qualify for Red Guard membership. In June 1966, the couplet 'If the father is a hero, the son is a real man; if the father is a counter-revolutionary, the son is a bastard' spread from the middle school attached to Beijing University to the other leading universities, such as Qinghua University and the People's University of China. The invention of *Xuetong lun* (*The Theory of Lineage*) was devised as the measure with which to join the organisation and caused heated debates over the following two months.[50] The couplet obviously intended to bring people's differences in political and social status out into the open with crude and preposterous references to a hereditary system. The believers and defenders of the 'lineage theory', particularly those early Red Guards set up before Mao's inspections in August, distinguished themselves as the 'Old Red Guards'. They claimed,

> We are the successors of the revolution with an indomitable spirit… the fathers got the political power, the sons have to take it over, and hand it down.

Continued on page 102

Xiao Zhuang,
An Assembly of 150,000 People at Wutaishan Stadium Celebrating 'the Whole Country Being Awash with Red', Nanjing, Jiangsu province, 1968.

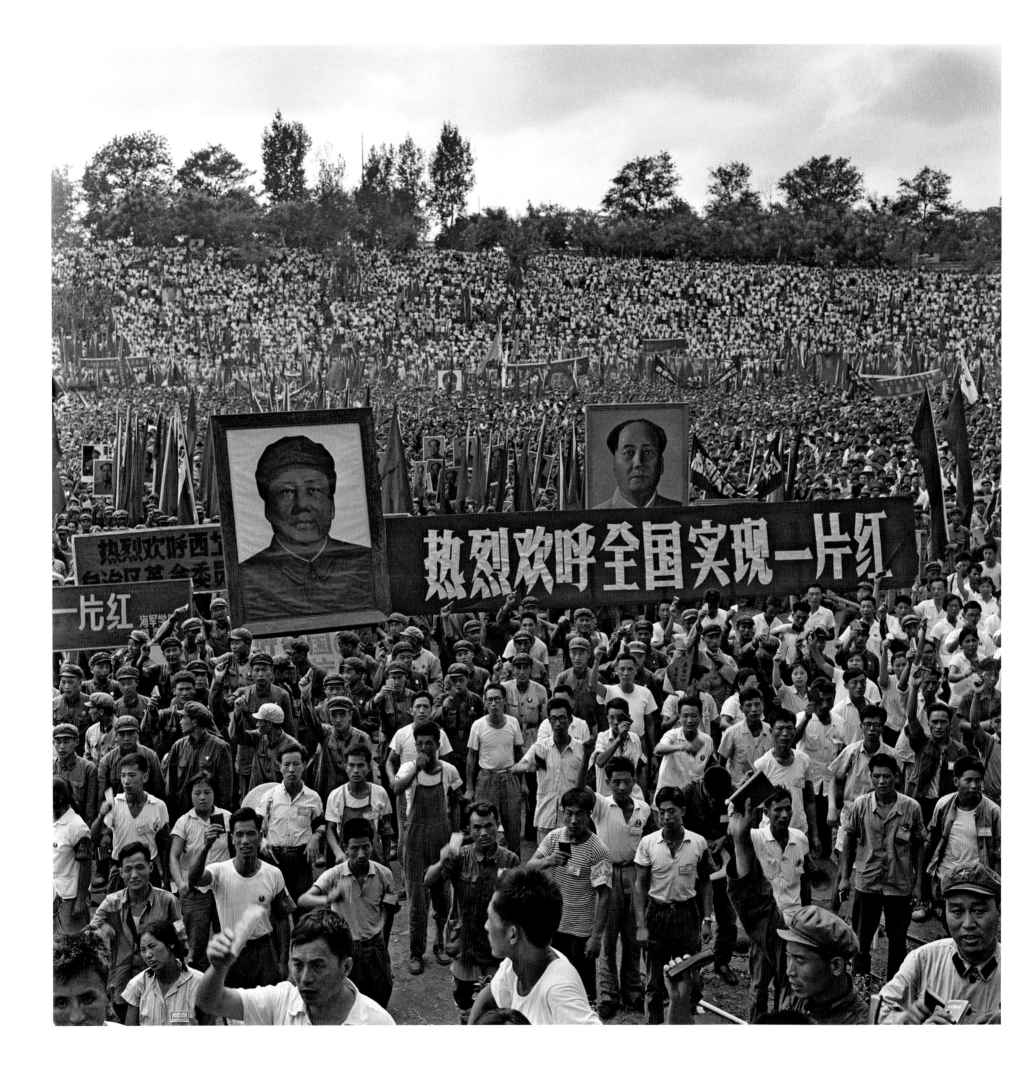

We were born under the red flag, grew up in the red family, and received full red revolutionary education… Our fathers' revolutionary spirit is constantly infiltrating into our bodies, we are totally red inside out. The 'Born Red' is an exact definition of how the revolutionary tradition is handed down from the older generation to the later; we have the purest revolutionary extraction…[51]

However, when in October 1966 Mao and his Cultural Revolution Small Group realised that *Xuetong lun* had become the theoretical tool for the Liu-Deng (Liu Shaoqi and Deng Xiaoping) group in the political campaign, the head of the Chen Boda Group accused the *Xuetong lun* of being 'completely contradictory to both Marx-Leninism and Mao Zedong's Thought, of presenting totally reactionary historical idealism, and being thoroughly counter to the Marxist analysis of classes'.[52] A *Hongqi* editorial marked the turning point in the beginning of the Red Guard movement. Here Mao pointed out that the 'Old Red Guards', the supporters of the Liu-Deng group, had steered the Revolution in the wrong direction, and called on the broad masses to smash down this 'Reactionary Route of the Capitalist Class', and to attack his political opponent Liu-Deng.[53] After the domination of the Communist regime for seventeen years, this was the first time that people could express their dissatisfaction with the Party and their rebellion could be legitimised and supported by the highest authority, Chairman Mao. Especially for those 'non-Reds', Mao again became the saviour to release their political inhibition and empower their revolutionary spirit with the title of Red Guard. These new Red Guards named themselves the Rebels (*Zaofan pai*), and took their revenge against their former ruler,

the 'Old Red Guard', with the slogans 'Smash down the Reactionary Route of the Capitalist Class', 'Continue the Revolution' and 'Liberate Mankind', in essence, with the red flag of Maoist Thought. When the 'Old Red Guards' eventually realised that the situation had changed completely, they could not bear the fact that the older revolutionaries, including their parents' generation, were being criticised and even beaten by the Rebels. Just as Mao described his strategy, 'The status of the Red Guard can be uncertain, it is revolutionary in the summer, but may be counter-revolutionary in the winter', so the decline of the 'Old Red Guard' was matched by the rise of the new one, the Rebels.

No matter whether 'old' or 'new', the Red Guards acted as the revolutionary vanguards of the political struggle. To be red was their ultimate aim. Since the 1950s, young students were required to be *youhong youzhuan* (not only red, but also expert), in a context where red represented a sign of political virtue. Later on, 'redness' was emphasised as an ultimate aim, when education could better serve politics, and the advocacy of the *zhuan* (expert) seemed much less important.[54] In the school system, since the establishment of the People's Republic, Mao's articles have replaced many classics of Chinese and Western literature as student texts. During the period of the Red Guard movement, with the intense discussions on political and revolutionary correctness, the significance of red far outweighed its meaning as simply a colour. People would judge each other by discovering their family backgrounds, the saying '*genhong miaozheng*' (red root and orthodox seedling) becoming essential to social status and future development. With Mao's symbolisation as the red sun, his solar image could be extended to being the source of red itself. The Chairman had the

authority to bestow 'redness' on any faction of the Red Guards, depending on his changing strategy. Across China the colour red represented the people's revolutionary spirit, and became the essential ingredient in the visual endorsement of the mass movement.

The colossal upheaval was legitimised by Mao's doctrine, 'the thousands of truths about Marxism can be summed up in one sentence – to rebel is justified (*zaofan youli*)'. The visual world was utterly reconstructed in the image of the red sea at the moment the extreme dynamics of the Rebel Red Guard movement exploded at the spiritual home of revolution, Tiananmen Square. According to Wu, even the concept of the 'square' was political in the People's Republic.

> Every city, town or village must have a square for public gatherings on important occasions–holiday parades and pageants, announcements of the Party's instructions, and struggle rallies against enemies of the people. Big or small, a square is always conjoined with a platform built for the leaders to review the mass assemblies, a square thus becomes a legitimate place for people to meet their leaders, an indispensable joint between the high and the low, the brain and its body.[55]

In the post-1949 era, mass assemblies for the study of Maoism or political parades had become familiar and prominent in Chinese social life. They reached a climax during the Cultural Revolution. Although Mao had ordered a new square to be built shortly after the founding ceremony of the People's Republic, a square 'big enough to hold an assembly of one billion',[56] the square completed in 1959 could only hold 400,000 people. In 1966, it seemed tight for the rise of the red sea, both physically and spiritually (pp. 104–5). *Renmin ribao* reported the scene where Mao first received his Red Guards on August 18, 1966 (pp. 106–7),

> At five o'clock in the morning…Chairman Mao came to Tiananmen Square to meet the revolutionary masses from all around the country. Chairman Mao dressed in a set of green army uniform with a red star shining on his cap. Chairman Mao came through the Golden Water Bridge in front of the Tower into the masses, shaking hands with the masses…at that moment, the whole square was suffused, people raised their hands on high, jumped and acclaimed… Many people cried out, 'Chairman Mao is coming…Chairman Mao is coming to us! Long live Chairman Mao…'[57]

The whole square was covered in the colour red – red flags, red slogans and Mao's little red book. (pp.108–10). Li Xianting recalls,

> I was a Red Guard and honourably inspected within the collective assembly by the Chairman in Tiananmen Square. Red slogans and red flags, red suffused the whole Square entirely. Nothing would be able to replace the red. It was the virtual red sea.[58]

The notion of the collective in China was developed into a primary belief. It was the means by which people could learn, understand and share

Continued on page 116

Anonymous photograph,
An Assembly of 1,500,000 People Celebrating the Seventeenth Anniversary of the People's Republic of China,
Beijing, 1966, provided by China Photo Service.

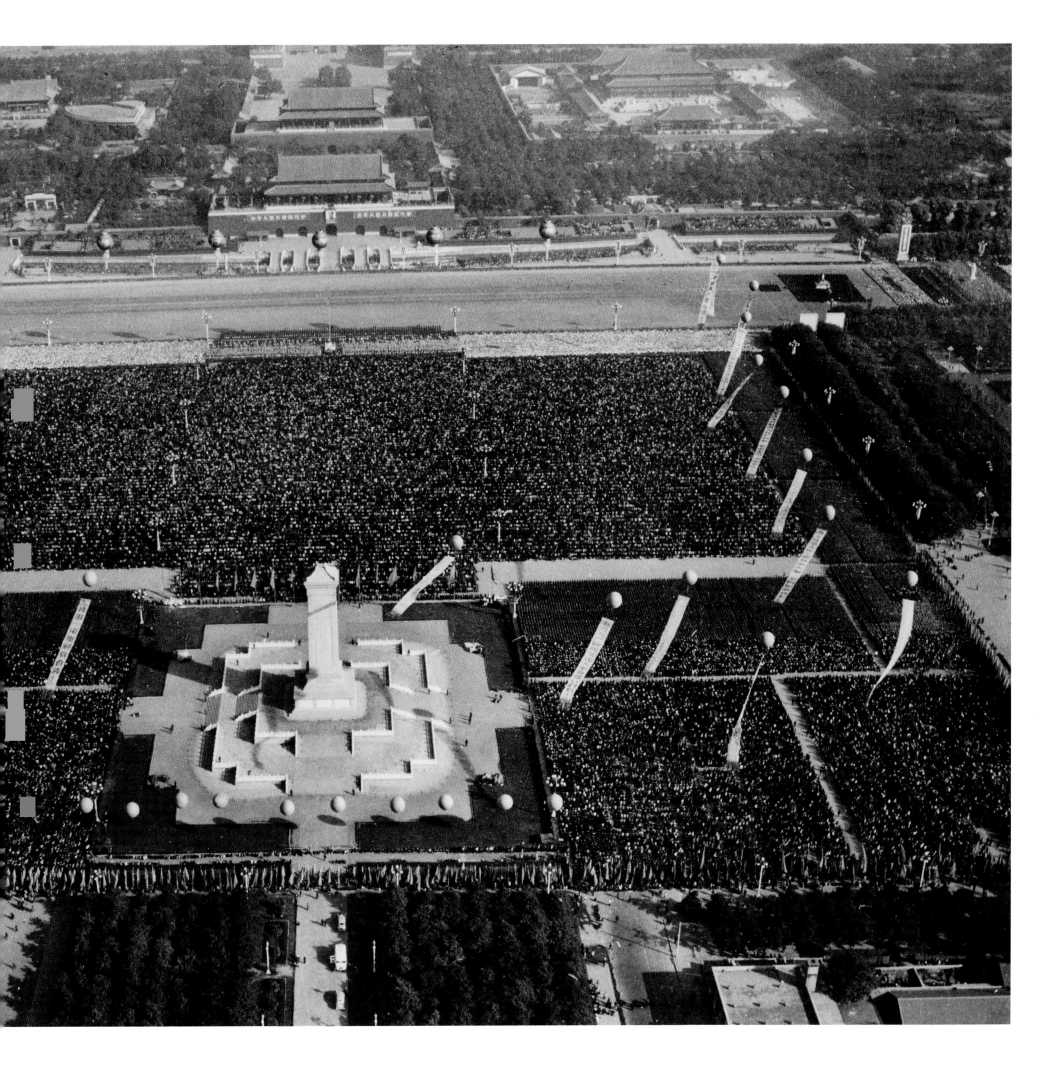

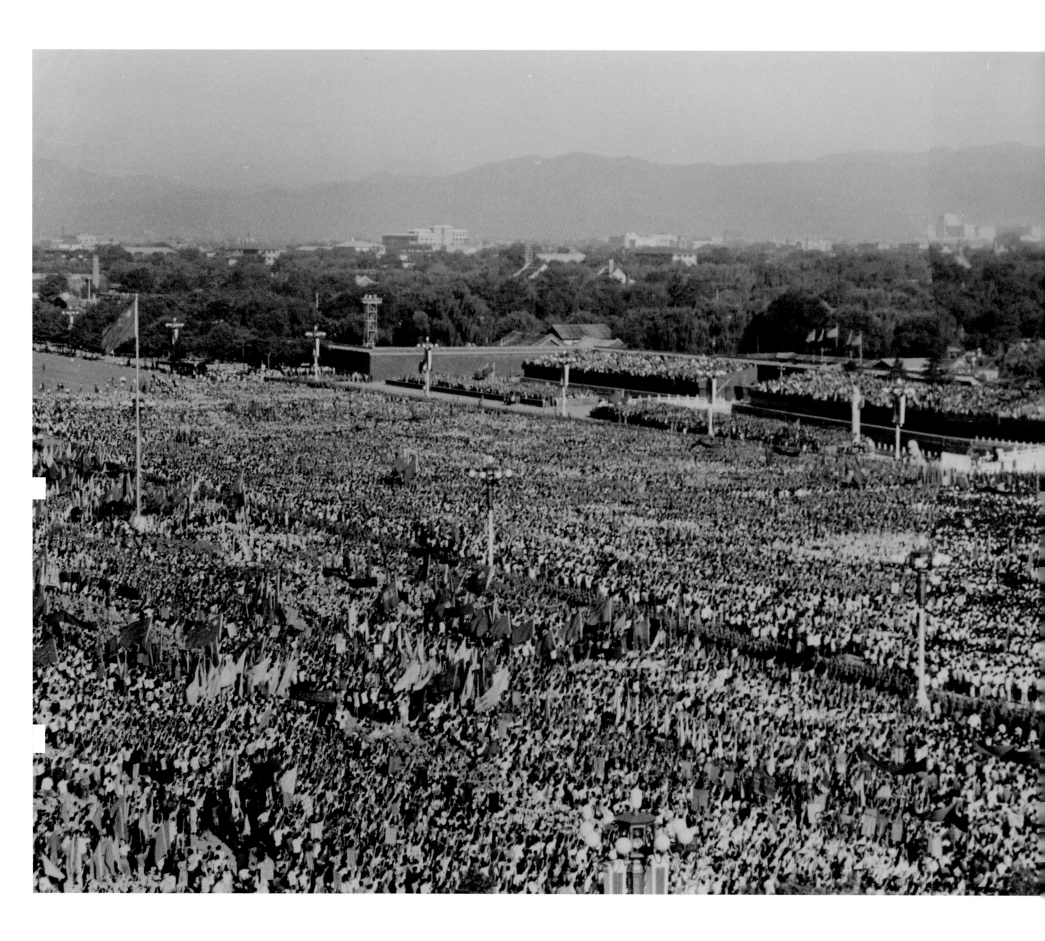

Anonymous photograph,
Mao's First Inspection to the Millions of Red Guards on 18 August, Beijing, 1966, provided by China Photo Service.

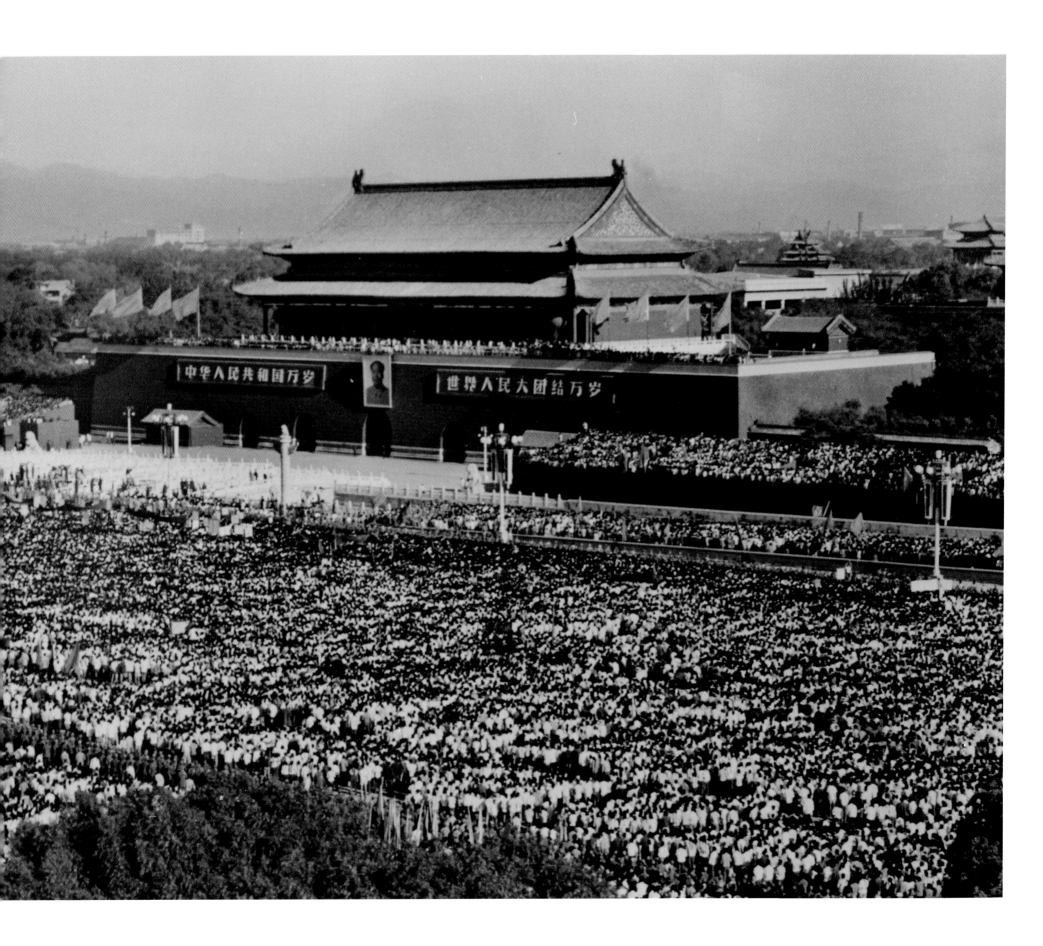

Anonymous photograph (detail),
'The millions of people attending the gathering pledged their determination to carry out the Great Proletarian Cultural Revolution under the leadership of the great leader Chairman Mao' (Beijing, 1966),
China Pictorial, Vol. 219, September 1966.

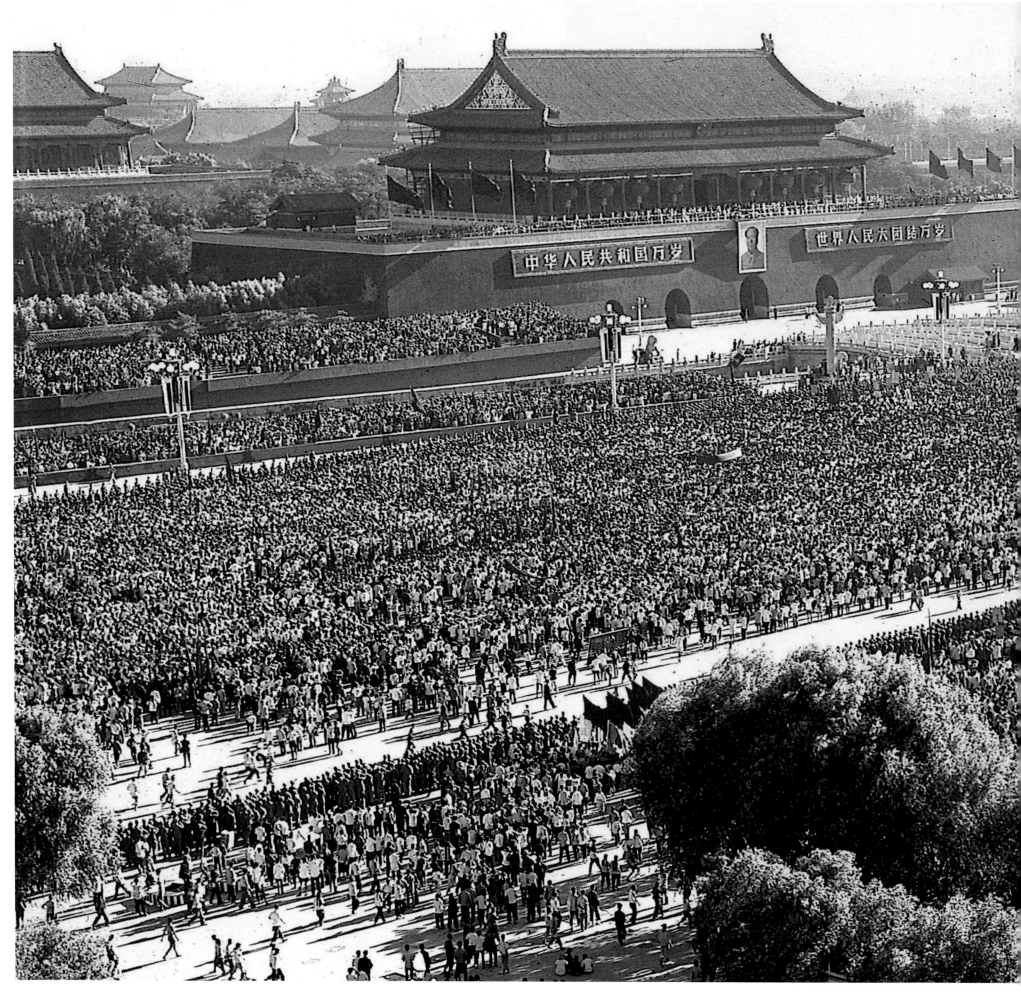

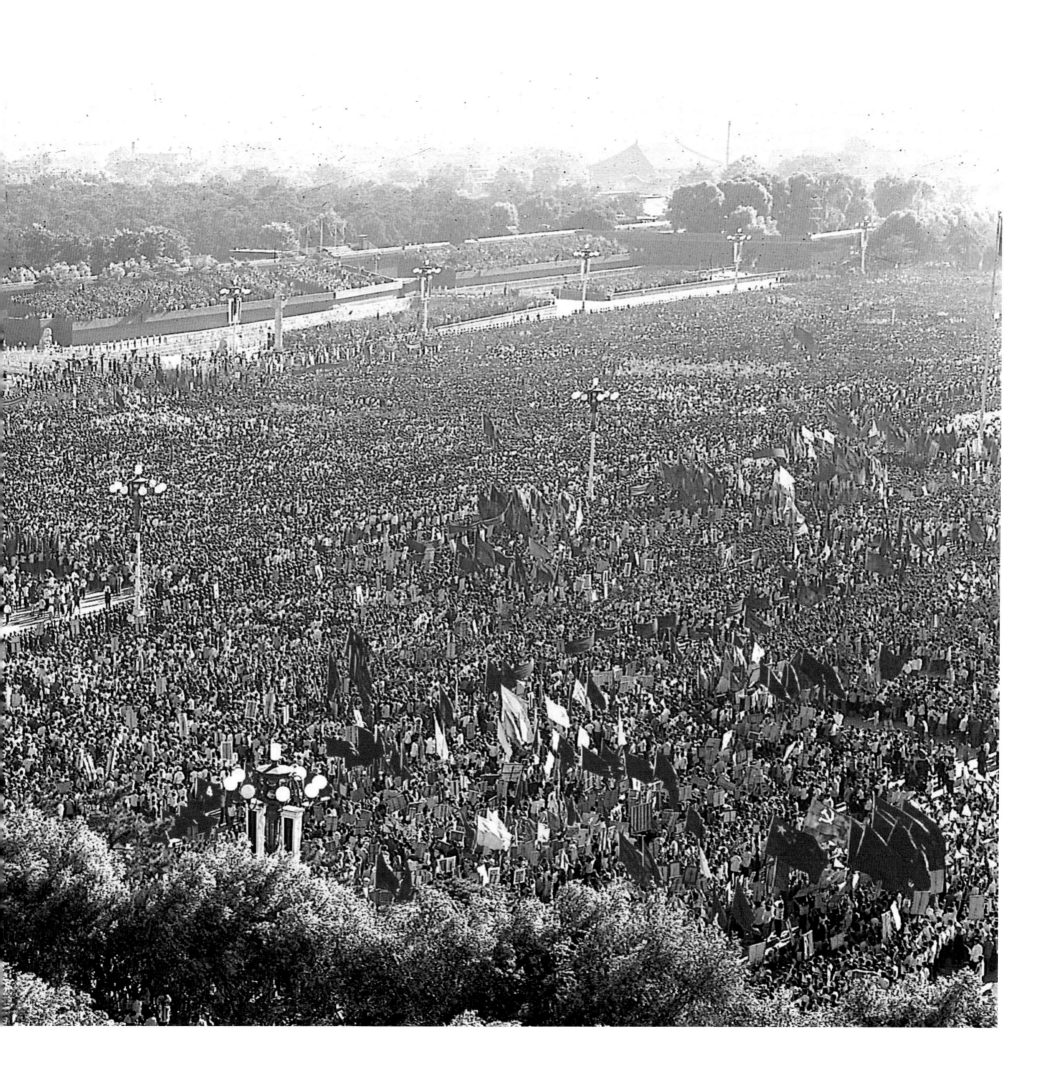

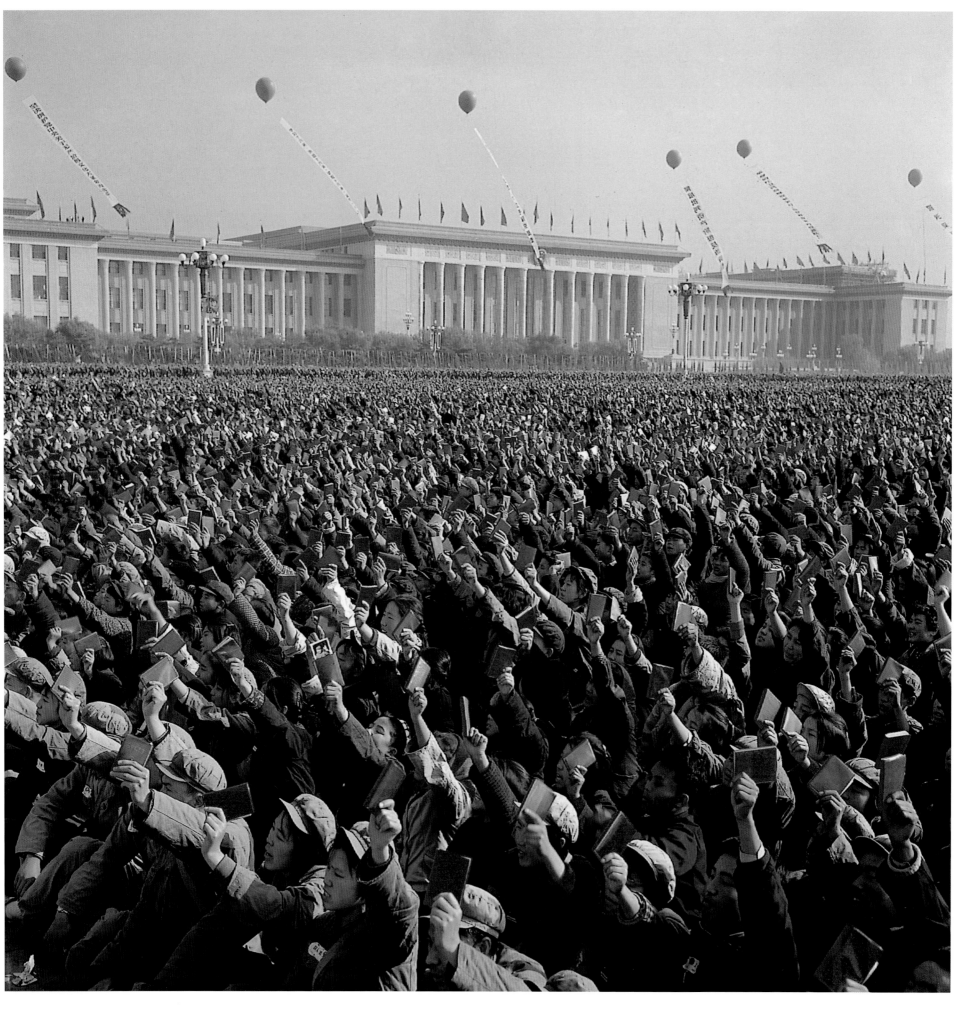

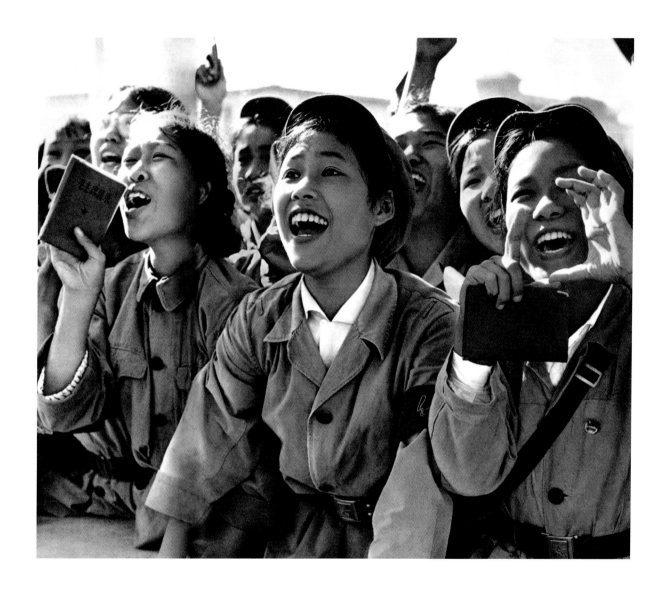

Anonymous photograph,
'The hearts of the revolutionary people are turned to the great leader Chairman Mao' (Beijing, 1966),
China Pictorial, Vol. 224, February 1967.

Anonymous photograph,
'The revolutionary little generals: with their endless love towards the great leader, the Red Guards were cheering
enthusiastically on Chairman Mao' (Beijing, 1966), *China Pictorial*, Vol. 219, September 1966.

Anonymous photograph (detail),
Celebrating the Seventeenth Anniversary of the People's Republic of China, Beijing, 1966, provided by China Photo Service.

Anonymous photograph (detail),
Celebrating the Twentieth Anniversary of the People's Republic of China, Beijing, 1969, provided by China Photo Service.

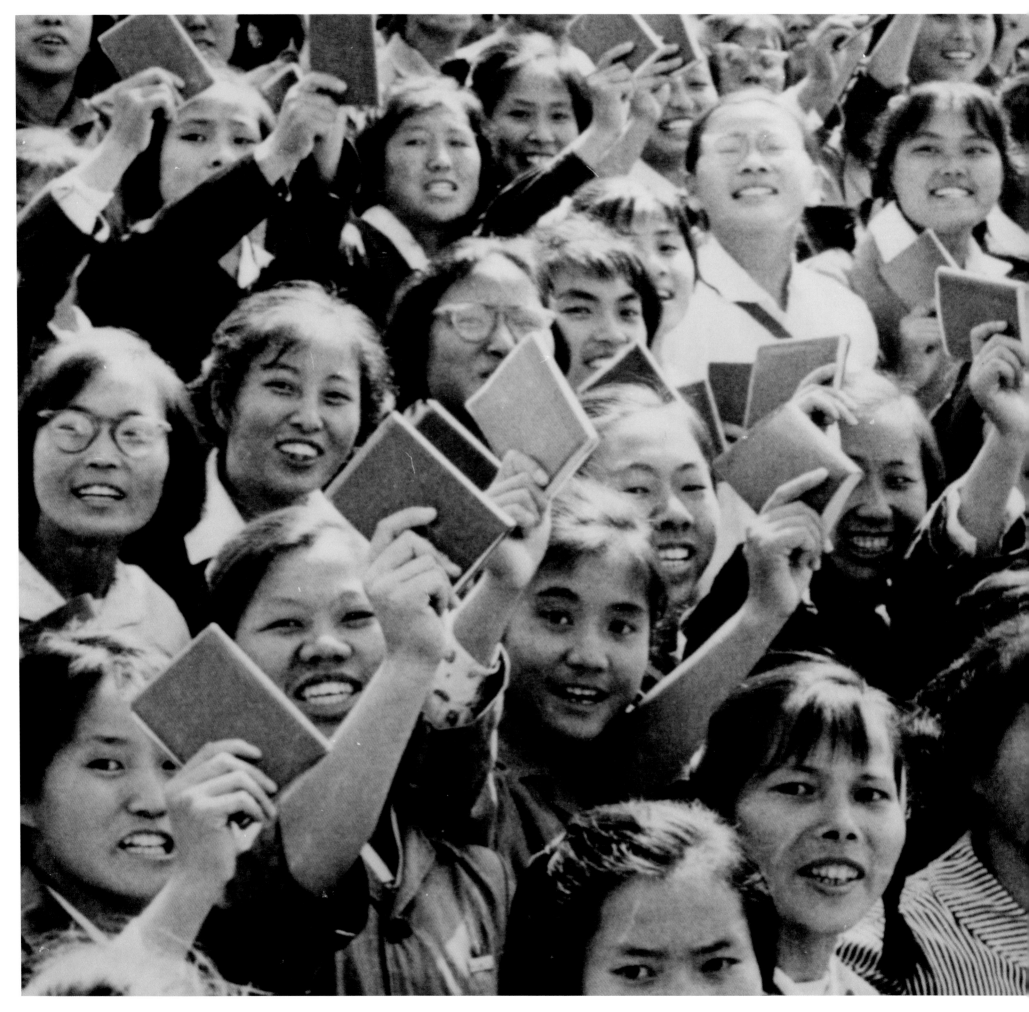

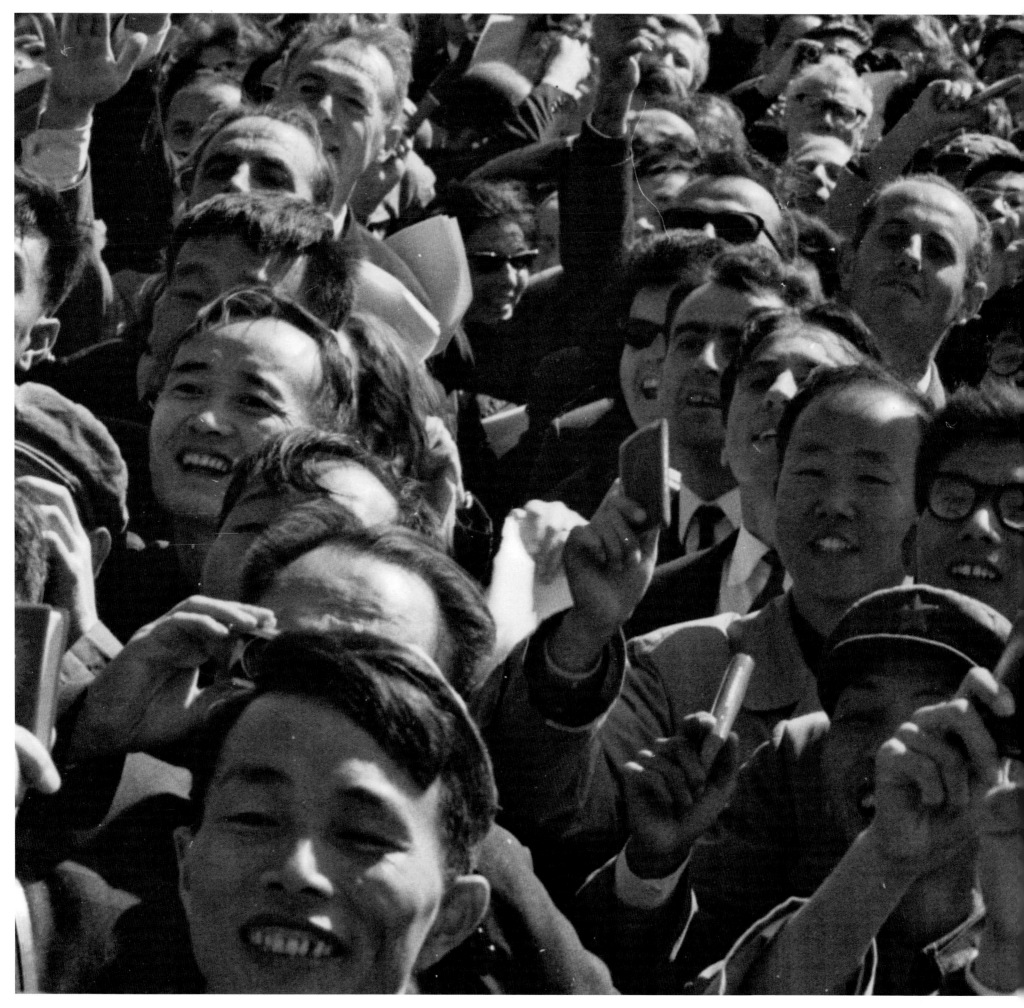

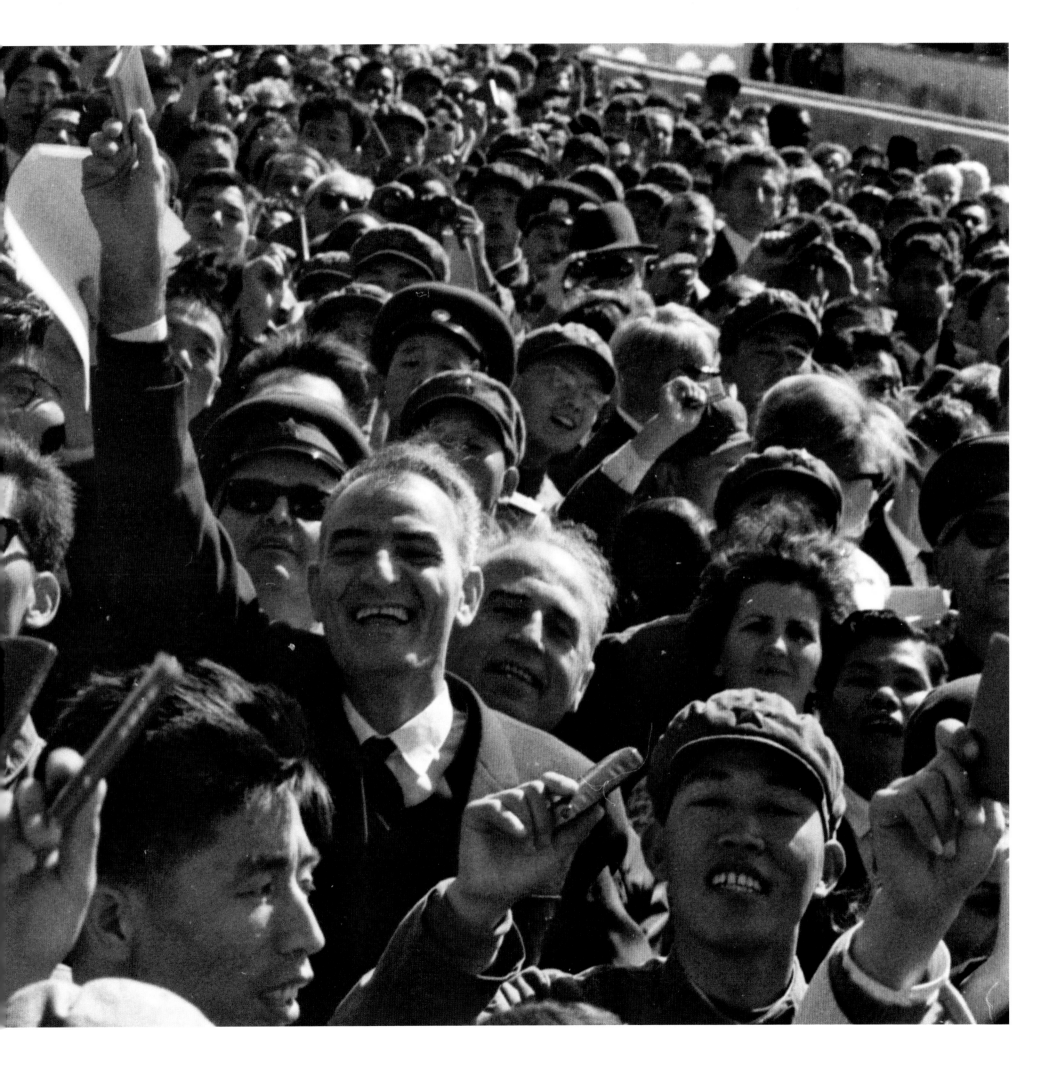

their lives. It is sometimes referred to as a 'family' movement. The ideology of collective life is not necessarily independent of individuals, but it suggests a conformity with which one can be recognised and granted legitimate status. During the assemblies in Tiananmen Square, there was a shared excitement among individuals. The mood was empowered and released by red. Nothing could hold it back. People were crying out to express their passion for one man, who calmly waved his arm and remained almost invisible in the distance (pp. 111–5). They seemed to be transported far beyond the conditions of normal life, and for the moment they felt themselves beyond ordinary morality. They belonged to a glorious collective and were elevated to an entirely different world defined by the colour red.

The Red Flag Combat Regimental Team of the Beijing Institute of Aeronautics also attempted to turn China into the red sea. With lightning speed, they mobilised and in a few days gave the doors and walls of houses and shops a coat of red paint. Slogans were written in red on all available surfaces. Paper designs in red showing devotion to Mao covered the walls of shops, homes and dormitories. The stores, government offices, tea shops, noodle restaurants and various dining places were so completely covered that it was impossible to tell which was which.[59] In response to activities at the revolutionary centre of Beijing, red suffused the country. As far as Handan in northern China,

> It looked terrifying when the street walls were painted all in red, and were so red all over the city, throughout 1967 to 1968. I felt that the main tide, a huge tide, was coming and could not help following the tide. I was quite sensitive compared with the other teenagers, and used to doubt whether people should beat each other during the revolution. However, I felt so excited anyhow when I saw the red tide.[60]

On December 30, 1966, the Central and the State Council finally responded by issuing the *Notice about Restraining the Indiscriminate Action of the So-called Red Sea*. It read,

> According to the reactions of the masses of various places, some municipal Party and official units, on the pretext of recording the sayings of Chairman Mao and of 'beautifying the city aspects', have enthusiastically entered into 'red sea' activities–that is, using red paint to cover doors and large wall surfaces and even forcing every household to pay up. In some villages, in addition to 'red sea' action, there were even attempts at 'big edifices'. Then there are the otherwise-motivated capitalist-roaders still in power and those in support of the capitalist reactionary line who would take advantage of such activities to deprive the masses from posting their own posters. Such was their way of covering up their own crimes against Mao Zedong's Thought. This method of theirs not only completely disobeys the way of diligent frugality long taught by Comrade Mao Zedong, but also constitutes the base action of showing resistance to big-character posters and to the Great Proletarian Cultural Revolution. The Central Committee is of the view that every level of leadership must resolutely put a stop to such erroneous methods. So be it noted.[61]

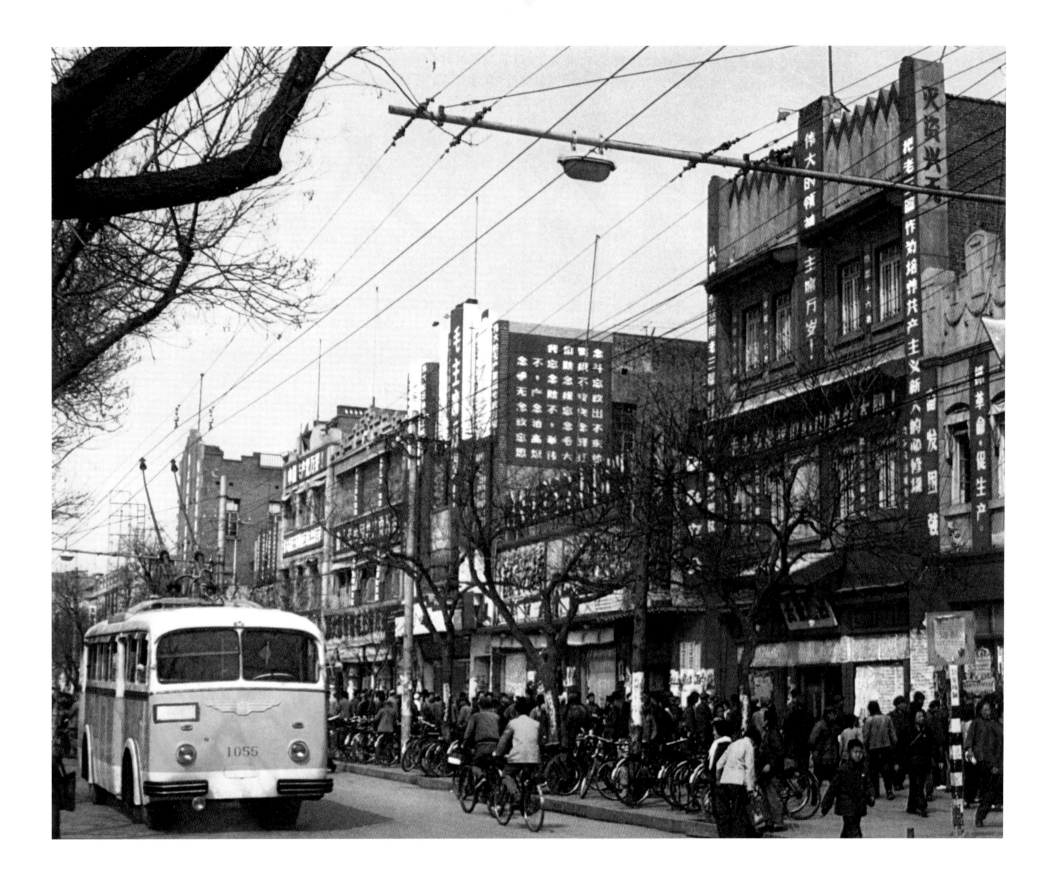

Anonymous photograph,
'Revolutionary slogans and songs everywhere, carrying the new names, new customs and habits, offered everlasting glories to our great capital city, the heart of the proletariat, whilst the former Wangfujing Street has been renamed as People's Road' (Beijing, 1966), *China Pictorial*, Vol. 229, July 1967.

Anonymous photograph,
'Beijing Red Guards and revolutionary masses swim across the Kunming Lake to commemorate the first anniversary of Chairman Mao's swim in the Yangtze River' (Beijing, 1967), *China Pictorial*, Vol. 231, September 1967.

The rising tide of the Cultural Revolution was understood as great news for the nation, or even universally for all mankind. Although the activity of painting everything in red was eventually halted by the *Notice*, red remained dominant. If possible, consumables for daily life were produced in the definitive colour and lined up on the shopping shelves in an arrangement of the red sea (pp. 117, 119–23).

The transfer of the unshaped colour to the portrait of Mao was itself supposed to be a reflection of the mobility of red. To create a dynamic image of the red sea was therefore in the very nature of the colour. This illustrates a particular phenomenon that one might call 'red suffusion'. In '*Ode to Red Guards*', published in *Hongqi*, a 'red flood' was highly praised.

> Thousands and millions of Red Guards get out from schools to go along streets and appear as a resistless flood. They hold the red flag of invincible Maoist Thought high, develop the proletarian revolutionary spirit by daring to think, to say, to do, to dash and to rebel, sweep away the dirtily muddy water left from the old society, together with the junks and garbage piled up over thousands of years.[62]

The cult of Mao could present an atmosphere of liveliness and boisterousness consistent with traditional Chinese celebrations. It could provide carnivals of nationalistic excitement representing liberation from, and transformation of, conformity. After Mao's inspection, there were countless political initiatives, movements within movements, and ad hoc campaigns launched during the Cultural Revolution. Celebratory parades became very popular events in Tiananmen Square and elsewhere across the country. Provincial Red Guards came to Beijing to join the movement and travelled around China to share their revolutionary experiences. These nationwide excursions, generally known as *Da chuanlian* (the Great Exchange), were encouraged by Mao. At a meeting in Hangzhou on June 10, 1966, Mao was so pleased that students from all over the country wanted to come to Beijing that he suggested that this request should be granted and students should not be charged for their travel costs (pp. 124–5).[63] Millions of the Red Guards took advantage of this opportunity to visit the sacred revolutionary lands where Mao and the Communist Party had lived and worked (pp. 126–9). 'Like the religious practice of pilgrimage to holy places for the purpose of gaining protection, inspiration, and enlightenment from saints or other holy figures who function as channels of the divine, travel by members of the Red Guards was conducted to sacred revolutionary lands', wrote Lu, 'in order to experience firsthand the glorious history of the Communist Party and bring themselves closer to the spirit of Mao.'[64]

Endless local political demonstrations (pp. 132–9), were organised through Red Guard organisations and work units (*danwei*) to respond to the upheaval in Beijing, in particular, to constantly 'announce the good news' (*baoxi*) of Mao's updated instructions. On special occasions, such as National Day festivals and the establishment of the provincial Revolutionary Committees, people outside the capital likewise showed their enthusiasm towards the Cultural Revolution with red flags, slogans and, sometimes, with the giant red characters of 'double happiness', which are traditionally used in wedding ceremonies (pp. 140–9).

Continued on page 130

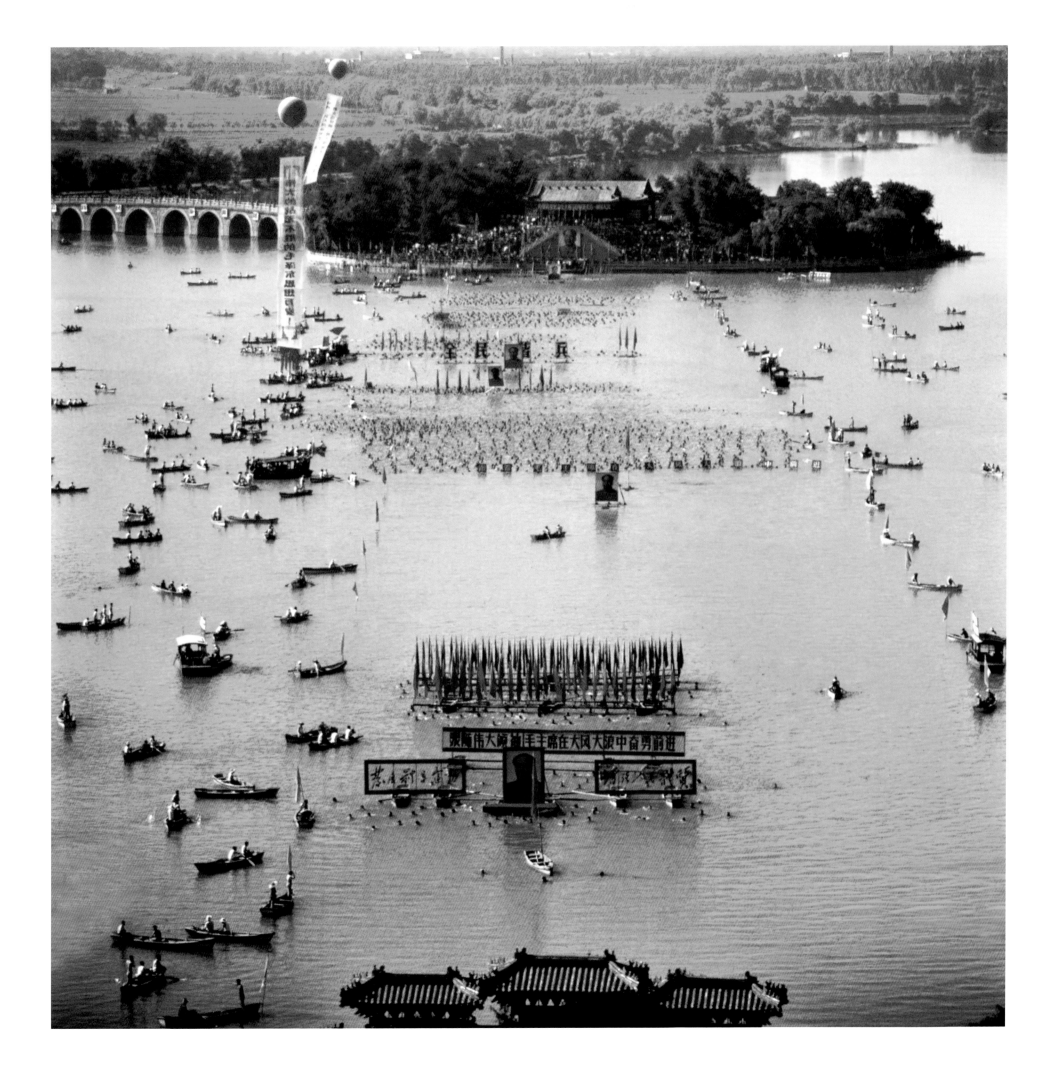

Anonymous photograph,
'To transfer our markets to the battlefields for promoting Mao Zedong Thought' (Beijing, 1967), *China Pictorial*, Vol. 238, April 1968.

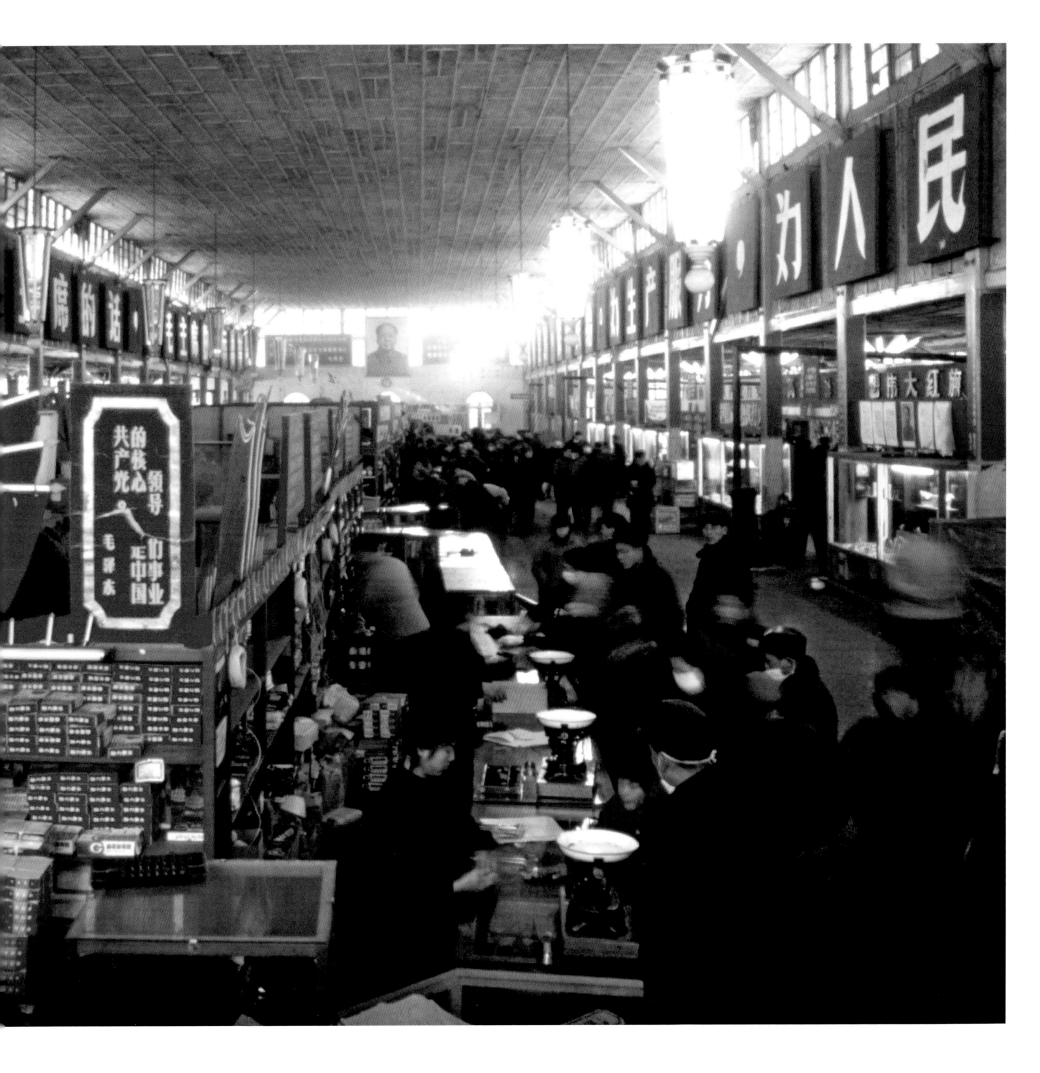

Sun Yifu,
'Xintang Commune market' (Xintang, 1966), *China Pictorial*, Vol. 215, May 1966.

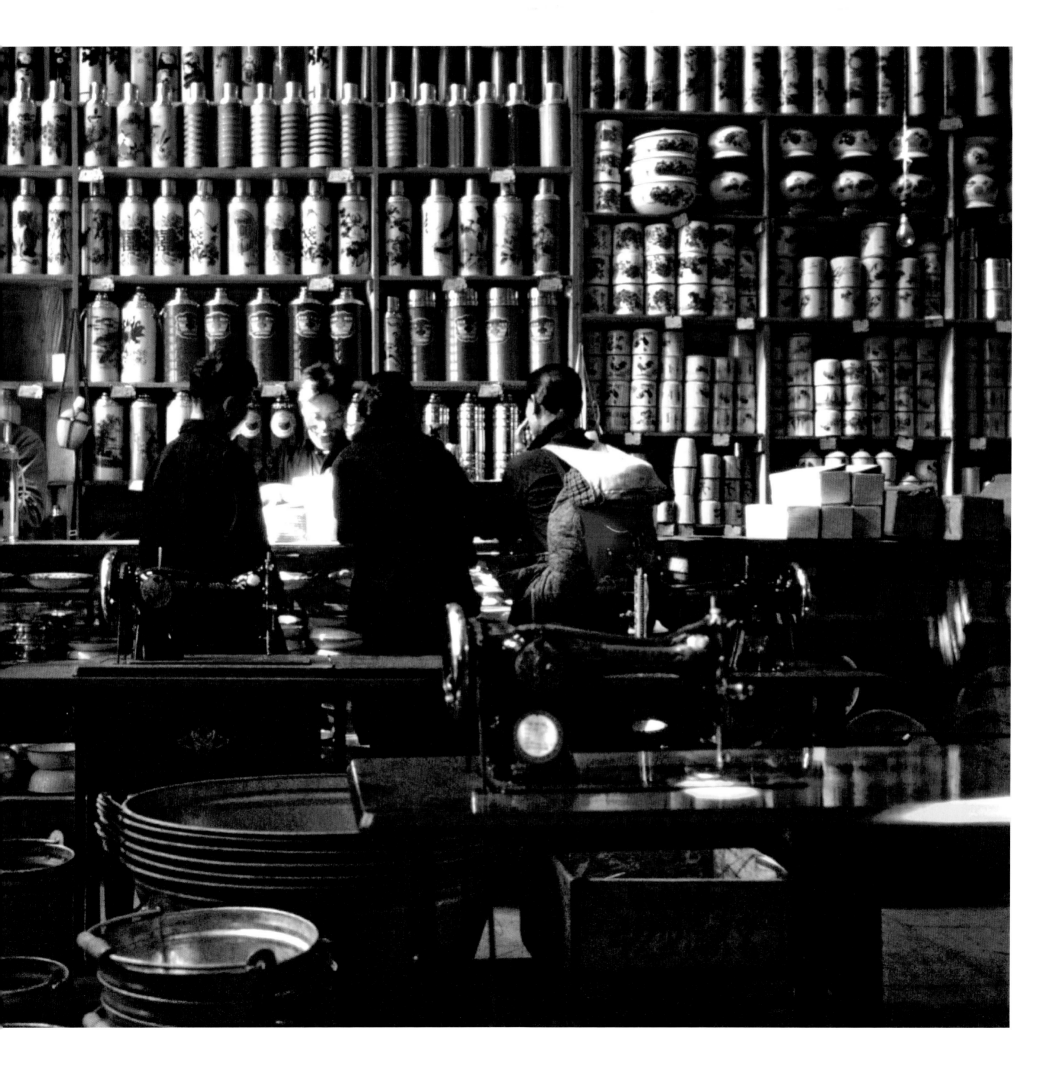

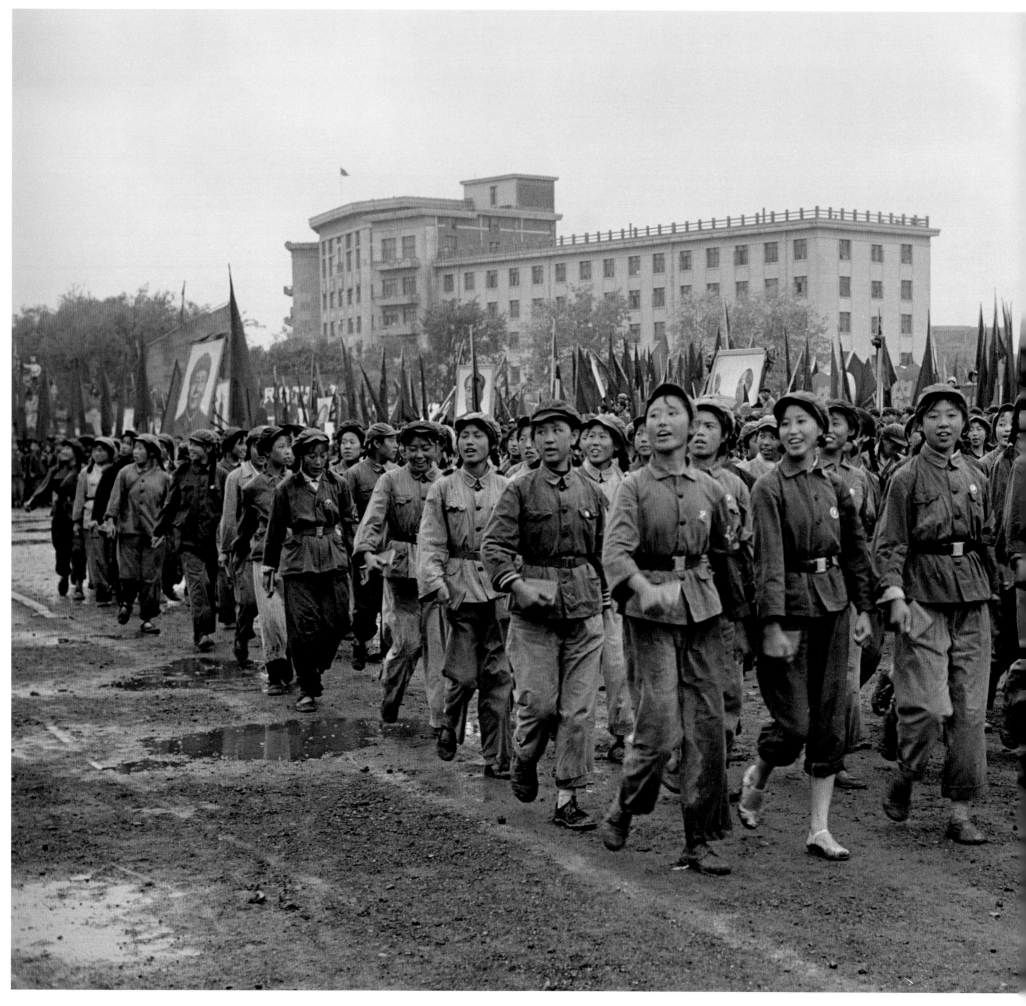

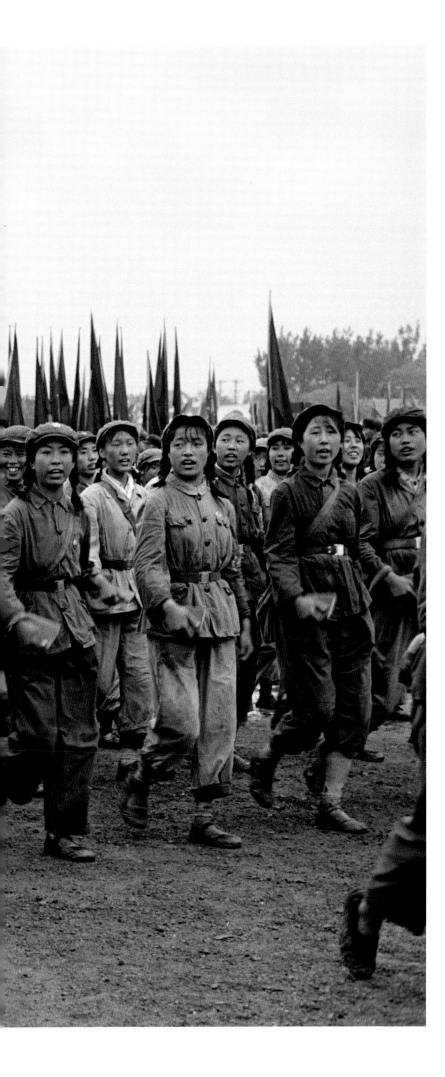

Jiang Shaowu,
Shenyang Red Guard Parade through the Street in Beijing, Beijing, 1966.

Weng Naiqiang,
Red Guards Crossing the Lugou Bridge, Wanping, Beijing, 1966.

Zhang Yaxin,
Launch of the Red Guard Long March, Shanghai, 1966.

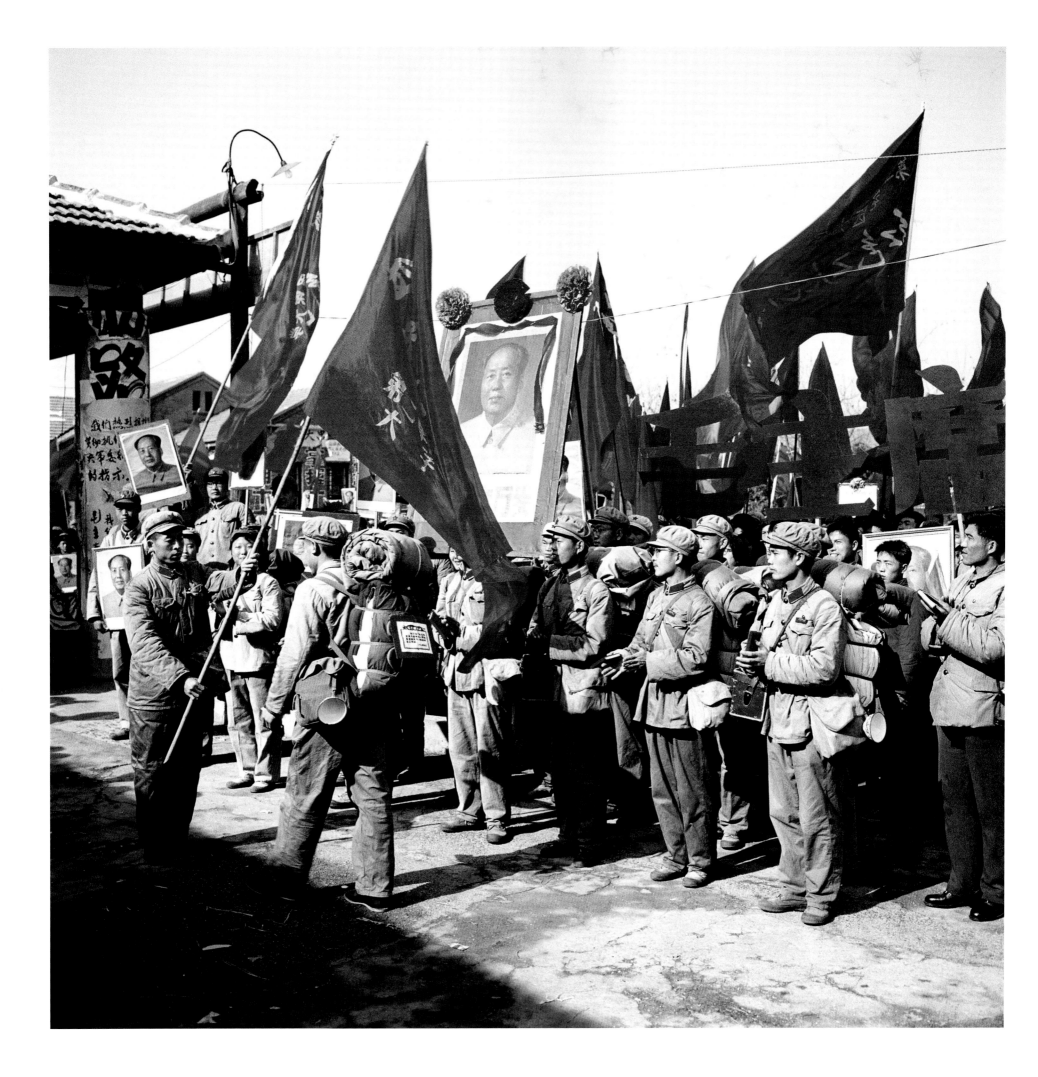

Zhang Yaxin,
Red Flags Flying Along the Baota Mountain, Yan'an, 1966.

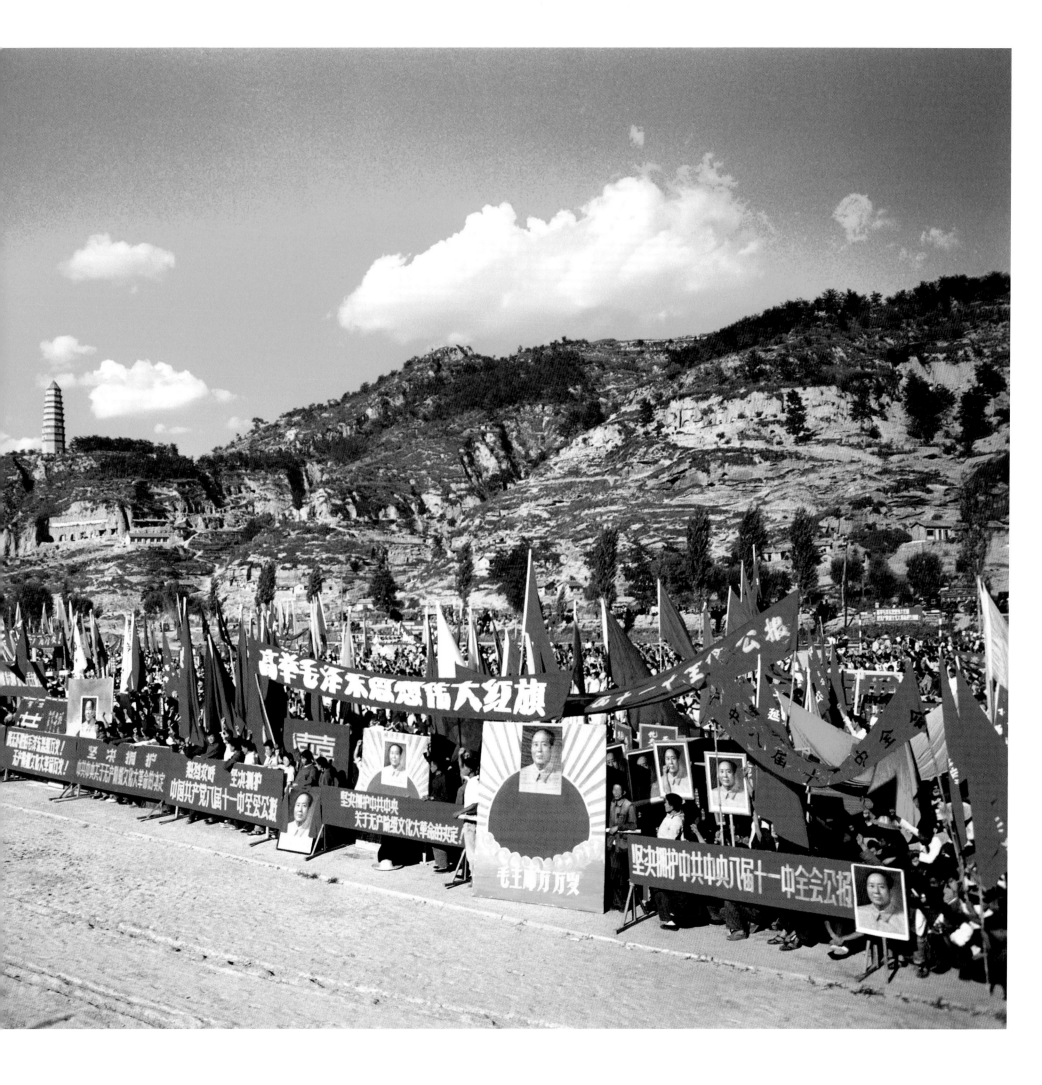

The red sea extended to the colour of the Red Guards' armbands and to Mao's books. The arrangement of dress details granted individual expression, yet everything was contained within a greater conformity. A former Red Guard proudly described their sense of style.

When the middle-school students gathered together, everyone dressed in a kind of old military uniform with an armband, some even got the red pentagrams on their hats, looking like new soldiers. We carried army bags embroidered with Chairman Mao's indoctrination, '*wei renmin fuwu* (to serve the people)', and with the little red books inside. We were wearing Mao badges, the favourite ones…[65]

Clothing was coded according to occupation and service, or to other positions of status. The Mao suit varied in colour – blue, grey or army green. So too did the accessories such as a brown leather belt and rifle. A khaki belted jacket, popularly worn by the Red Guards, suggested the military uniform of the People's Liberation Army and recalled an earlier revolutionary tradition, which was regarded as the true spirit of modern China.[66] Though common civilian dress remained plain, the red badges, armbands and little books stood out in the crowds. They became the new chic ornaments, instead of rings, brooches and necklaces, signifying the transition from the indulgence in a 'bourgeois hobby' to revolutionary pursuit. A red vogue surfaced that satisfied both political and decorative needs.

In the first Red Guard parade in Tiananmen Square, Song Binbin, the student representative from the High School Attached to Beijing Normal University, was received by Mao in person and dedicated an armband to the Chairman. At that very moment when the Red Guard organisations were legitimated and glorified, the red cloth of the armband would have borne evidence of the 'great spirit' in the form of the three characters of *Hong weibing*, in the style of Mao's own handwriting.

The appearance of Mao's books demonstrated the integration of red and Mao's words. Up to 1969, 740 million copies of Mao's books were printed.[67] Xinhua Books announced that during the whole decade of the Cultural Revolution more than forty billion volumes of Mao's works were distributed and only 8 per cent of all those books remained unsold by the middle of 1979 (p. 150).[68] That amounted astonishingly to fifteen copies of Mao's books for every man, woman and child in the country. There was no official rule for the design, but every single book had a red cover. They were therefore referred to as the 'Red Treasure Books' (*Hong baoshu*). Depending on the versions or contents, the covers of Mao's works would be designed somewhat differently today. Sometimes Mao's profile appeared on the cover, and sometimes there would simply be a title above a small pentagram. The only characteristics that have remained unchanged are the colours – the golden images or texts printed on a glossy red background.

Certain political rituals took the form of 'Everyday Reading', known as *Tiantian du*, during which every morning children and adults were required to read the red books and recite Mao's quotations, essays and his new directives, either in a group or led by one individual. The reading usually lasted one hour and was preceded by the three wishes for Mao's longevity and the singing of '*The East Is Red*'. According to a former

Red Guard, many did not understand the meanings of these quotations, but it was a fashion at the time to be able to recite as many quotes as possible. This repetition became an indication of how loyal one was to Mao and how well one knew Mao's teachings.[69] The ritual could take place in schools, factories, government offices and virtually every public place, even during work in the fields or on a moving bus (pp. 151–3). More significantly, the red books were carried in the enthusiastic crowds in Tiananmen Square, on parades, in the streets or on the trains. They were waved above people's heads, demonstrating loyalty to Mao (pp. 154–63). Although the red book was not a piece of dress, it was firmly linked to the body. Its simple red form served as a flag. Carrying Mao's books built people's confidence, even when they remained in pockets and bags. They were brilliant demonstrative objects, regardless of their contents.

In addition to the revolutionary connotations of red, according to Chinese folk culture red contains the power to defend 'our' collective happiness, but also to defeat the evil 'others'. For those reasons the colour red is widely used during the New Year and traditional wedding ceremonies. At a more personal level, during *benming nian*, the year of the same animal as that of one's birth year, people are supposed to wear red to avoid inauspicious happenings and to attract good fortune. Under the political circumstances of the Cultural Revolution, individual security and peace were at all times under serious threat. Anyone exposed as a counter-revolutionary could be criticised and beaten, even to the point of death. The application of red continued to ward off the dangers of the time. When the 'Olds' had been extinguished, Mao's books, red armbands and Mao badges became legal talismans, symbolically securing people's fate through the turbulence.

Through the endless political initiatives, the flags and slogans contributed to the grand picture of the red sea. The red of the badges and books, constantly in motion, enriched the red suffusion with fine detail. Red was the essence of the visual language of the public gatherings and mass parades. The movable red extended the effects of people's exuberant spirit into everyday life, even after the assembly was dispersed.

48. Zhong Weiguang, 'Qinghua fuzhong hong weibing xiaozu dansheng shishi (The Historical Fact of the Birth of the Red Guard Group at the Middle School Attached to Qinghua University)', in *Huaxia wenzhai (China News Digest)*, Supplement Issue 109, December 28, 1996. Available from: http://www.cnd.org/CR/ZK96/zk109.hz8.html#1 [accessed on December 4, 2008].
49. Cited in Yan and Gao (1996), op. cit., p. 57.
50. Yin Hongbiao, 'Hong weibing yundong de liangda chaoliu (The Two Main Trends in the Red Guard Movement)', in Liu (ed.) (1996), op. cit., p. 232.
51. 'Zilai hongmen zhan qilai le (The Born Reds Stand up)', originally published in *Bingtuan zhanbao (Corps Bulletin)*, November 26, 1966, cited in Song Yongyi and Sun Dajin, *Wenhua da geming he tade yiduan sichao (Heterodox Thoughts during the Culture Revolution)*. Hong Kong: Tianyuan shuwu, 1997, pp. 83–5.
52. Cited in Song and Sun, ibid., p. 80.
53. Editorial, 'Zai Mao Zedong sixiang de dalu shang qianjin (Go Forward on the Road of Mao Zedong's Thought), *Hongqi*, Vol. 184, No. 13, October 1966, pp. 4–6.
54. Xu Youyü, *Ziyou de yanshuo (The Discourse of Freedom)*. Changchun: Changchun chubanshe, 1999, pp. 142–5.
55. Wu Hung, 'Tiananmen Square: A Political History of Monuments', in *Representations*, Vol. 35, Summer 1991, p. 90.
56. Cited in Wu Liangyong, 'Tiananmen guangchang de guihua he sheji (The Plan and Design of Tiananmen Square)', in *Jianzhushi Lunwenji (Essays on Architectural History)*, Vol. 2, 1979, p. 26.
57. 'Mao zhuxi tong baiwan qunzhong gongqing wenhua da geming (Chairman Mao Celebrates the Great Cultural Revolution Together with Millions of Masses)', *Renmin ribao*, August 19, 1966, pp. 1–2.
58. Interview with Li Xianting, op. cit.
59. Yan and Gao (1996), op. cit., pp. 89–90.
60. Interview with Li Xianting, op. cit.
61. Cited in Yan and Gao (1996), op. cit., p. 90.
62. Editorial, 'Hong weibing zan (Ode to Red Guards)', *Hongqi*, Vol. 183, No. 12, September 1966, p. 15.
63. Wang Nianyi, *Da donghuan de niandai (The Age of the Great Turmoil)*. Zhengzhou: Henan renmin chubanshe, 1996, p. 79.
64. Lu Xing, *Rhetoric of the Chinese Cultural Revolution: The Impact on Chinese Thought, Culture, and Communication*. Columbia: University of South Carolina Press, 2004, p. 136.
65. Feng (1997), op. cit., p. 128.
66. Chen, Tina Mai, 'Dressing for the Party: Clothing, Citizenship, and Gender-formation in Mao's China', *Fashion Theory*, Vol. 5, No. 2, 2001, pp. 155–8.
67. Lu (1993), op. cit., p. 14.
68. Su Ya and Jia Lusheng, *Buluo de taiyang (The Endless Sun)*. Zhengzhou: Zhongyuan nongmin chubanshe, 1992, p. 29.
69. Lu Xing (2004), op. cit., p. 138.

Wang Shilong,
Political Demonstrations, Zhengzhou, Henan province, 1966.

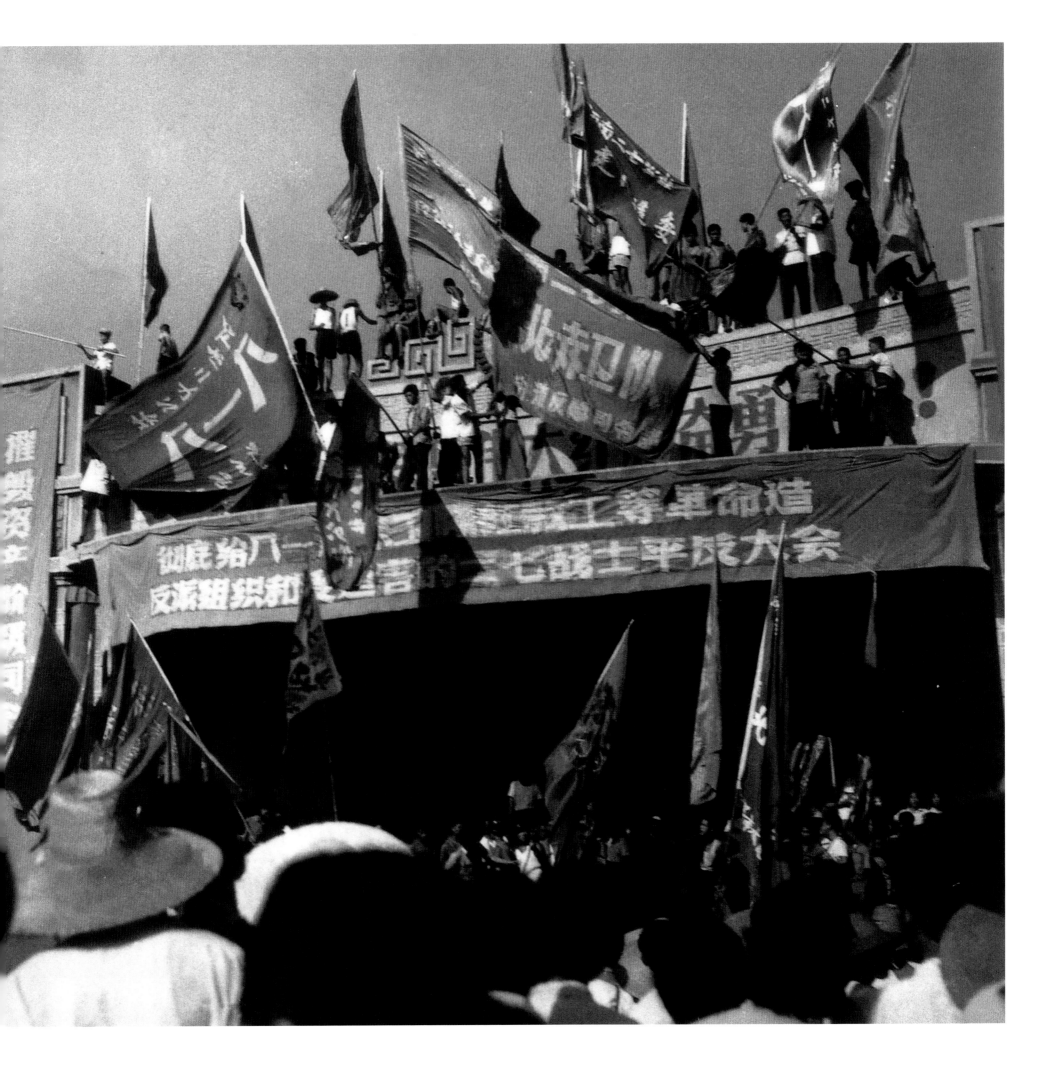

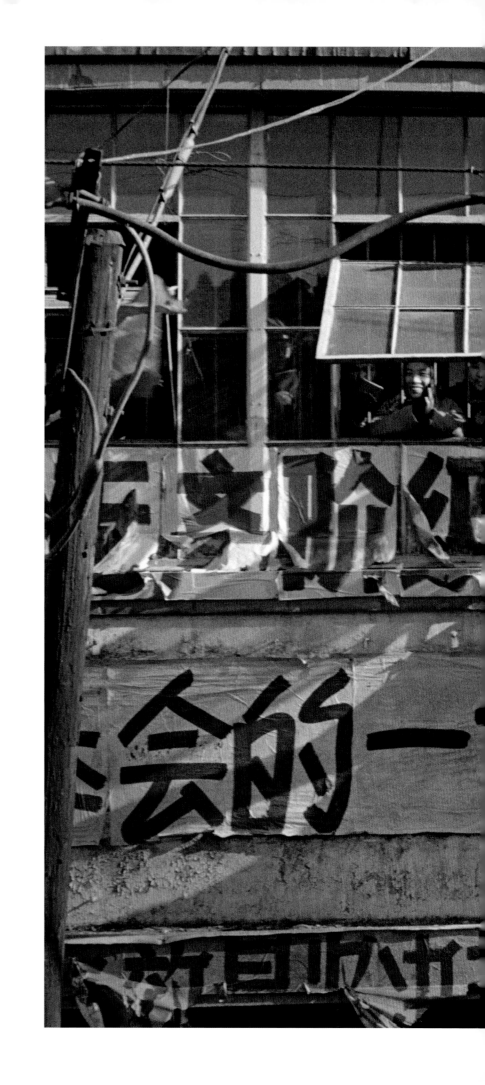

Jiang Shaowu,
Political Demonstrations, Shenyang, Liaoning province, 1966.

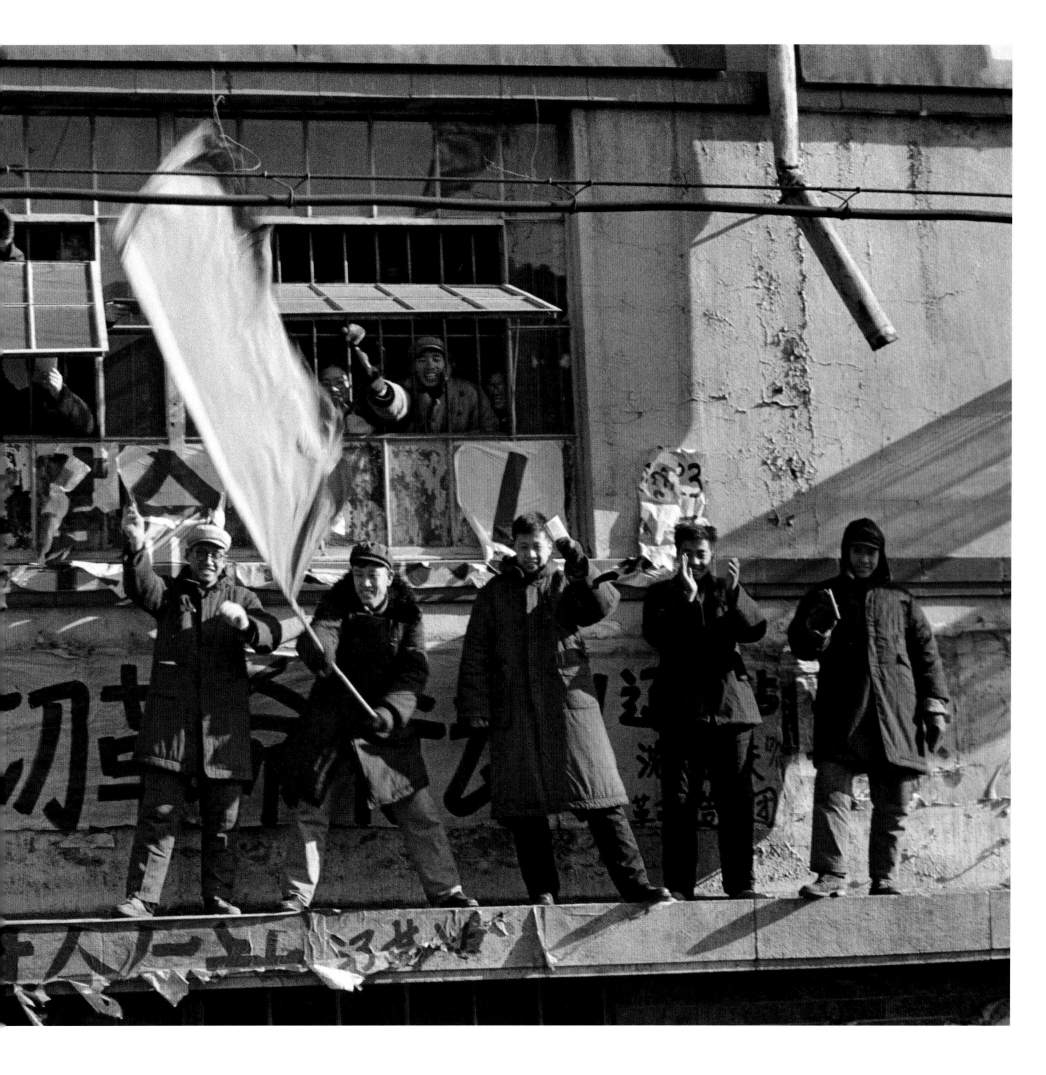

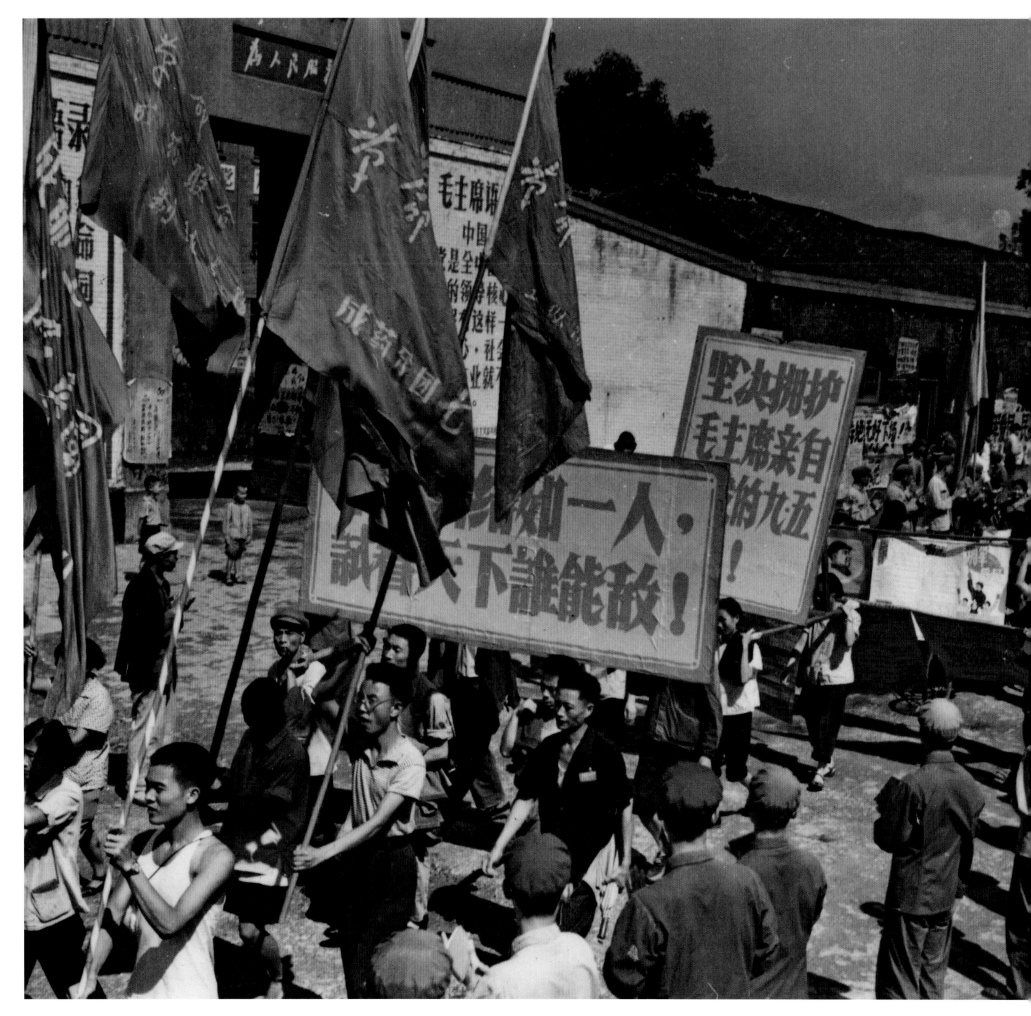

Chen Ke,
Mass Parade in Chengdu Military District, Chengdu, Sichuan province, 1966.

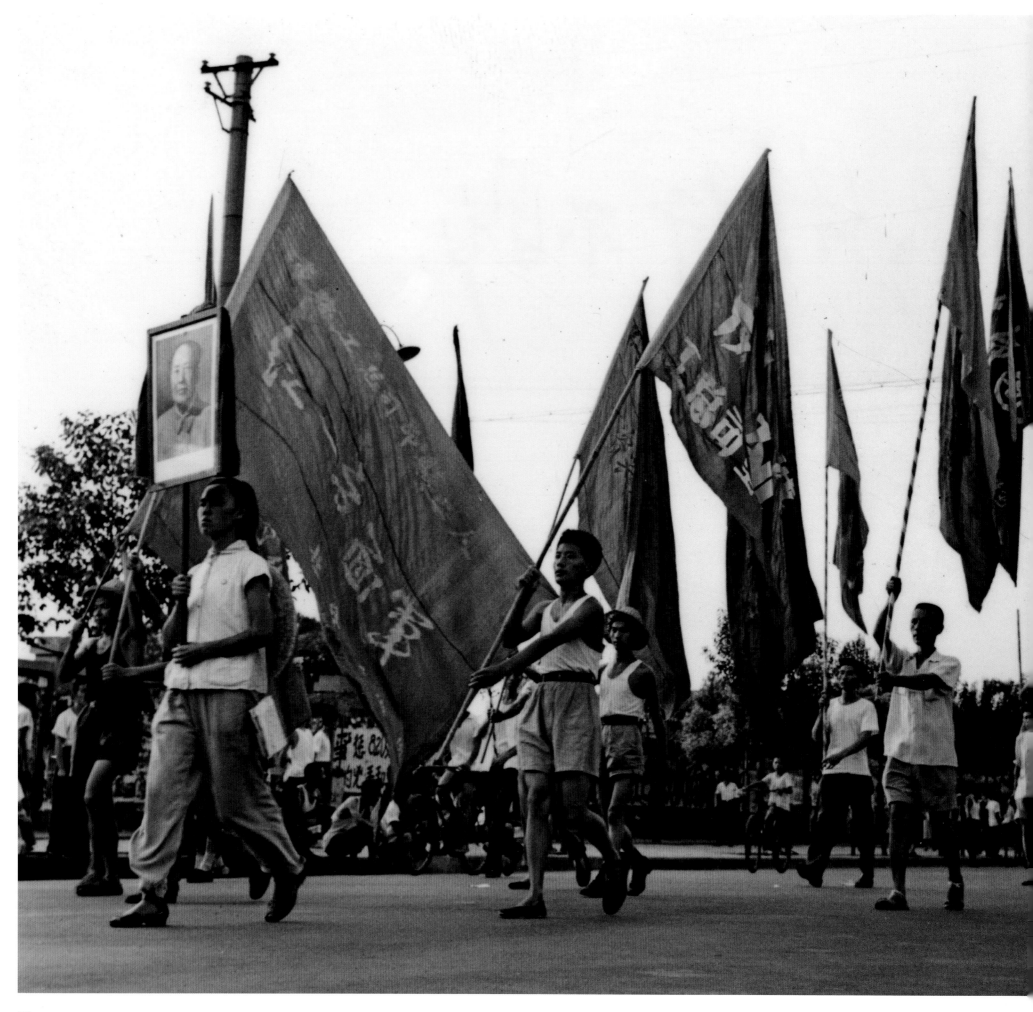

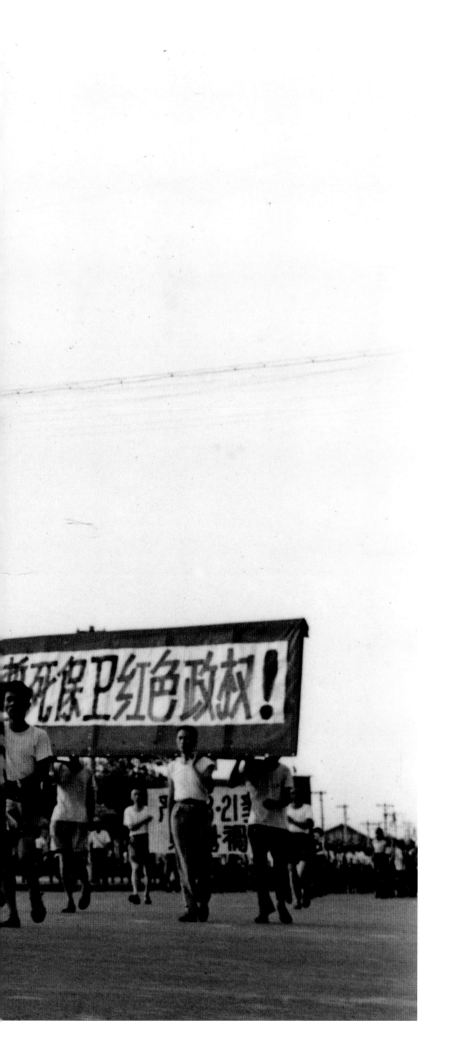

Chen Ke,
Parade for Defending the Red Regime, Chengdu, Sichuan province, 1966.

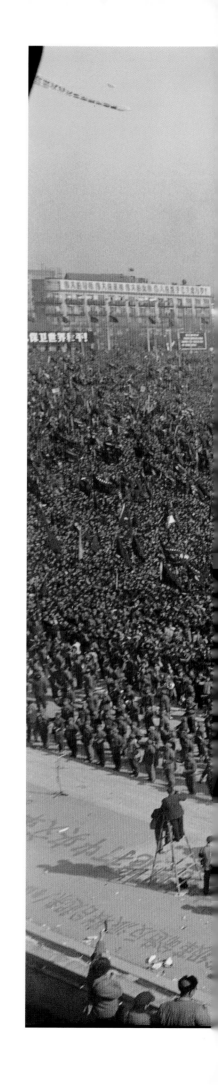

Zhang Yaxin,
The Shanghai January Storm, the People's Square, Shanghai, 1967.

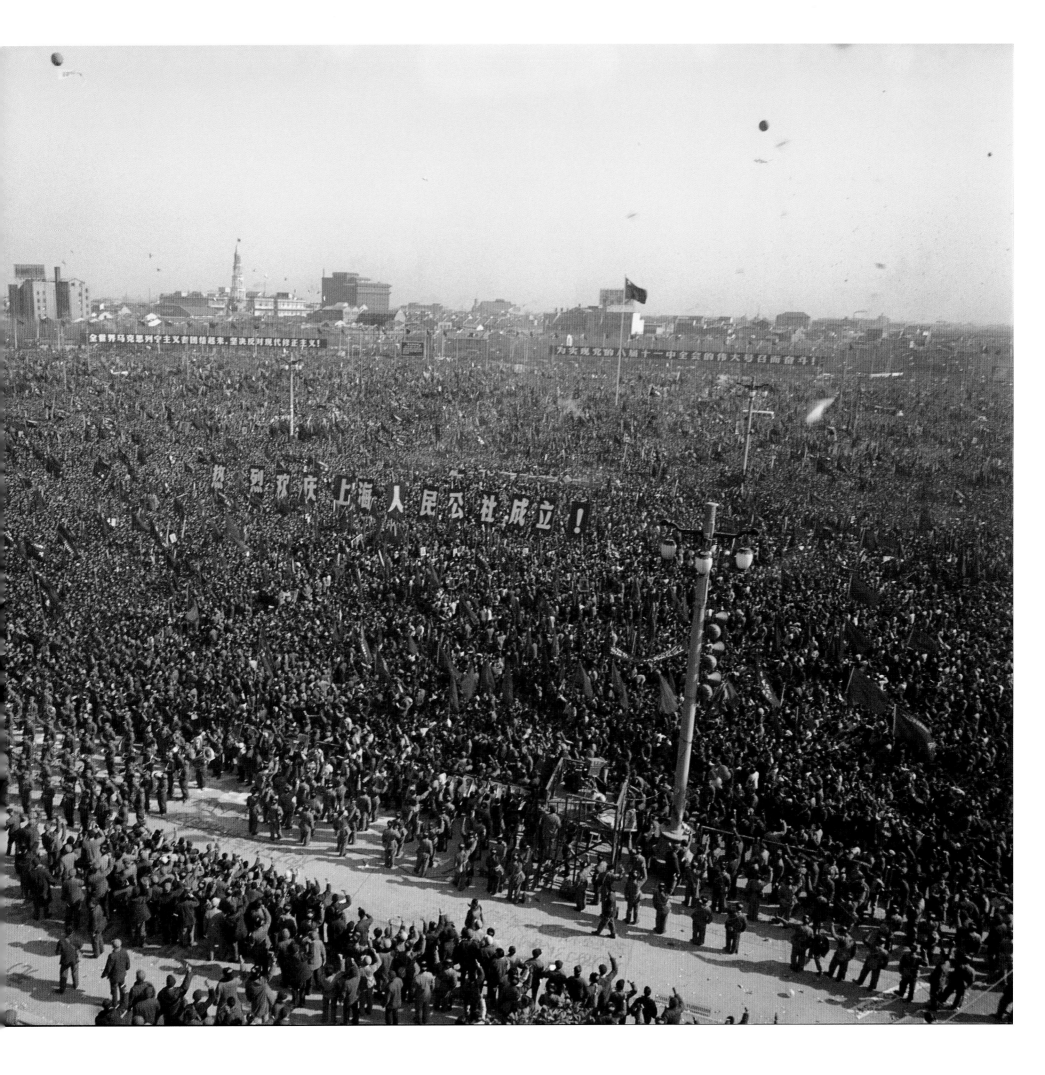

Anonymous photograph,
'A mass parade of 400,000 people to celebrate the establishment of the Revolutionary Committee in Hebei province' (Beijing, 1967), *China Pictorial*, Vol. 238, April 1968.

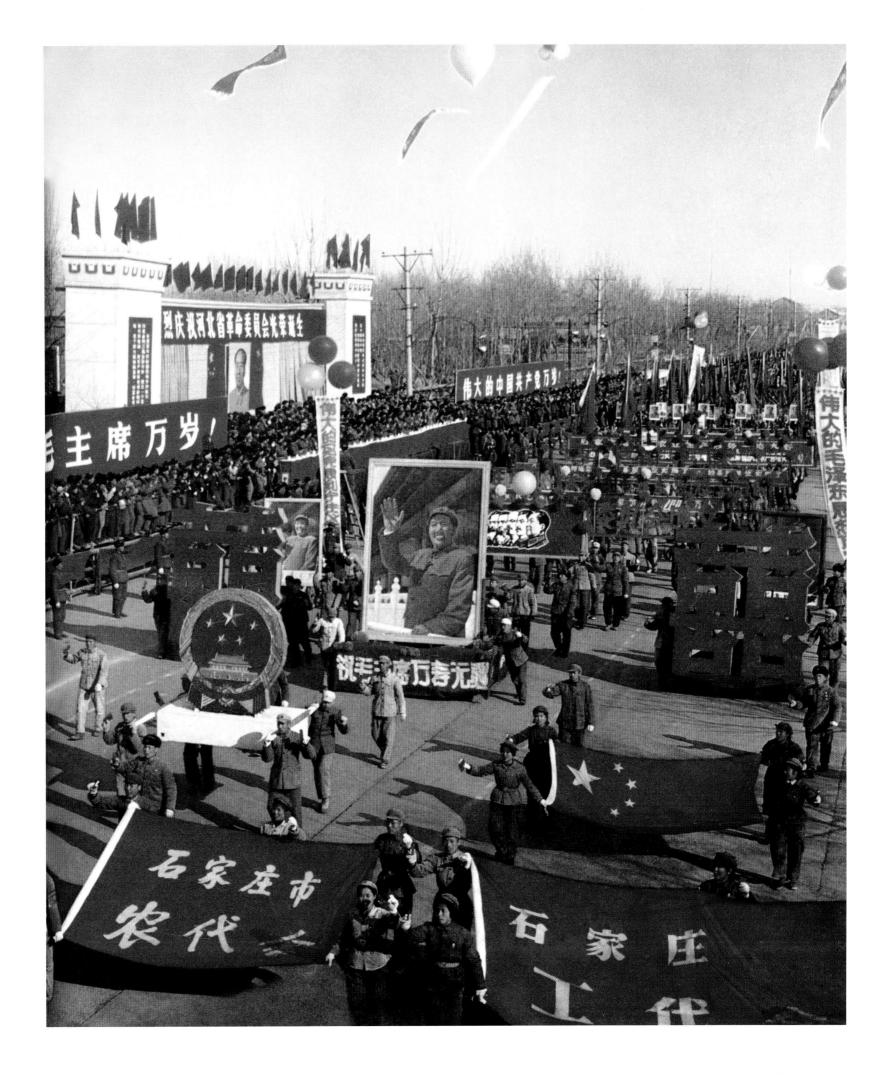

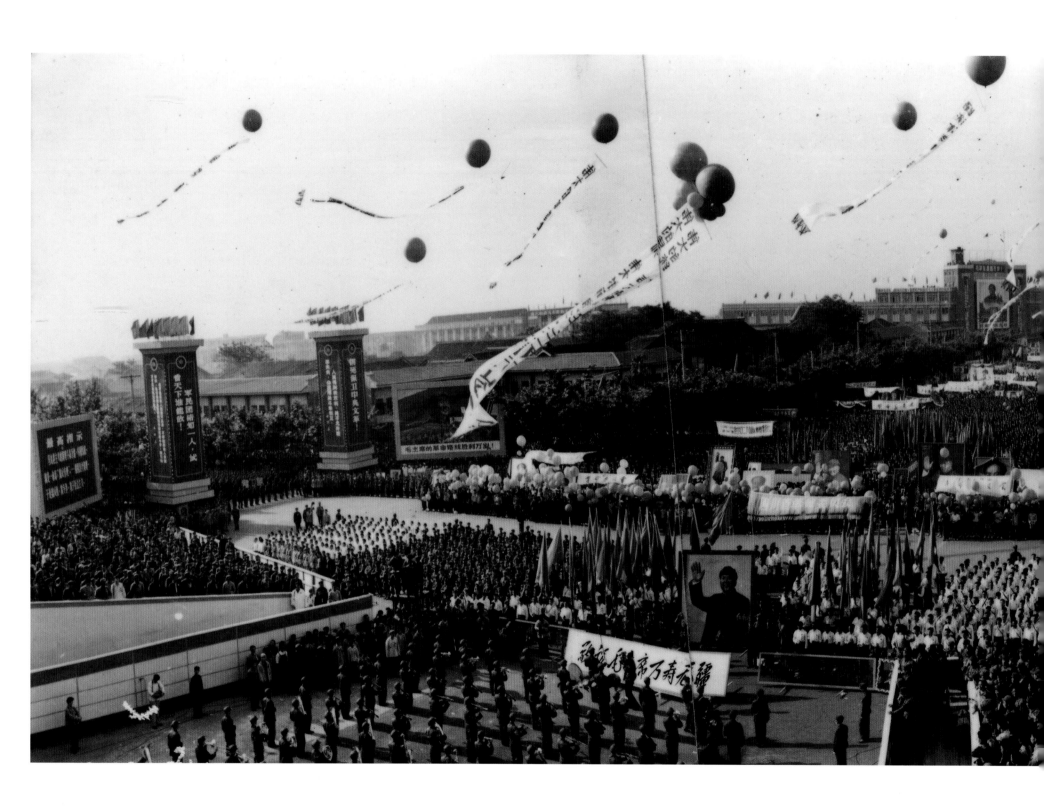

Chen Ke,
An Assembly of 300,000 people at South Renmin Road Square Celebrating the Establishment of the Sichuan Revolutionary Committee, Chengdu, Sichuan province, 1968.

Chen Ke,
Parade for Celebrating the Establishment of the Sichuan Revolutionary Committee, Chengdu, Sichuan province, 1968.

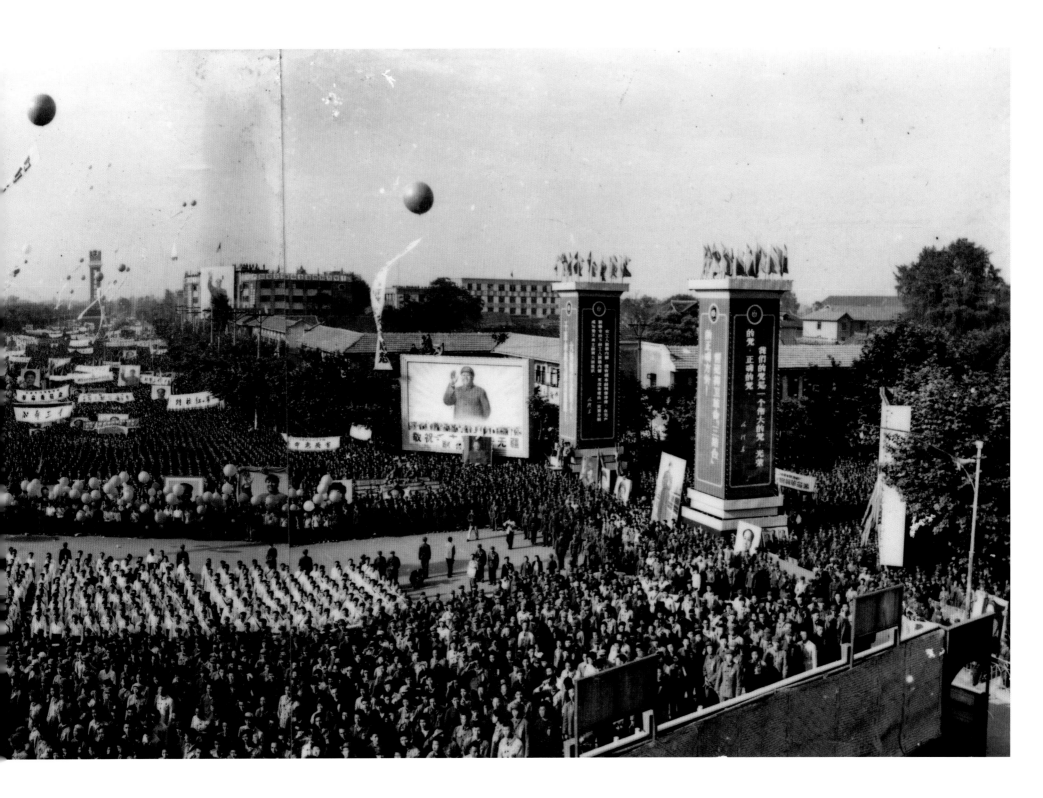

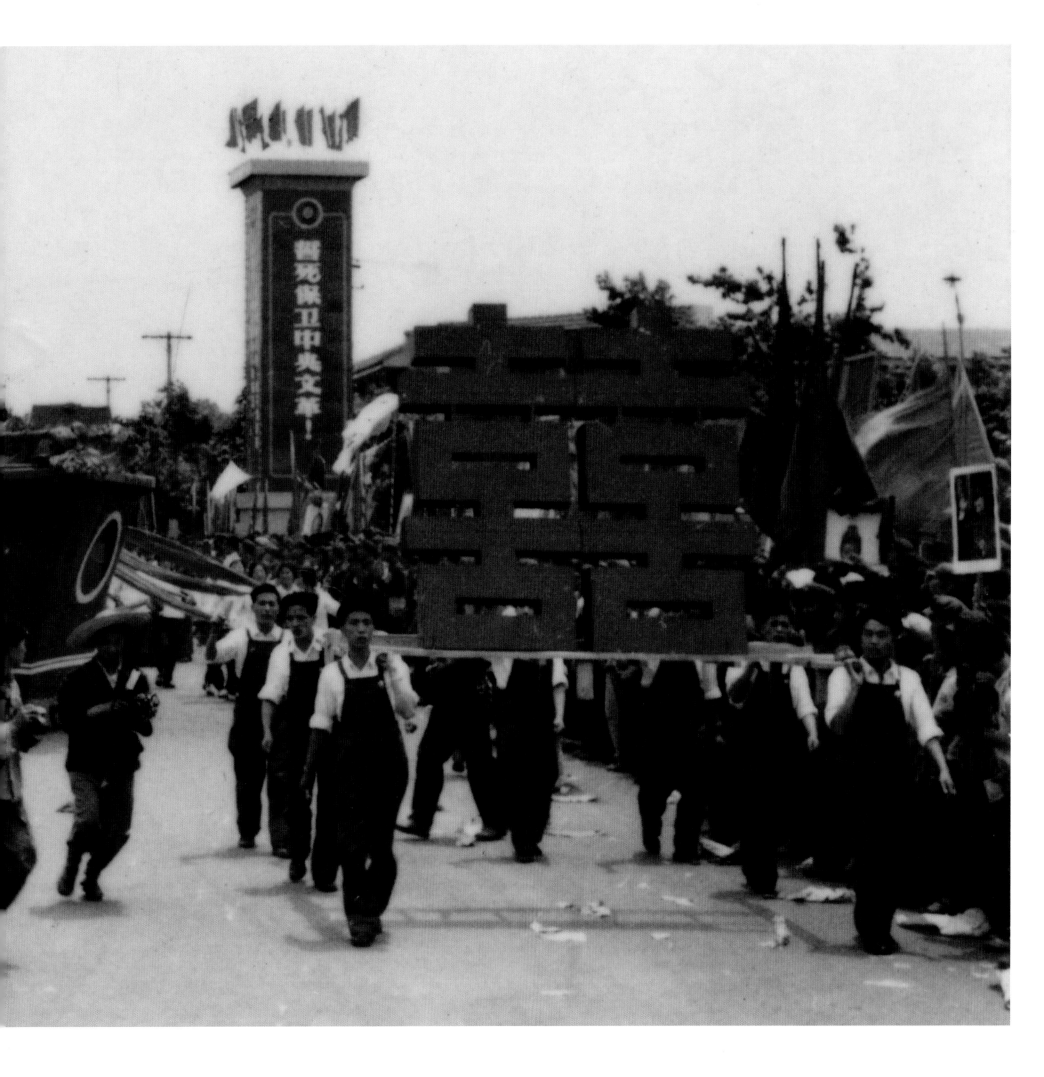

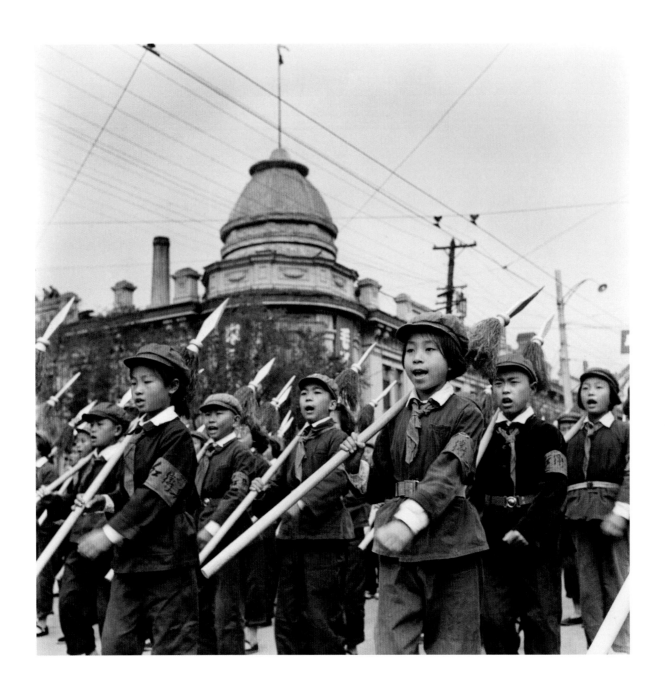

Li Zhensheng,
'On National Day, schoolchildren carrying red-tasselled spears and wearing Red Guard armbands parade
through the streets past a Russian-style department store' (Harbin, 1966), *Red-Colour News Soldier*, p. 125.

Jiang Shaowu,
Red Guard Celebrating National Day, Shenyang, Liaoning province, 1966.

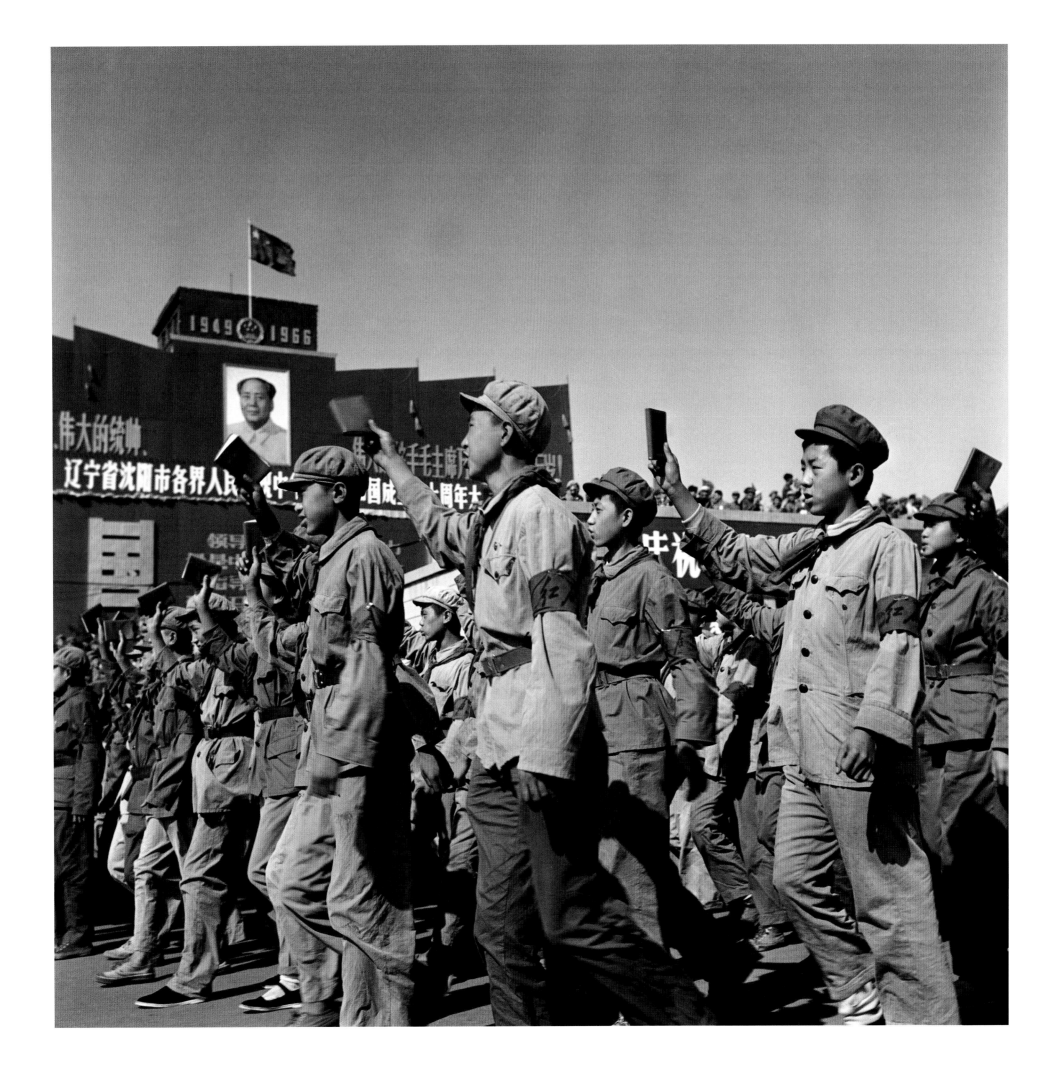

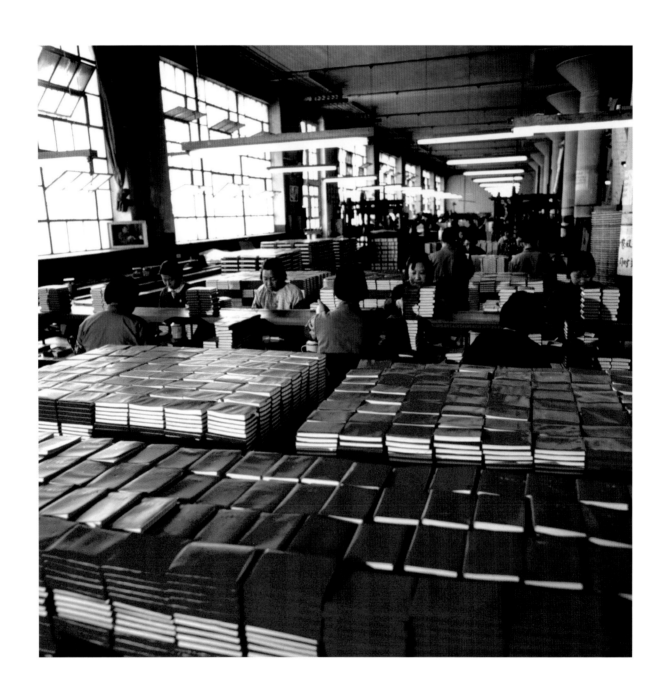

Anonymous photograph,
'The proletarian revolutionaries and the mass in the capital city determined to build Beijing as the red school of Mao Zedong Thought, while *Mao Zedong's Quotations* were being printed at Xinhua Press to suit the revolutionary needs' (Beijing, 1966), *China Pictorial*, Vol. 229, July 1967.

Weng Naiqiang,
Tibetan Children Studying Chairman Mao's Quotations, Zhongdian, 1968.

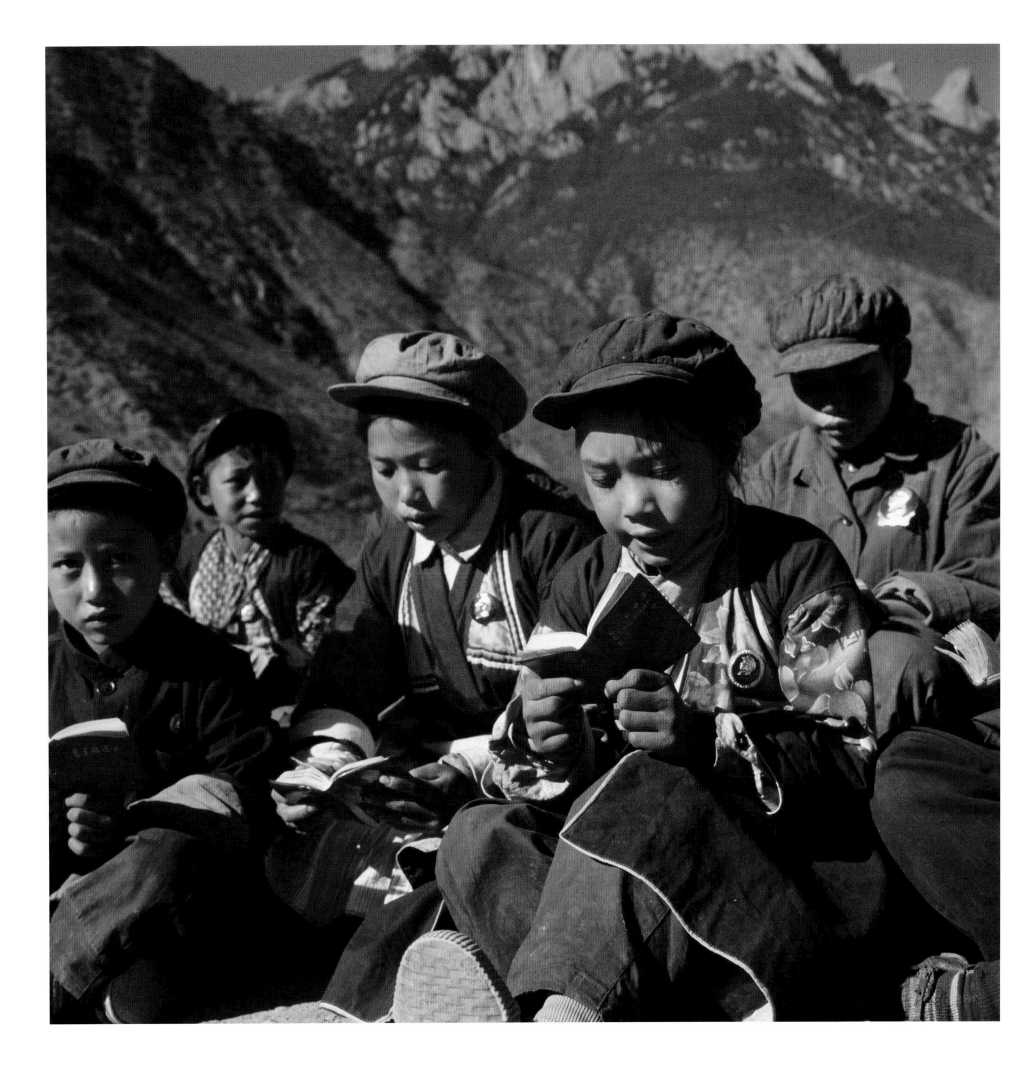

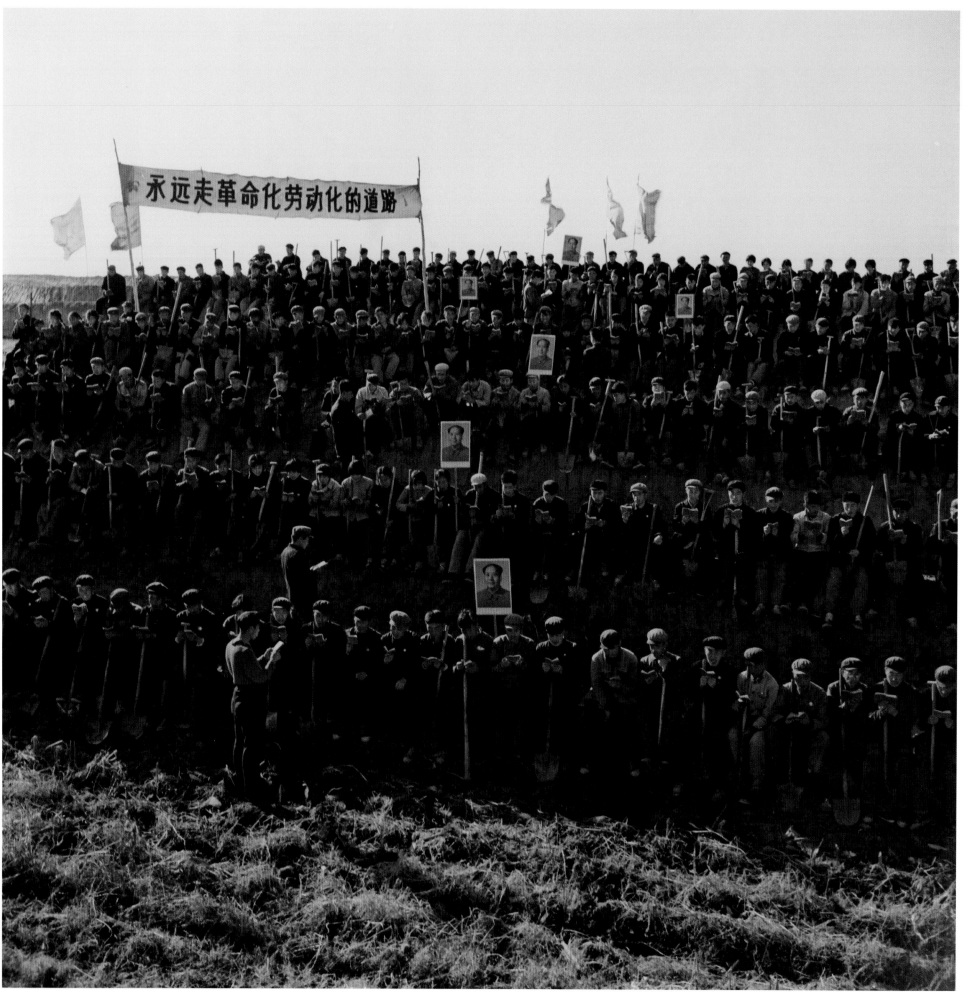

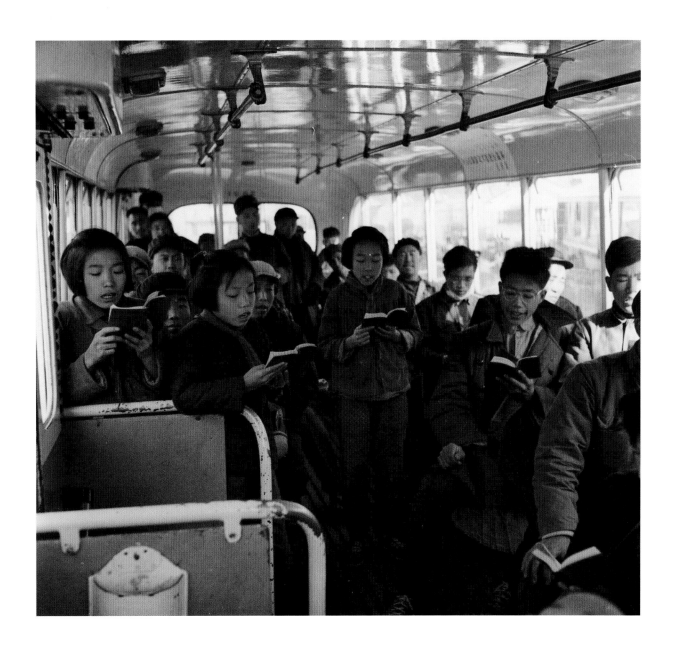

Anonymous photograph,
Cadres Sent to be Re-educated by Poor-and-Lower-Middle-Peasants, Dongfeng, Jilin province, 1968,
provided by China Photo Service.

Anonymous photograph,
Children Reading Mao's Quotations on a Bus, Beijing, 1967, provided by China Photo Service.

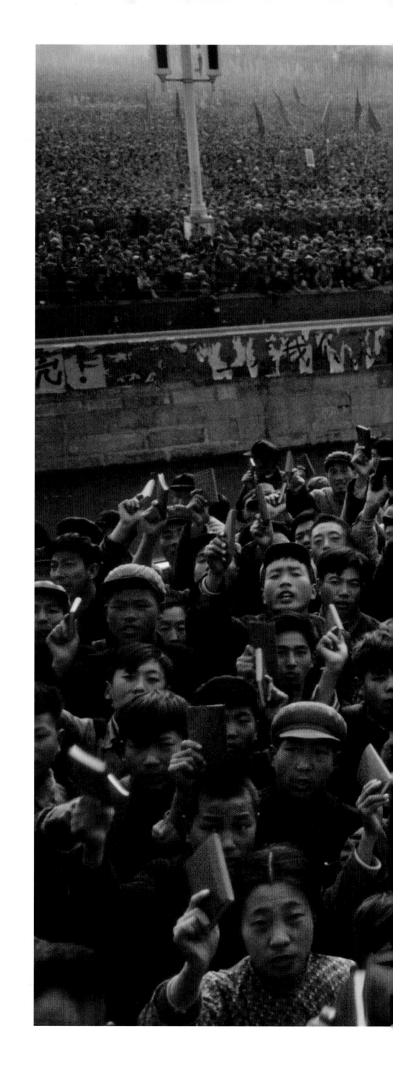

Weng Naiqiang,
Red Guards on the Platform of Tiananmen Square, Beijing, 1966.

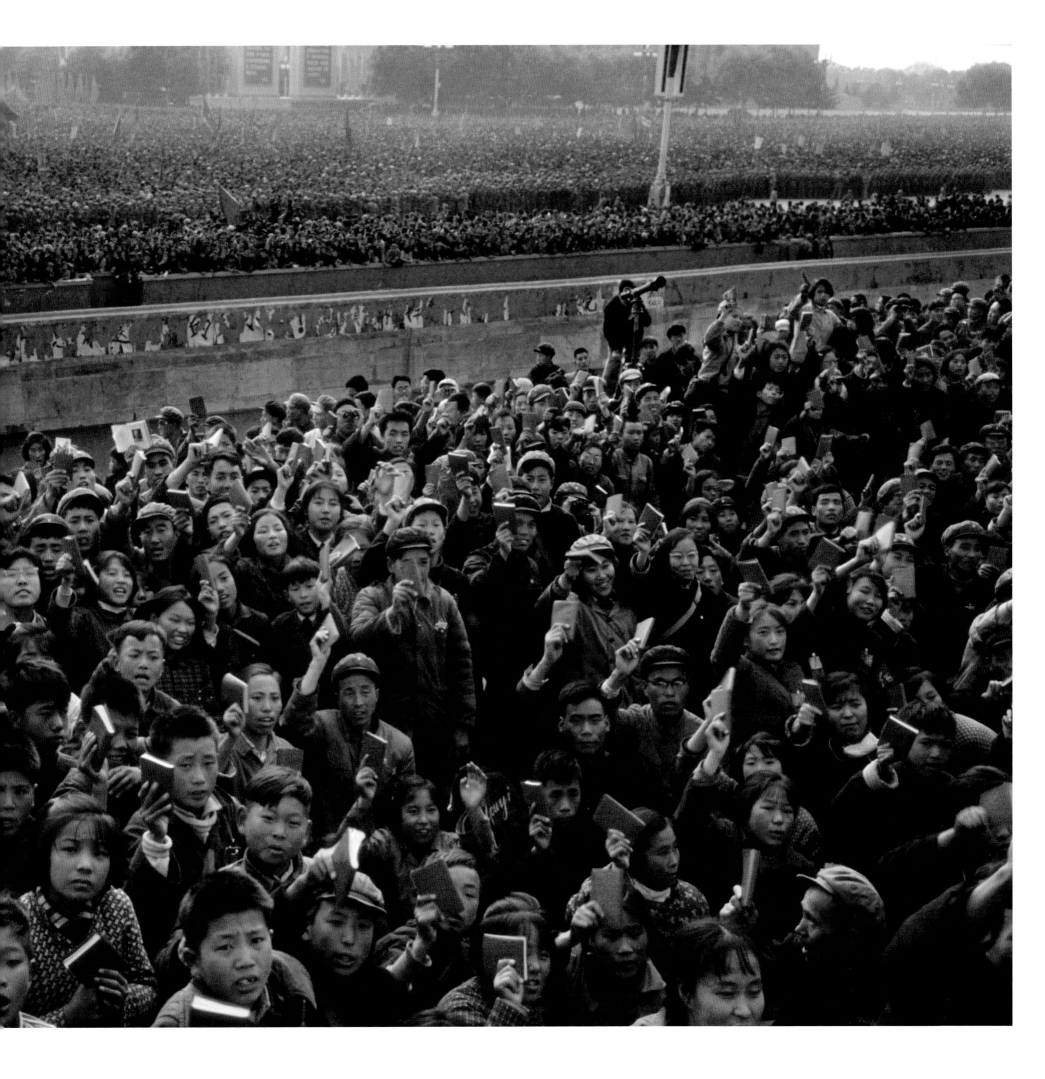

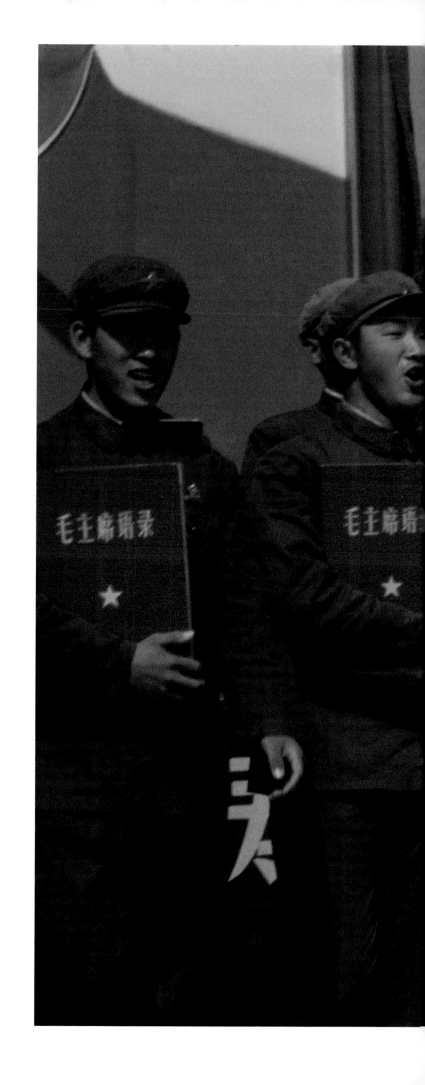

Weng Naiqiang,
Parade at Tiananmen Square on National Day, Beijing, 1966.

Weng Naiqiang,
Propagandising Mao's Thought on the Train, 1966.

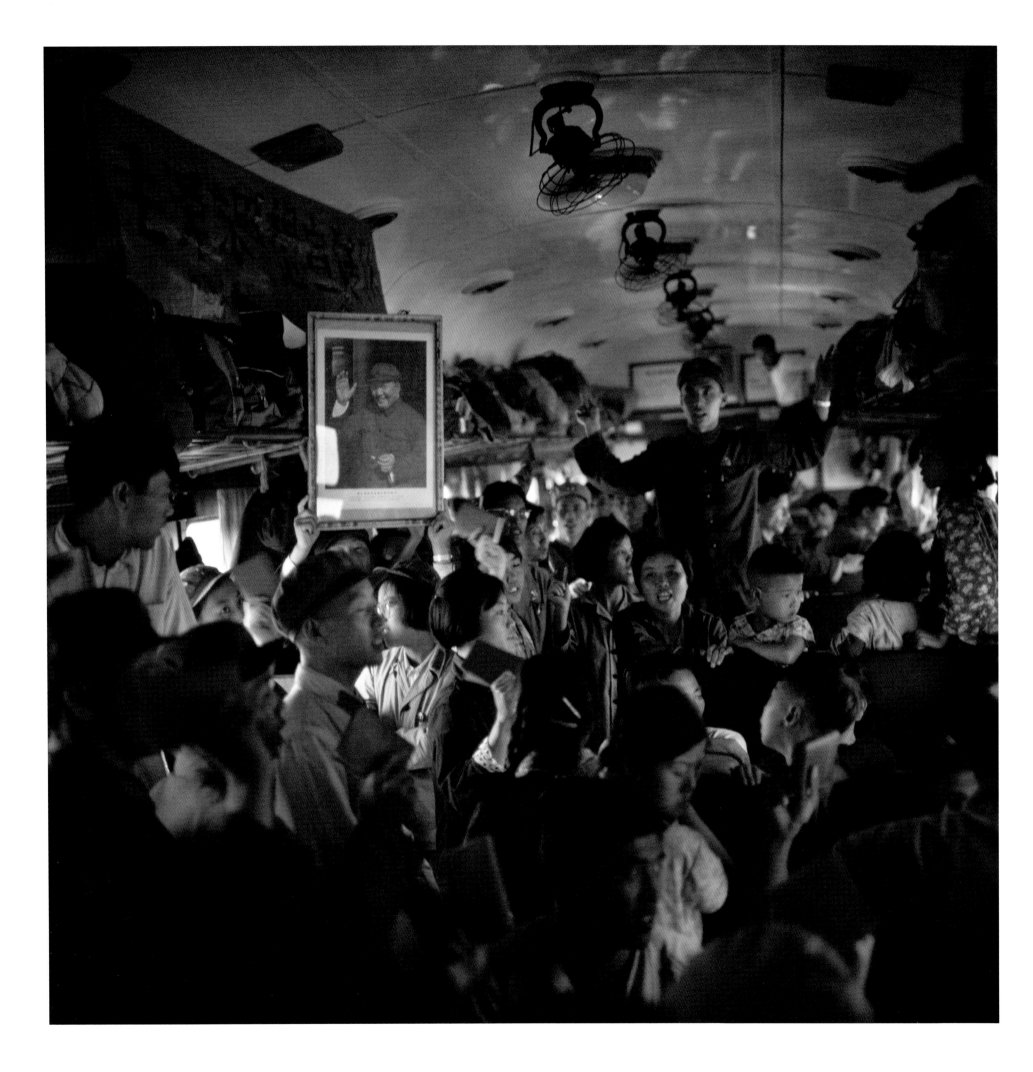

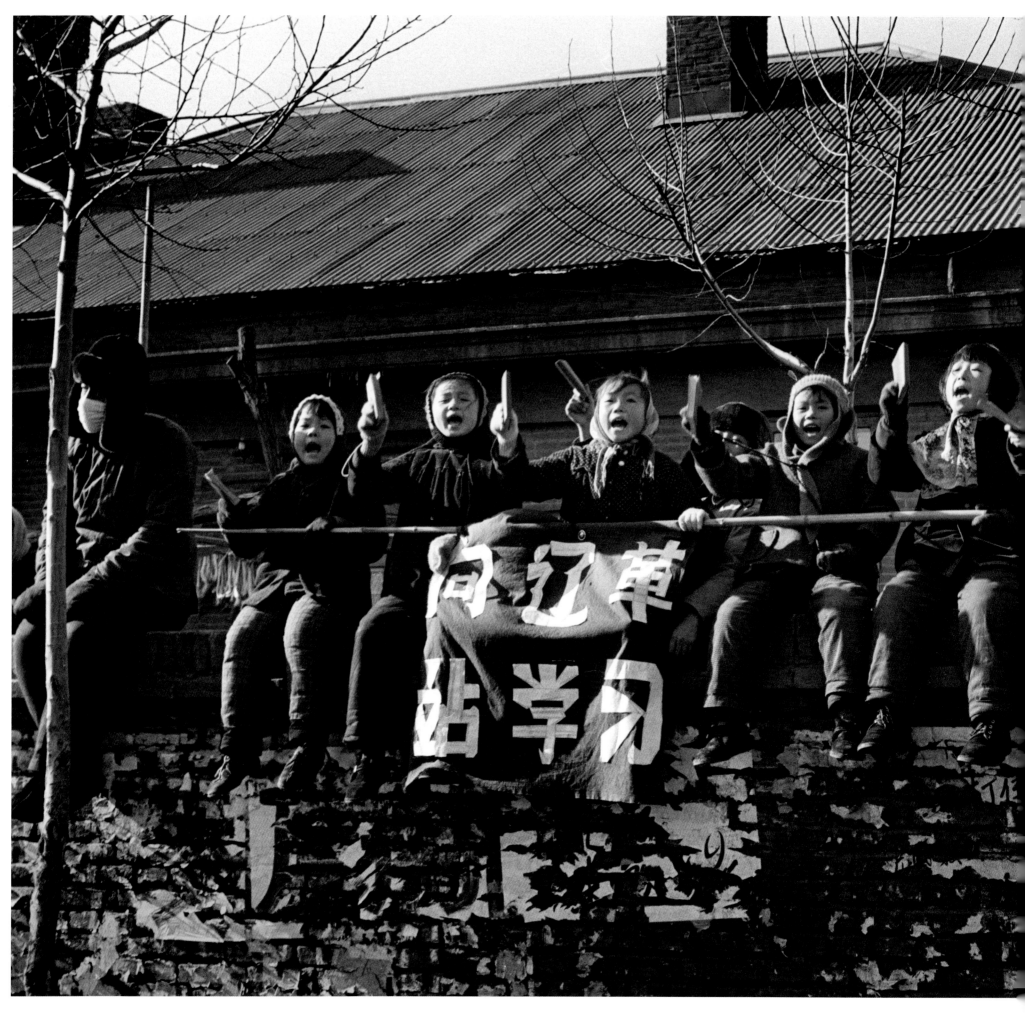

Jiang Shaowu,
The Little Red Guards' Demonstration, Shenyang, Liaoning province, 1967.

Weng Naiqiang,
Urban Youths' Morning Report (to Mao) in the Great Northern Wildness, Heilongjiang province, 1968.

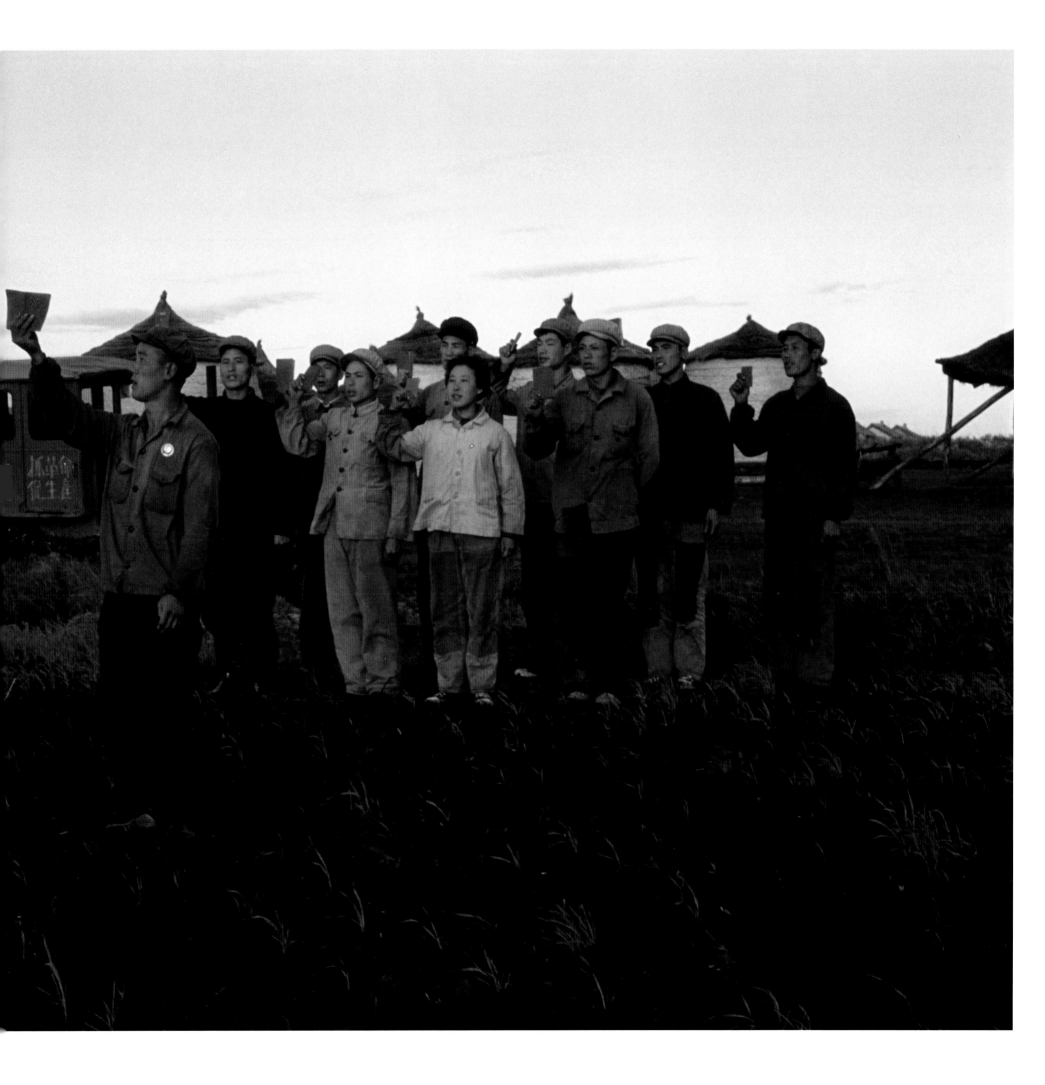

竹藝邦

THE RED ART

The visual productions of the Cultural Revolution do not constitute art in any conventional manner, but they represent what was produced outside the art academies and studios – the works of the masses. These creations were seen simply as political instruments of no aesthetic importance. As a result, the period has been largely excluded by authorities on Chinese art history. In the *Chinese Art Almanac*, no art exhibitions are recorded from 1967 to 1971, and the omission of the year 1967 suggests an absolute halt to Chinese art history.[70]

In reality, however, that particular year does not represent an artistic void, but rather the climax of the red-art movement. Numerous works appeared in the frequent local and national Red Guard art exhibitions that year (pp. 166–7), including *Smash the Liu-Deng Reactionary Line Caricatures Exhibition* at the Beijing Observatory in February, organised by Red Guard groups from over twenty Beijing institutions of higher education. The *Long Live the Victory of Mao Zedong Thoughts Revolutionary Painting Exhibition* and the *Long Live the Victory of the Great Proletarian Cultural Revolution Touring Art Exhibition* opened in Tiananmen Square in May, to commemorate respectively the first anniversary of the Cultural Revolution and the twenty-fifth anniversary of Mao's *Talks at the Yan'an Forum on Literature and Art*. In October, the nationwide touring exhibition, the *Long Live the Victory of Chairman Mao's Revolutionary Line Art Exhibition* which featured over 1,600 works, was opened at the China National Art Museum, to celebrate the eighteenth anniversary of the founding of the People's Republic.[71] An official review of the exhibition stated,

These revolutionary artworks were created by the workers, peasants and soldiers, Red Guards and revolutionary artists holding high the great red banner of Mao Zedong's Thought and following closely Chairman Mao's great strategy during the Great Proletarian Cultural Revolution. It was created during the life-and-death battle against China's Khrushchev and his fellow leaders who take the capitalist road. The artworks were not only from Beijing, the centre of the Cultural Revolution, but also Shanghai, Guizhou, Qingdao, Wuhan, and from the corps, villages, mines and schools, all parts of the country. More than 70 percent of the exhibits were created by the workers, peasants and soldiers [amateur artists], and reflect their lives during the struggle.[72]

However, is the red art 'art'? The aesthetic values of the red art have been considered to be poor. The visual products from the masses are not easily described within a traditional narrative of art history, given their more complicated relationship with social and political events.

There are exceptions to the enthusiastic amateur artists, such as Liu Chunhua's *Chairman Mao Goes to An'yuan* (p. 71), and Shen Yaoyi's woodcut prints of Mao (pp. 74–5). However, most of the Red Guard artists remain anonymously as part of 'the mass' in depicting the fervour of the Cultural Revolution centred on the image of Mao (pp. 168–71). One of their most significant works was the clay sculpture, *Ode to the Red Guards (Hong weibing zan)*, depicting the Red Guards destroying the 'Four Olds' and replacing them with the 'Four News' (pp. 172–5). This large-scale work, with possibly

Continued on page 176

The Red Guard Congress of Capital City Higher Education Institutions and Middle Schools, *Revolutionary Rebel Exhibition by the Capital City Red Guards*, front cover of the catalogue, 1967, personal collection of Wang Mingxian.

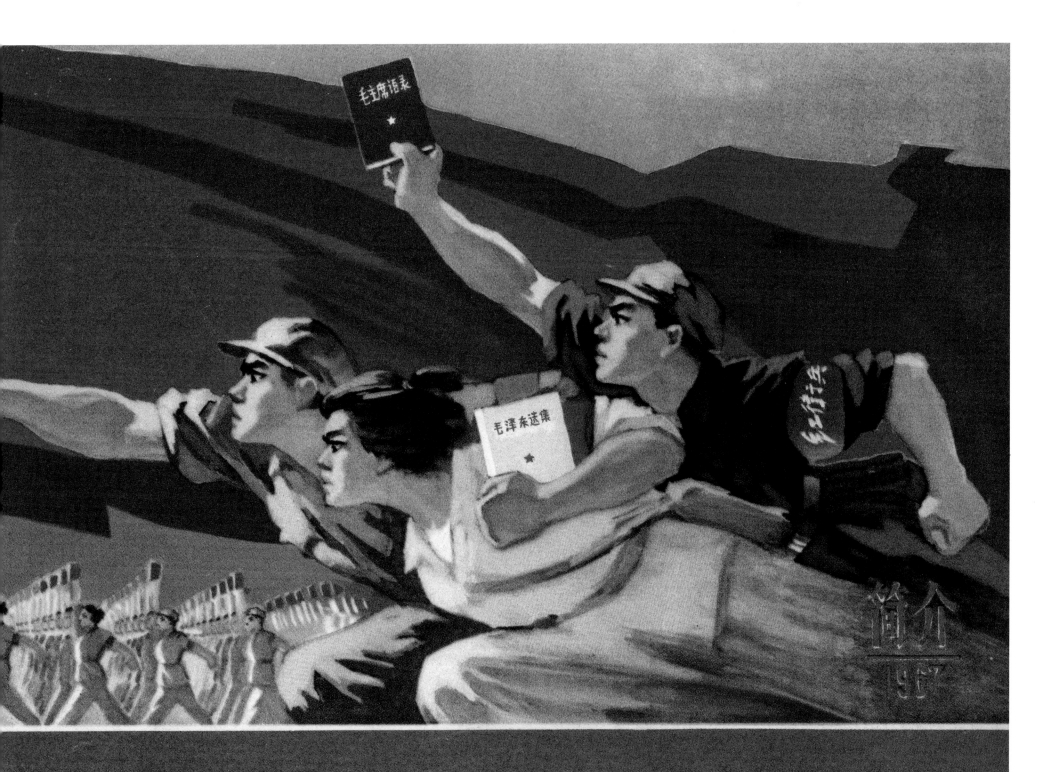

兵革命造反展览会

首都大专院校红代会　首都中等学校红代会　主办

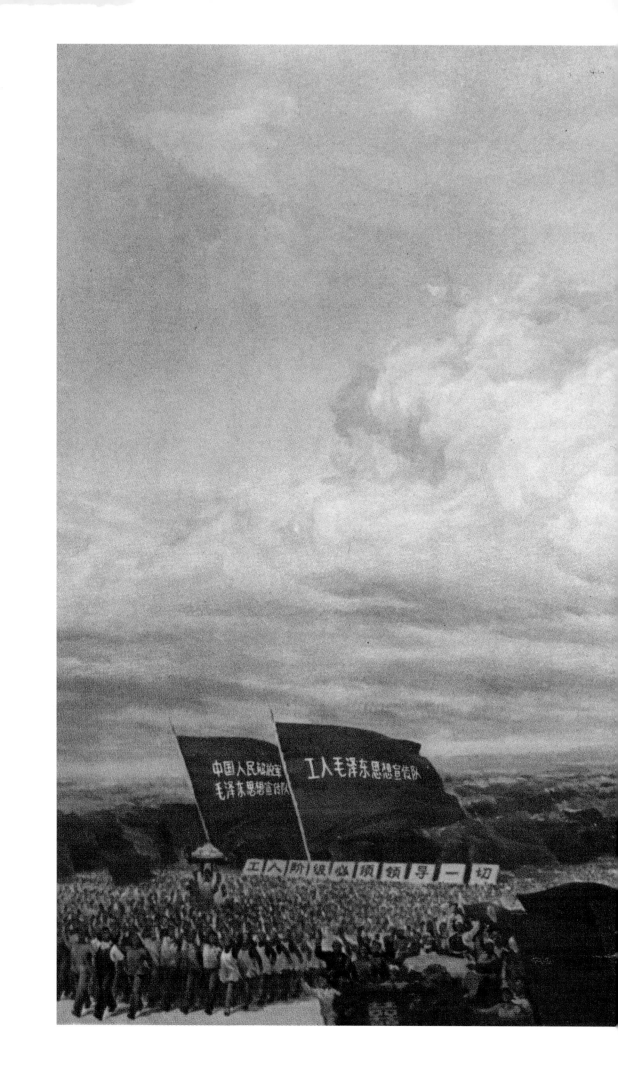

Anonymous,
Following the Great Leader Chairman Mao to Move Forward Vigorously,
print reproduction of oil painting, 1969, personal collection of Wang Mingxian.

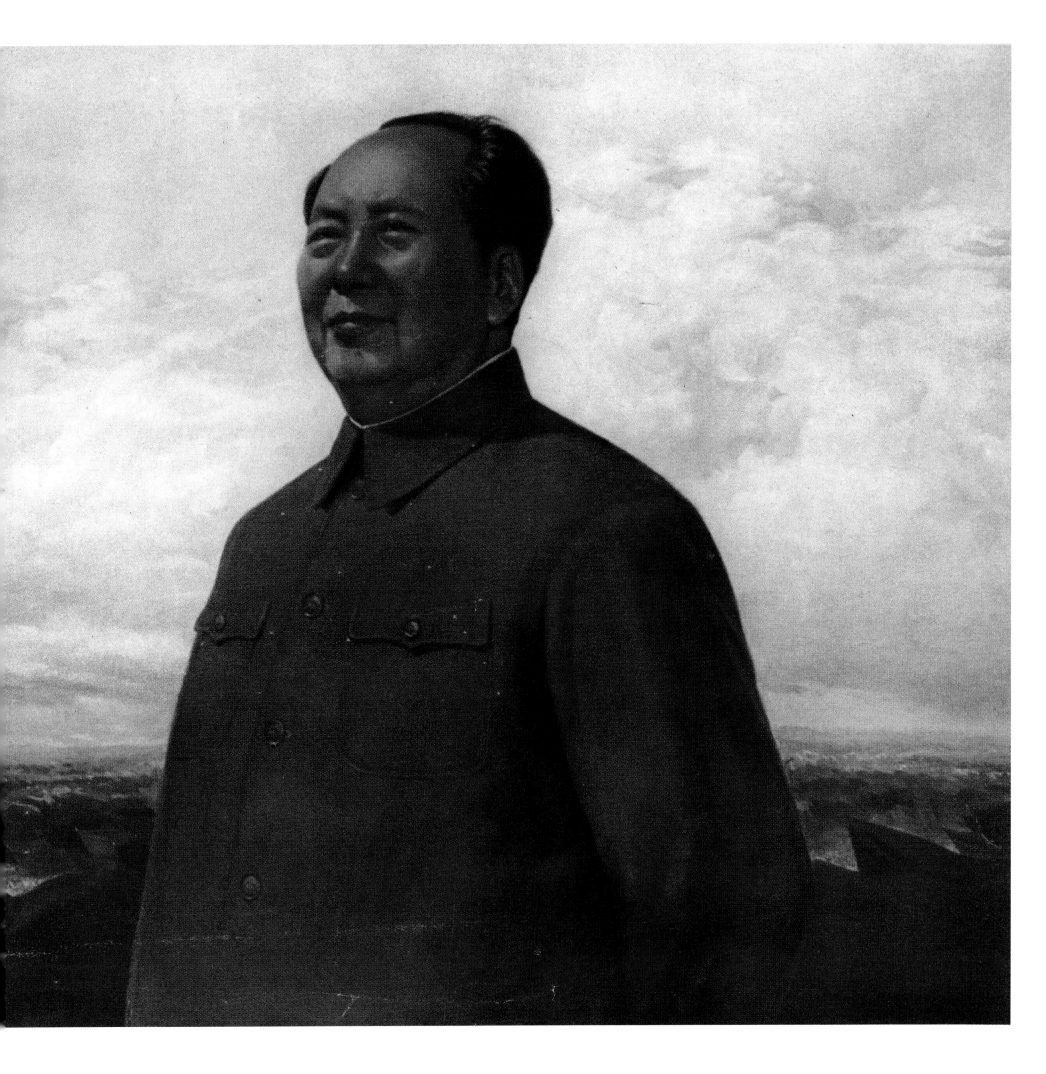

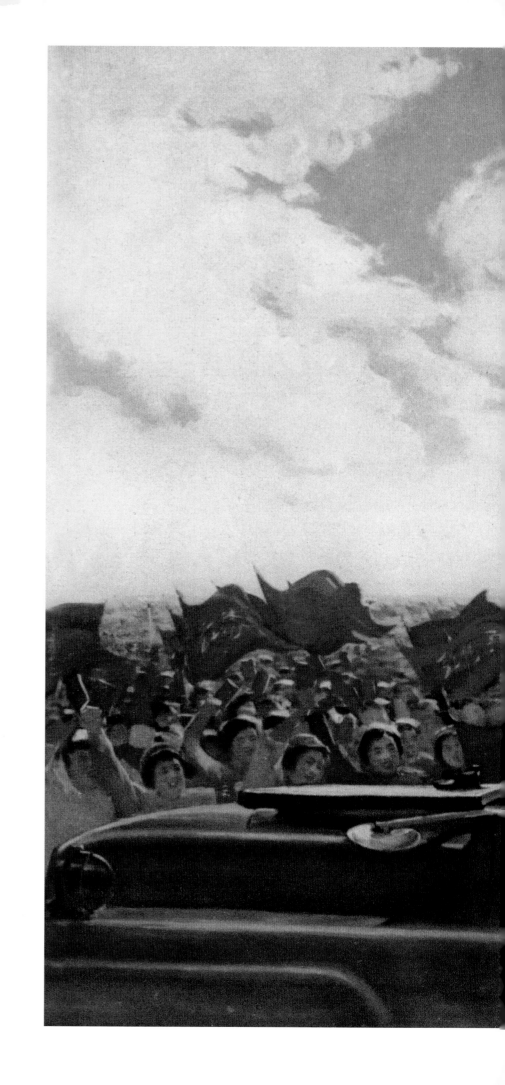

Anonymous,
Untitled, print reproduction of oil painting, 1967, personal collection of Wang Mingxian.

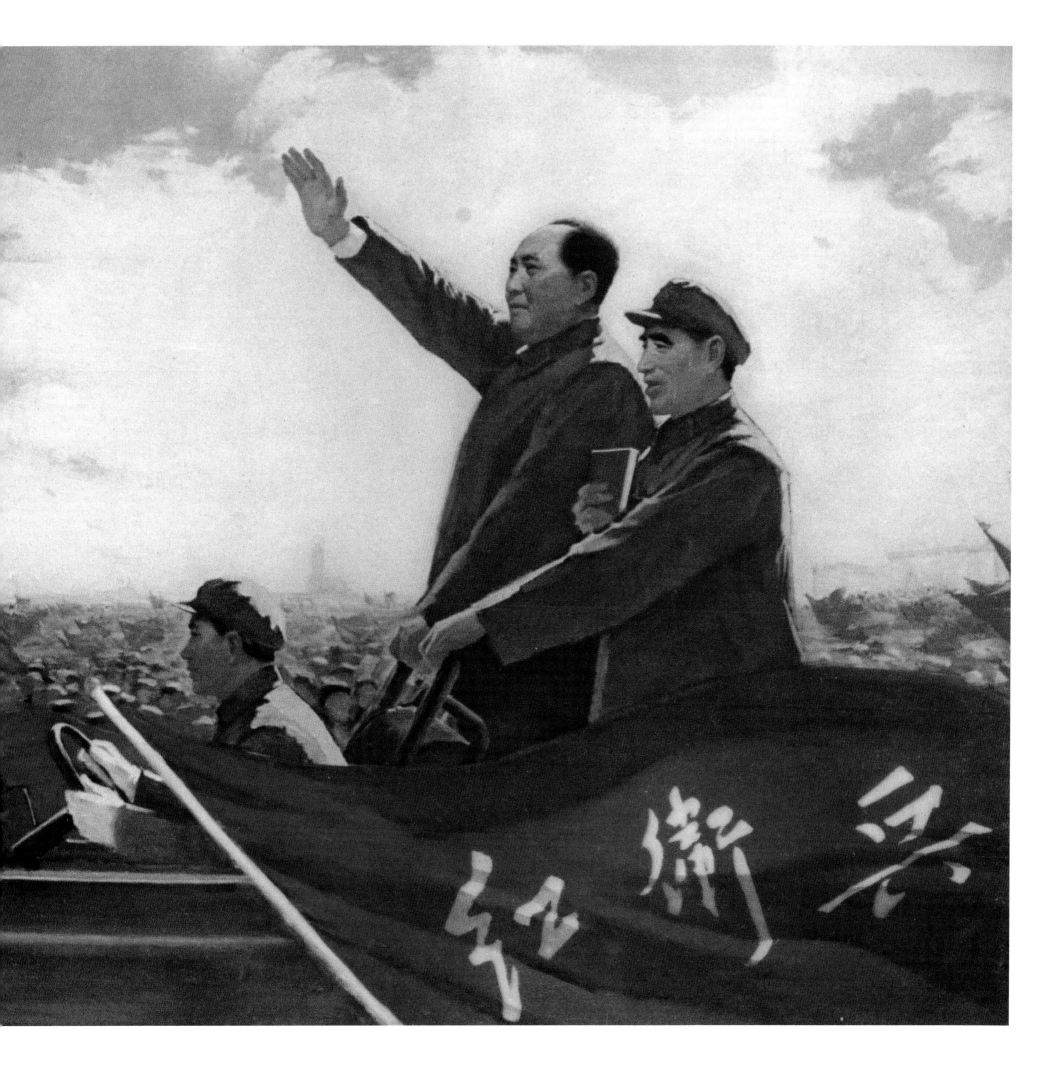

Anonymous photograph,
Ode to Red Guards (detail), fibre-glass, 1967, collected by Wang Mingxian.

Anonymous photograph,
Ode to Red Guards (detail), fibre-glass, 1967, collected by Wang Mingxian.

Li Zhensheng,
'Red Guards at Harbin's University of Industry paint Mao's portrait and write big-character posters'
(Harbin, 1967), *Red-Colour News Soldier*.

one hundred or so life-size figures,[73] is a collaborative work by People's Liberation Army soldiers, Red Guards and revolutionary professional sculptors. It was completed in only twenty days in 1967, and was then acclaimed as 'being unprecedented in the world history of sculpture'.[74] The red art crossed a variety of media, from folk art, such as New Year pictures and paper cut-outs, to institutional art; from portrait posters to giant billboard paintings; from Mao badges to spectacular large sculptures and statues; and from model operas to Red Guard street performances.

The posters from the Cultural Revolution focus mainly on adulation for the iconic Chairman. Some carry general messages of proletarian solidarity and collective unity, or address the interests of specific campaigns.[75] During the Red Guard Movement (1966–8), the conventions of the 1930s leftist woodcut movement were applied to poster prints. This style enabled amateur artists to become involved in the mass art practice. The woodcuts were seen everywhere – in prints, posters, publications and on public billboards. Mao's woodcut-like image with his words was even printed in red on matchboxes.[76] Everyone learned some basic techniques for visual propaganda, and the works were usually produced under the name of a collective, to eliminate personalities.

Professional works, such as Shen's woodcuts (pp. 74–5), were appropriated and presented in re-edited versions on wall paintings and in publications. Numerous Red Guard art newspapers and pictorials appeared in 1967 in response to the Red Guard art exhibitions. These included *Art War Bulletin (Meishu zhanbao)* and *Art Tempest (Meishu fenglei)*, produced by a group of organisations of the Central Academy of Fine Arts, *Crimson*

Flooding into the River (Manjiang hong) from the Central Academy of Arts and Crafts, *Red Artist Soldiers (Hong huabing)* from the Tianjin People's Publishing House (pp. 178–9), and many more local and non-professional Red Guard art publications.[77] Catalogues of *Baotou tu'an (Headline Images)* were published to introduce a variety of model images for public propaganda (p. 177, 181). For billboard paintings on a larger scale, the images would be either carefully copied directly using a grid on the wall space, or painted in sections, piece by piece, then assembled. Yü Youhan, a former student of the Central Academy of Arts and Crafts, together with his fellow students created a huge portrait of Mao and Lin Biao from more than sixty sheets of A0-size paper. It took them a day to mount it on the wall facing the Tiananmen Tower.[78] For those lacking artistic skills, a cut-out lead sheet of Mao's profile could be easily used to stamp the walls with the Chairman's head.[79]

Red Guards portrayed as 'little revolutionary generals' and the images of the worker-peasant-soldier were also popular woodcut subjects (pp. 182–3). To meet the demand for propaganda, so-called 'fake woodcuts' were painted with red colour and black ink in woodcut style, sometimes with white paints outlining the appearance of a knife-cut (pp. 185–7).[80] A former student remembers a huge wall painting, titled *Have You Confessed Today?*, which he used to pass on his way home from school. The Red Guards' eyes were full of fury and their fists were enormous. People were always scared into daily self-examination of their loyalty to Mao.[81] The exaggerated arms and fists expressed the revolutionary strength and confidence needed to defeat any counter-revolutionary. Those handmade posters were on a scale comparable to contemporary advertising hoardings (pp. 188–9).

Continued on page 184

掀起革命大批判

毛泽东思想宣传栏
第六期

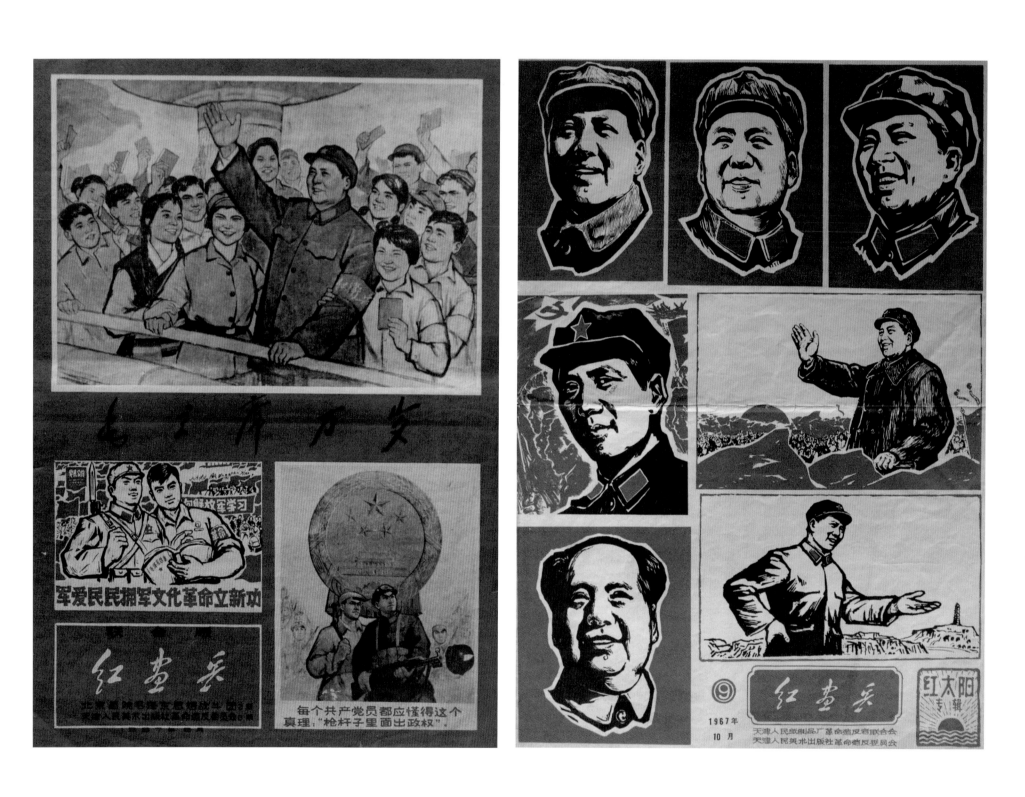

Red Artist Soldiers,
Red Guard newspaper, 1967, personal collection of Wang Mingxian.

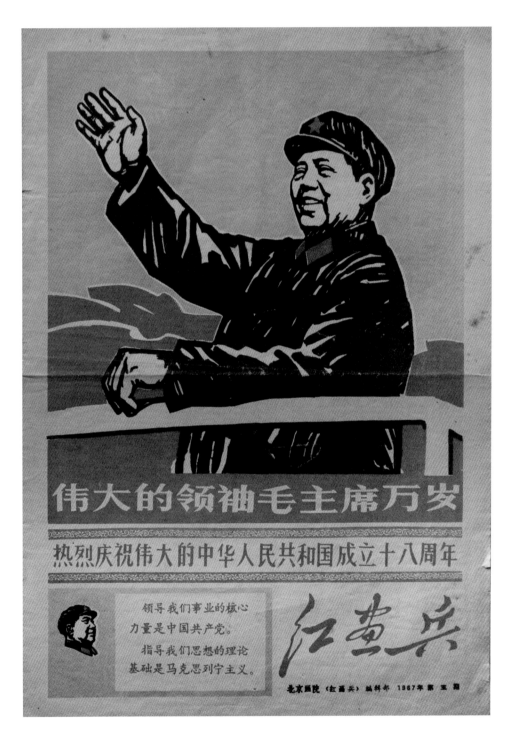

伟大的领袖毛主席万岁

热烈庆祝伟大的中华人民共和国成立十八周年

领导我们事业的核心
力量是中国共产党。
指导我们思想的理论
基础是马克思列宁主义。

红画兵

北京画院《红画兵》编辑部 1967年第五期

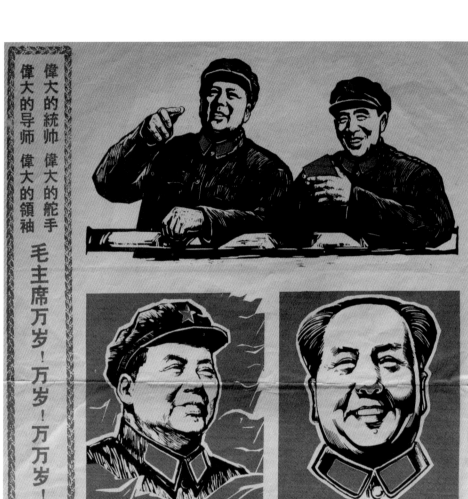

伟大的统帅 伟大的舵手
伟大的导师 伟大的领袖
毛主席万岁！万岁！万万岁！

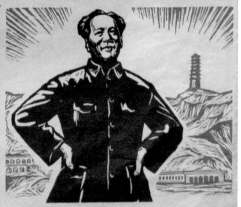

Selected examples in the catalogues of *Headline Images (Baotou tu'an)*, c. 1970, personal collection of the author.

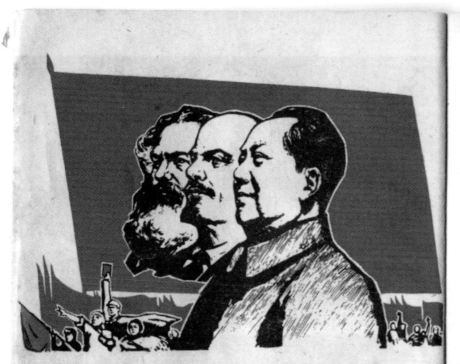

战无不胜的马克思主义、列宁主义、毛泽东思想万岁!

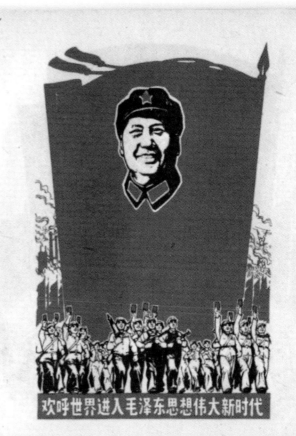

欢呼世界进入毛泽东思想伟大新时代

Weng Naiqiang,
Billboard Painting on Chang'an Boulevard, Beijing, 1966.

Weng Naiqiang,
Anti-Revisionism Meeting at the Workers' Stadium, Beijing, 1966.

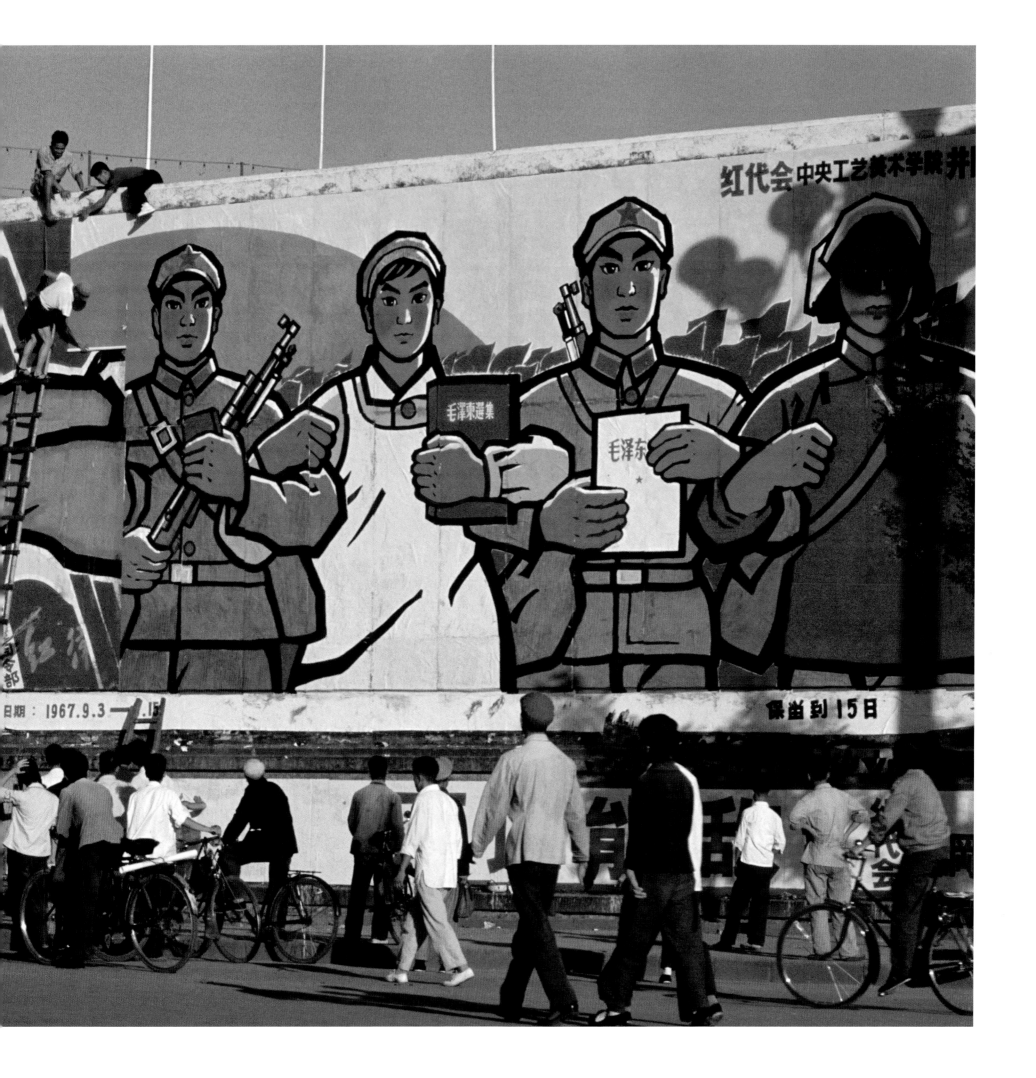

Though the big-character poster was a common medium in Mao's era, it reached its peak in the Cultural Revolution. Some consisted of no more than a few sentences, others contained massive treatises with thousands of characters. The posters declared campaigns, offered criticism of factions and denounced individuals. When this 'mass voice' was fully endorsed by Mao, chaos followed. At Tsinghua University alone, 65,000 posters appeared on the Beijing campus in June 1966. In the propaganda sector of Shanghai, 88,000 big-character posters attacking 1,390 persons by name had appeared by June 15.[82] They covered all possible surfaces. This daily flood of written language created an overwhelming new landscape (pp. 190–7).

Writing became an instrument of visual violence as well as political message. A saying of the time gave instructions to 'use your pen as your weapon and shoot down reactionary gangs'. Calligraphy could be considered the most representative indigenous mass art form in China. Everybody was educated in handwriting as part of the general curriculum, yet the Cultural Revolution launched new calligraphic developments.[83] Both the bold-face (heiti) and weibei style, which originated with tablet inscriptions from the Northern Wei dynasty (386–535), were considered appropriate to deliver the visual force required for the big-character posters. Both the posters and leaflets made of tightly written small characters could all be as carefully and neatly produced as professionally printed words. Even the largest slogan posters were perfect at the first inscription. Each character looked standardised and powerful.[84] The posters and slogans then spread across all available public wall space, onto temporarily purpose-built boards and, simply and rather creatively, they were even written in the fields or on the ground (pp. 198–201). They appeared on children's toys. A set of so-called East-Is-Red blocks could be assembled into little revolutionary arches or, indeed, into a miniature world of big-characters (pp. 202-3).

The woodcut images, big-character slogans and posters offered a prevalent colour complex comprised of red, black and white. Red coloured the mainstream movement for revolutionary excitement. Black and white posters aimed to eliminate the remaining counter-revolutionary elements or – as Mao's reminded – the dark side of the red revolution. In reality, black and white may even have been dominant.

> Huge amounts of big-character posters covered all walls, doors, boards and the other available spaces completely. Literarily containing mass criticisms, official news as well as rumours, big-character posters became the main materials for daily reading. Their black and white colours looked bitterly cold to my heart. While red, carried by all the slogans of Mao's words and directives, flowed on the surface of the red sea, the chilly colours underneath, black and white, represented the true feelings of the era.[85]

Another witness similarly records,

> The visual significance of red slogans was completely opposite to the big-character posters. They were more encouraging, generally political instructions and glad tidings, that didn't necessarily require literally reading, whilst the black and white posters usually

Continued on page 204

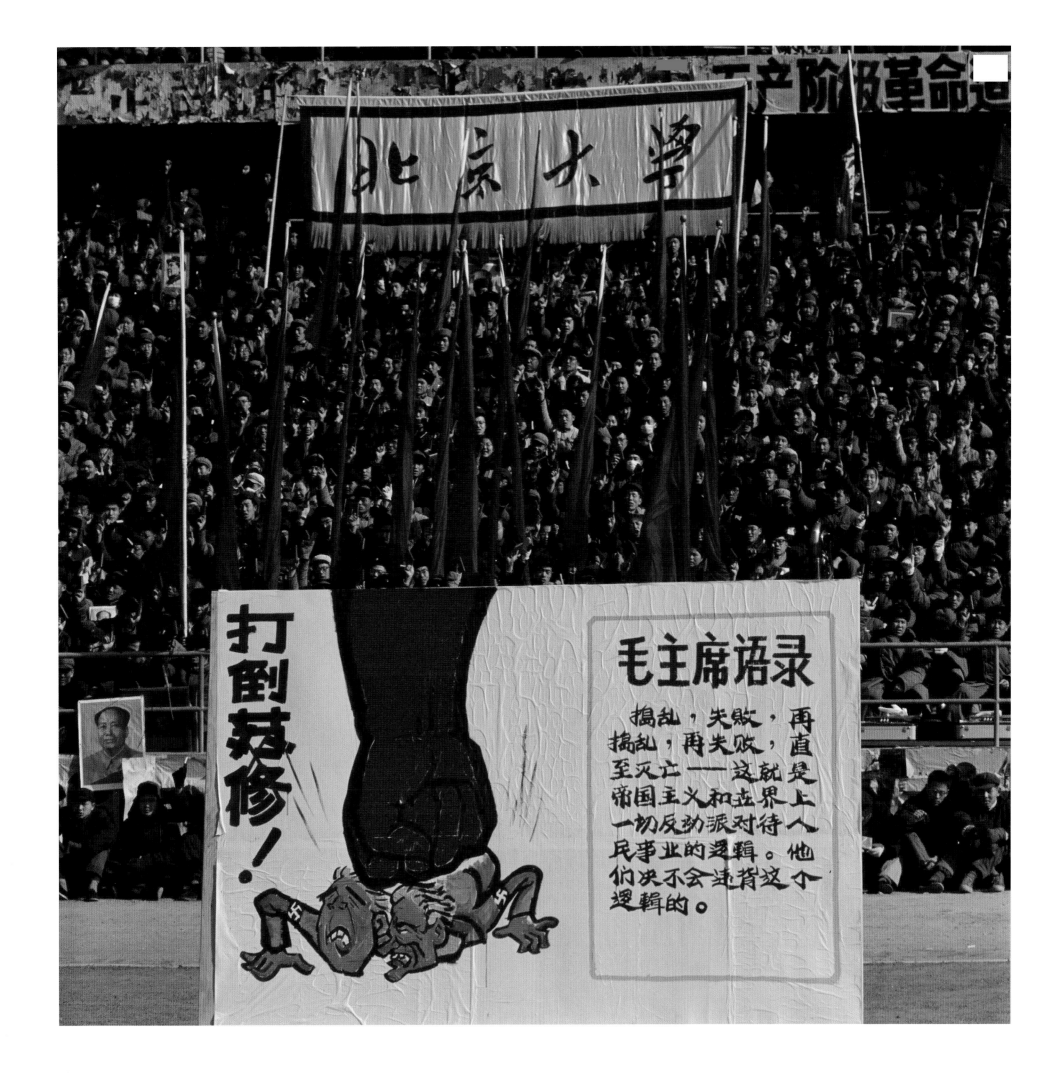

Chen Ke,
Great Criticism Meeting, Chengdu, Sichuan province, 1967.

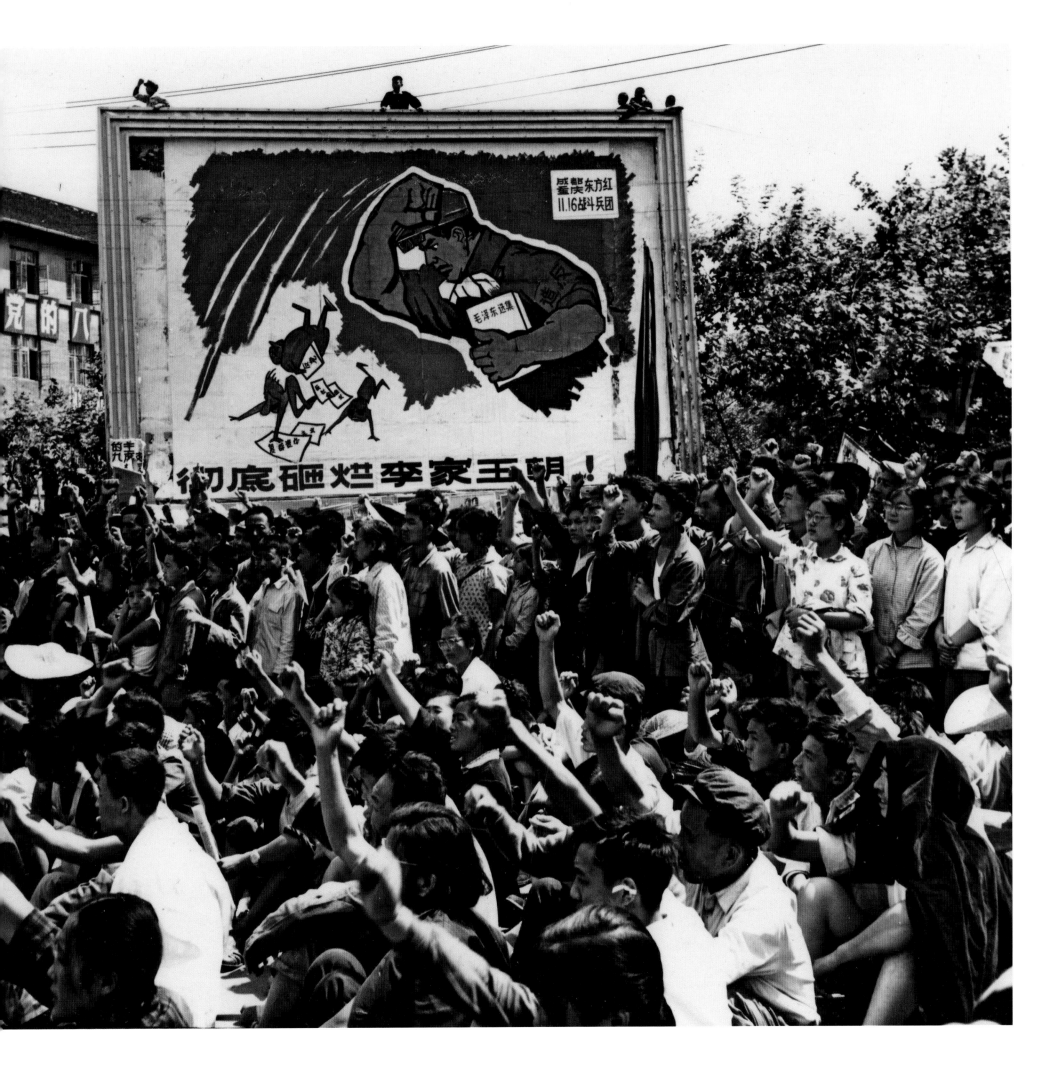

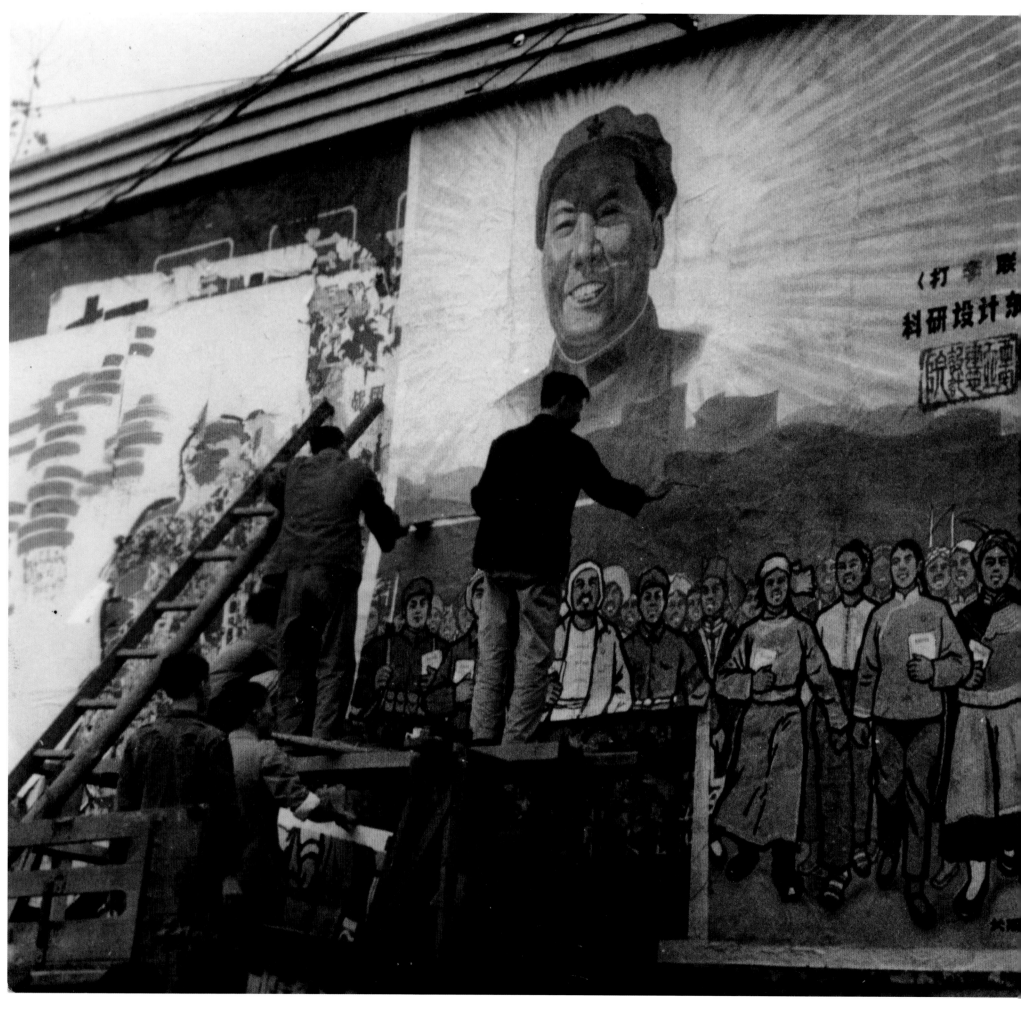

Chen Ke,
Street Billboard Painting, Chengdu, Sichuan province, 1967.

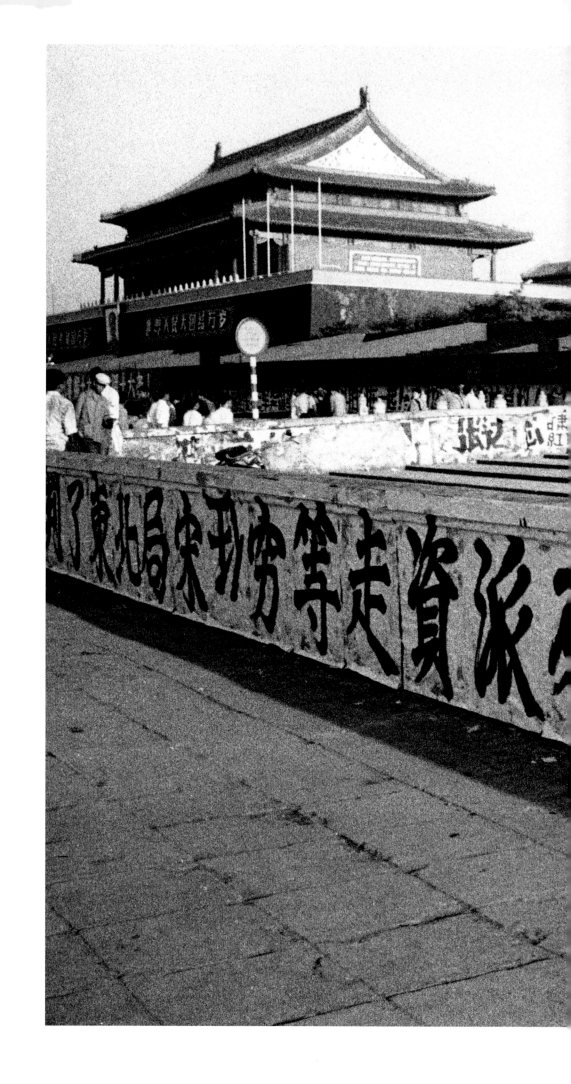

Jiang Shaowu,
Posters by Shenyang Red Guards in Tiananmen Square, Beijing, 1966.

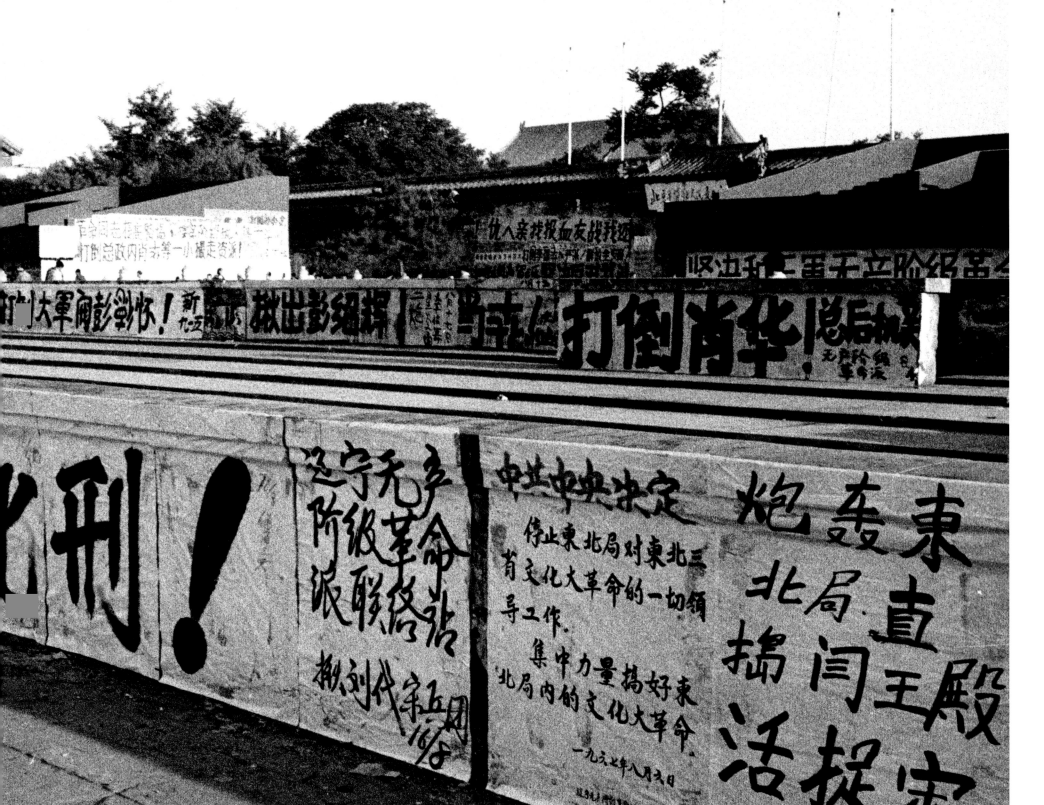

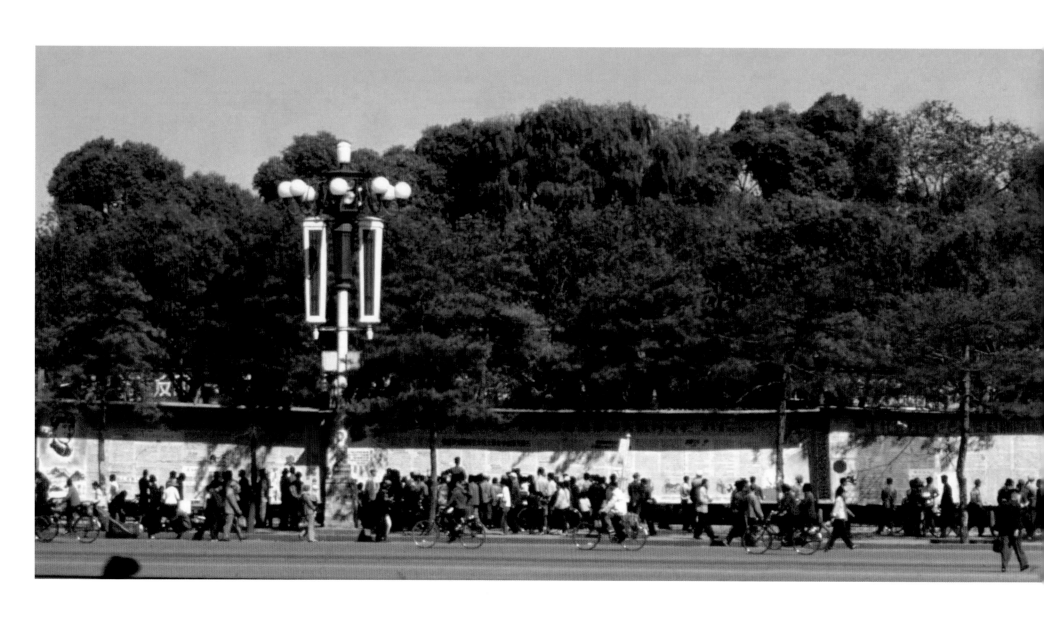

Anonymous photograph,
'The revolutionary great criticism billboards on a Beijing street' (Beijing, 1966), *China Pictorial*, Vol. 233, November 1967.

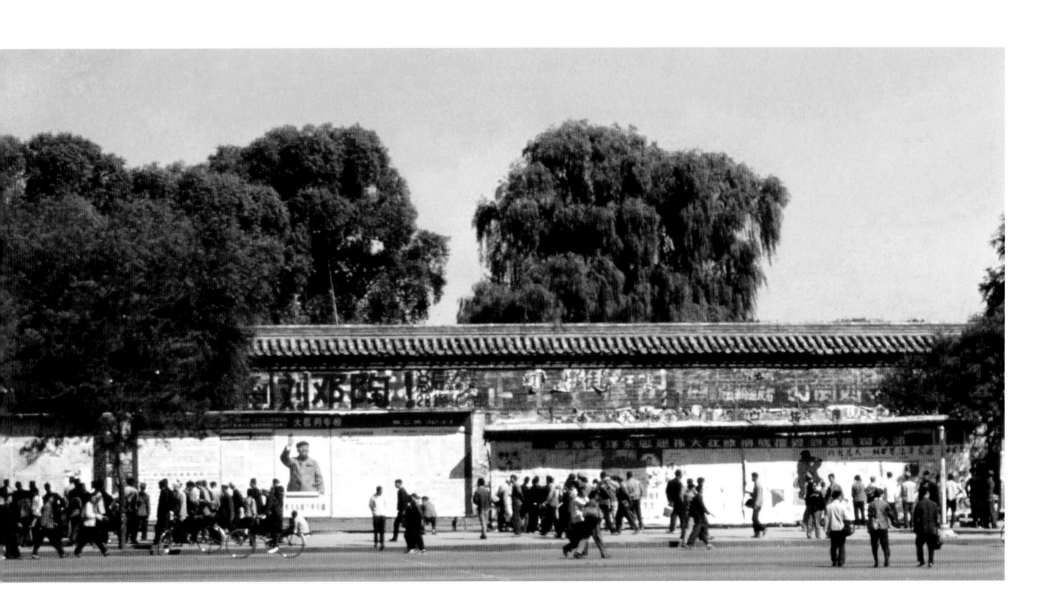

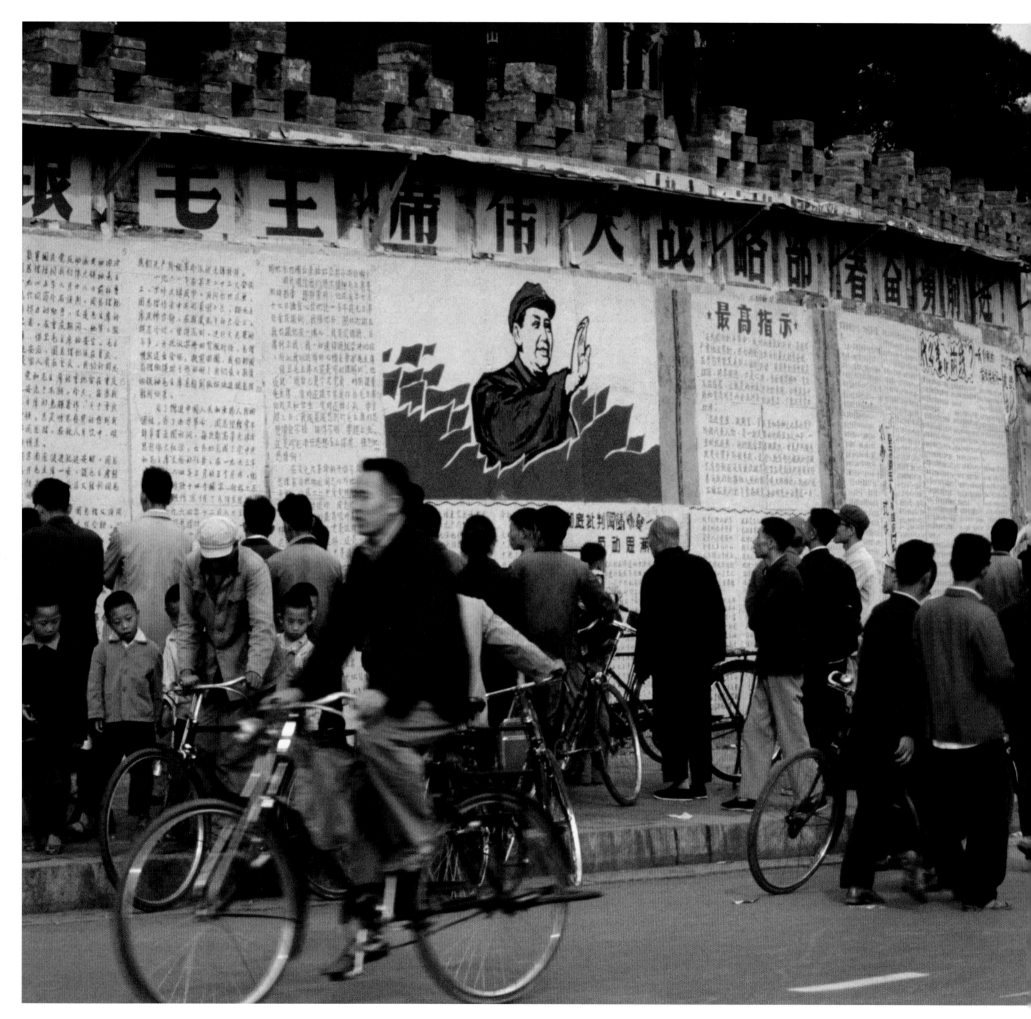

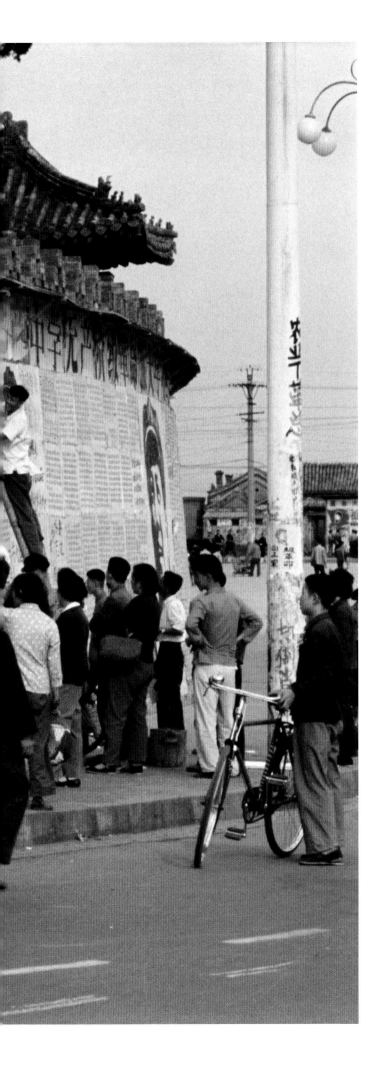

Weng Naiqiang,
Big-Character Posters at Beihaituan, Beijing, 1967.

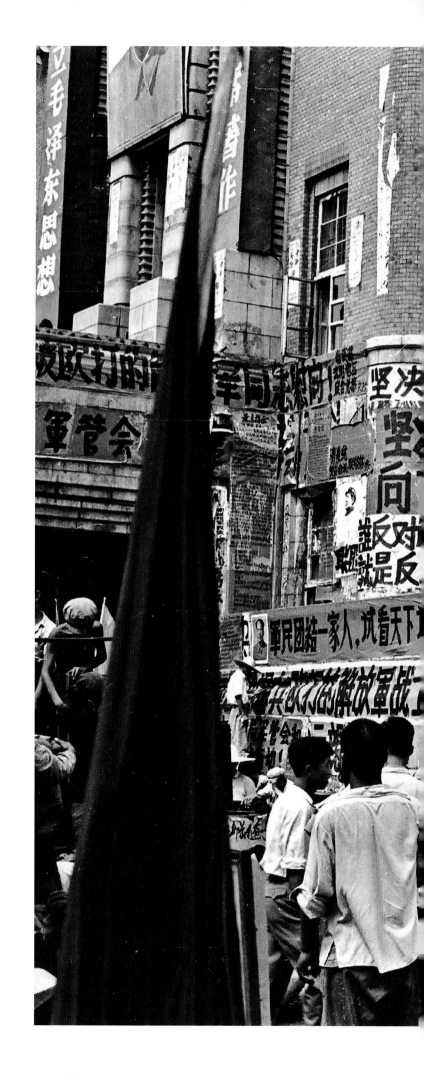

Jiang Shaowu,
Big-Character Posters in Red Flag Square, Shenyang, Liaoning province, 1967.

Wang Shilong,
Detail from *Political Slogans in the Farmland of Wangwu Commune*, Jiyuan, Henan province, 1966.

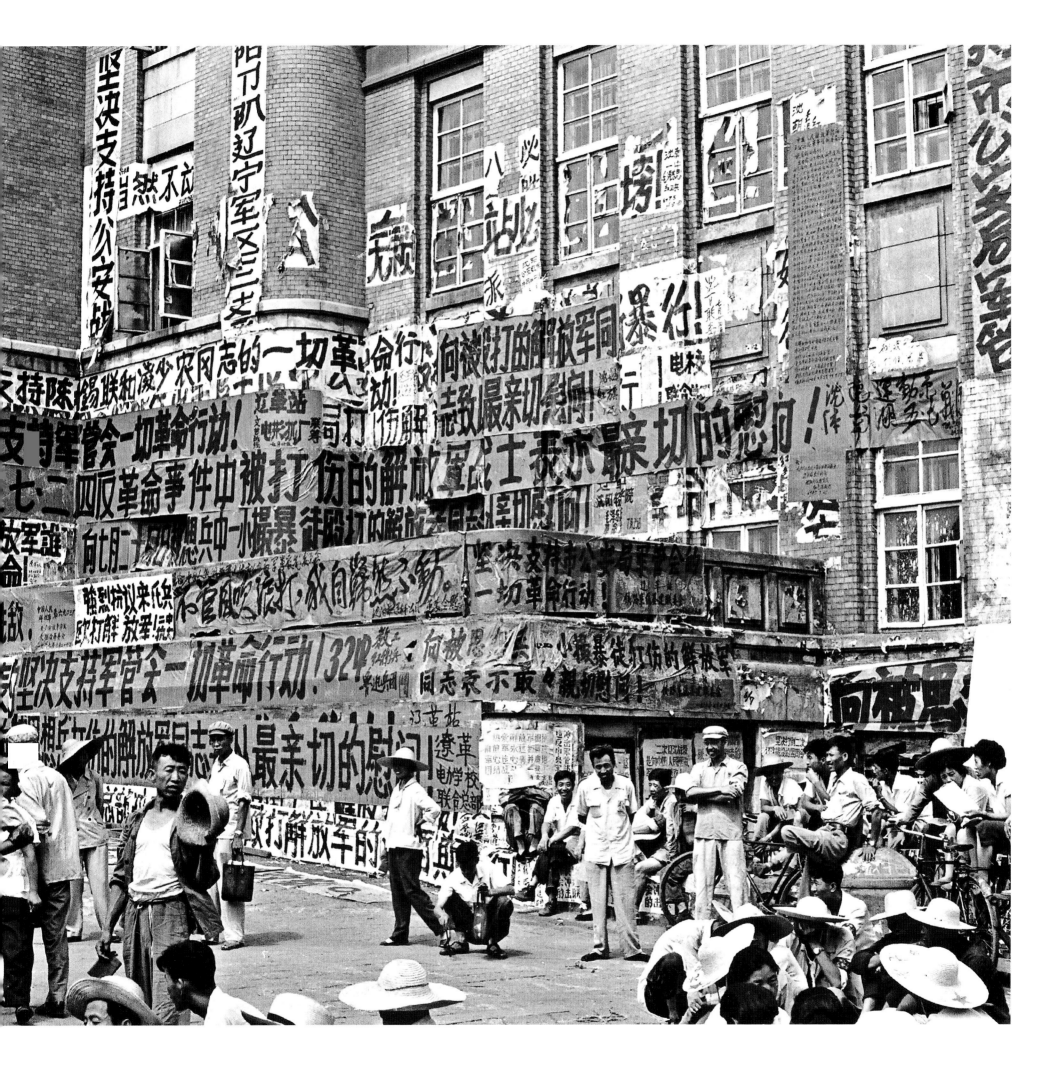

Jiang Shaowu,
Slogans in the Shenyang Municipal Square, Shenyang, Liaoning province, 1967.

Beijing No. 3 Toy Factory,
Specification of the *East-Is-Red* blocks, 1967, personal collection of Wang Mingxian.

Zhang Yaxin,
Opera *Red Lantern (Hongdeng ji)*, Beijing, 1974.

Zhang Yaxin,
Opera *Taking Tiger Mountain by Strategy (Zhi'qu weihu shan)*, Beijing, 1974.

Zhang Yaxin,
Opera *Sudden Attack on White Tiger Regiment (Qixi baihu tuan)*, Beijing, 1974.

Zhang Yaxin,
Opera *Shajiabang*, Beijing, 1974.

maintained serious contents exposing and criticising counter-revolutionaries or hidden enemies. As long as new big-character posters appeared, people would be immediately aware of the potential dangers that might have happened in their work units or local communities, and affected individual lives.[86]

There is a theory by Wang Yi that the intensity of people's religious fervour can be in direct proportion to their hostility to foreign nations, religions and cultures. During the Cultural Revolution, the more people loved Chairman Mao and his Revolution, the more, in theory, they would detest the counter-revolutionaries or bourgeoisie.[87] The balance between applauding 'ourselves' and cursing 'others' was then reflected in the increasing colour conflict between the ever-present red and black and white. Red represented the positive encouragement of people's revolutionary enthusiasm and provided a metaphorical mask for public view. The black and white big-character posters displayed the negative side – the uncertainty, hazard and terror of real life – in other words, the reverse side of the mask, which left people facing none other than themselves.

Seemingly, there was no distinction between artists and the masses in a highly conformist practice produced by an anonymous collective. In Mao's *Talks at Yan'an Forum on Literature and Art*, which in 1942 had laid down the principles for cultural policy of mass art, he summarised with the idea that the thoughts and feelings of artists should be fused with those of the masses as a 'top-down strategy'. To reinforce the importance of learning the language of the masses, Mao made this appeal,

China's revolutionary writers and artists, writers and artists of promise, must go among the masses; they must for a long period of time unreservedly and wholeheartedly go among the masses of workers, peasants and soldiers, go into the heat of the struggle, go to the only source, the broadest and richest source, in order to observe, experience, study and analyse all the different kinds of people, all the classes, all the masses, all the vivid patterns of life and struggle, all the raw materials of literature and art. Only then can they proceed to creative work.[88]

However, a 'bottom-up strategy' became Mao's ultimate concept of mass art after the Great Leap Forward (*Da yuejin*) at the end of the 1950s. According to official comment, 'The fact that the roles of the masses shifted from audiences to artists ended the era in which art was created only by a few people. Art belongs to all the masses and everybody is an excellent artist. It is the time when the difference between physical work and mental work is gradually disappearing.'[89] In the early stage of the Cultural Revolution, Mao's idea of mass art was fully achieved. The woodcut images, big-character posters and slogans featured magnitude of both scale and quantity, which constituted 'maximalism', the visualisation of an infinite revolutionary enthusiasm. The artist was recast as a member of the masses and everybody could claim to be an artist.

During the practice of mass art, the traditional aesthetic qualities of visual products were unavoidably lost. Instead, it provided a kind of

anti-art that subverted the old order in which the individualism of the artist was fundamental. It abolished the difference between the artists and the masses, so as to produce art by the masses and for the masses. A reified status for the artist was no longer acceptable in the new Chinese society; the artist had to be reborn as a member of the masses. If we look at the institutional perspective of art in China, it can be argued that everyone in the masses was an artist, actually thus abolishing the idea of the artist. With political restrictions, and the use of art as a political instrument, one can grieve the death of the individual freedom of expression but at the same time one can also acclaim the bountiful harvest of visual art production during the mass art.[90]

The mass movement was also evident in the performing arts. The popular saying 'eight hundred million people watching eight shows *(bayi ren kan batai xi)*' referred to the eight model operas from the years of the Cultural Revolution. Jiang Qing and her allies controlled the existing cultural organisations and determined Chinese cultural life. Formally promulgated on May 1967, the eight model operas include *Red Lantern (Hongdeng ji)*, *Taking Tiger Mountain by Strategy (Zhi'qu weihu shan)*, *Sudden Attack on White Tiger Regiment (Qixi baihu tuan)*, *Harbour (Haigang)*, and both the opera and symphony of *Shajiabang*, as well as the ballets *White-haired Girl (Baimao nü)* and *The Red Detachment of Women (Hongse niangzi jun)* (pp. 205–6, 209, 211, 214).[91] For a time, they were the only dramas permitted to be performed by opera troupes

around the country and represented the only permissible examples of Chinese literature. Different local dramatic troupes all adapted them. The symphony *Shajiabang* and the arias of *Red Lantern* accompanied by piano were the only choices for those orchestras with Western instruments.'[92] Later, a few others were also designated as model works, including *Azalea Mountain (Dujuan shan)* and *Ode to Yimeng (Yimeng song)* (pp. 213, 215). These new products of red art created the people's heroes, who featured in the representation of '*gao-da-quan* (lofty-glory-complete)', appeared in revolutionary surroundings and celebrated glorious victory. They provided the models for behaviour and attitude in the service of a new ideology. It was observed that a new mythology had emerged.

> The result essentially was a mythology of the Chinese Communist revolution. God-like main heroes came down to often remote earthly situations, showed the way forward for other heroes, and sometimes died in the process. The deep roots that such stories were able to tap into help to account for the power of these model operas. It was not just the mind-boggling repetition of their performance during the Cultural Revolution years, whether on stage or on celluloid or in other versions and extracts, that put these operas at the centre of Chinese culture in those years.[93]

The performances were strictly controlled. According to Wang Yongji, the former conductor of *Harbour*, 'the national troupes of the model operas enjoyed their prestigious position in the field of theatre art

in those years. We had only presented fifty or so shows in some major cities annually, in order to maintain the absolute quality of every single second of music, dialogues, singing and dancing, whilst the whole performance had to be finished on the one hundred and eighteenth minute, as precisely as possible.'[94] Although not all audiences would have the opportunity to view an authentic version of the model opera, they could enjoy the operas performed by local troupes, especially those that were transformed into folk operas, such as *Huaiju* and *Chuanju*. The performances could also be watched in organised groups on film screens, or over and over again in extracts on communal television screens. They could be seen as 'the ritual enactment of a morality that its audiences and performers needed to internalise'.[95] The imagery of the operas had a life beyond the theatre – on posters or billboard paintings, in books, calendar cards and even on everyday household utensils. This ubiquity again demonstrated the ambition to reshape the entire mass culture.

While the first-class performers were touring the nation with the model operas, the Red Guard were pioneering mass performances, often in public, to promote the spirit of the Cultural Revolution and Mao's Thought (pp. 217–19). The internal migration of millions of young Red Guards during the Great Exchange brought their shows from cities to villages and remote areas (pp. 220–5). These performances were usually enthusiastically presented by a group of Red Guards adopting revolutionary postures in old military uniforms. The audience themselves conformed with the occasion in costume. Mass performances were part of the festival parades celebrating occasions such as National Day (October 1), Labour Day (May 1), the

success of the National Congress or the establishment of a local Revolutionary Committee (pp. 226–31). Mao was always a central figure in these mass parades, by the presence of his portraits, statues and images of red sun. There was no protagonist, but the Chairman himself was the star of the performance.

Even the forced daily rituals of the personality cult can be seen as a mass performance. Apart from the exercise of *Tiantian du*, massed singing and dancing were common.

> The issuing of a new directive was usually announced on the radio several hours before the new directive was actually read on the air, often after eight p.m. Ritualistically, every time the advance notice was given, people would start preparing a parade or loyalty dance in celebration. As soon as the new directive was issued, people were expected to remember it and recite it by heart. During the ensuing celebration people would flood into the streets and parade around while reciting the new directive, singing songs eulogising Mao, and dancing the loyalty dance. Such celebration rituals would last until midnight.[96]

Numerous songs were written during the Cultural Revolution, most of them adapting simple folk melodies. Songs of eulogy for Mao were broadcast through loudspeakers and over the airwaves everywhere in China. '*The East Is Red*' was the most well known of all.

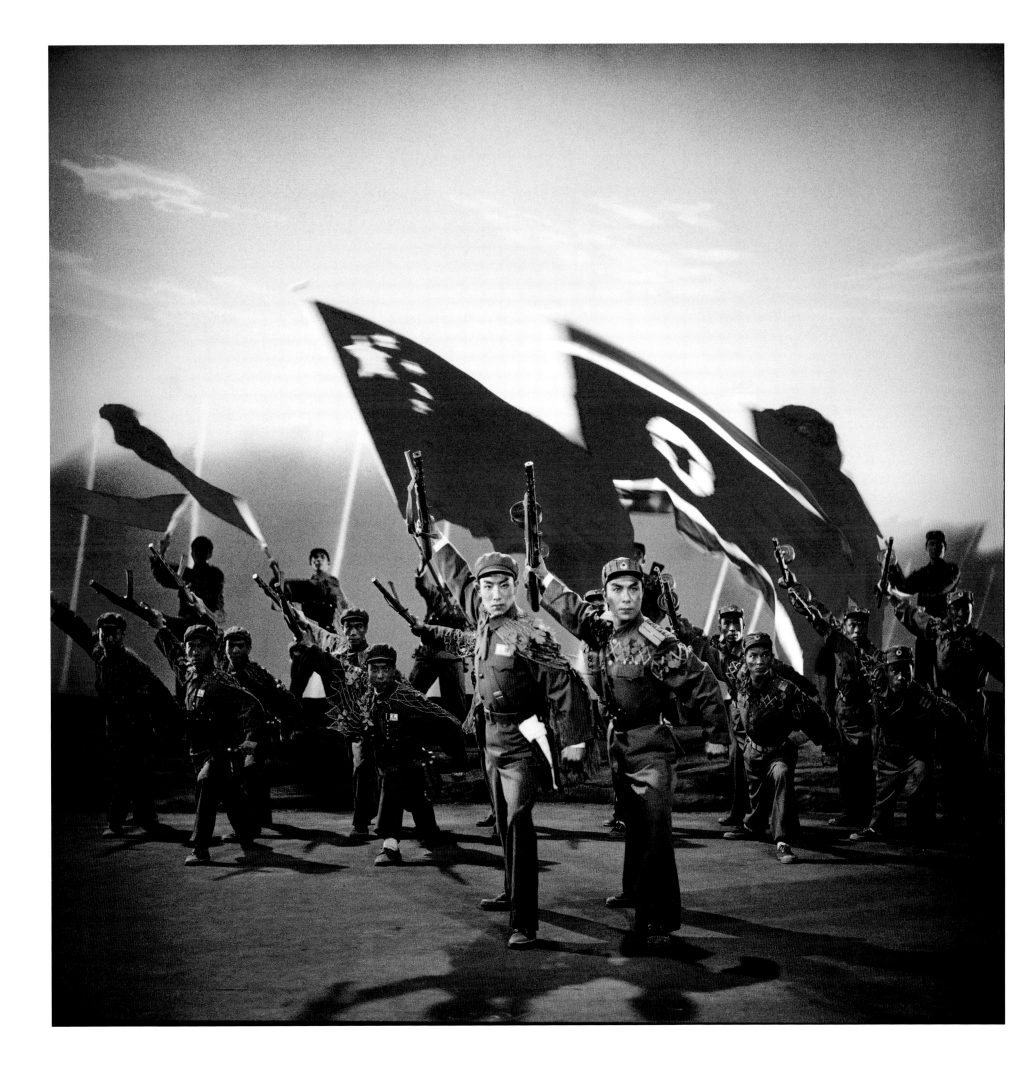

The East is red, rises the sun,

China has brought forth a Mao Zedong.

For the people's happiness he works,

Hu reh hai ya,

He is the people's saviour.

It was the first tune on the official radio broadcast every morning, and was played through the loudspeakers at every significant ceremonial event. An important occasion would normally begin with '*The East Is Red*', and end with '*Sailing the Sea Relies on the Helmsman*'. They were sung by the masses and performed all the time. (pp. 236–9).

The ritual singing was often accompanied by *Zhongzi wu* (the Loyalty Dance), which involved the simple movement of stretching one's arms from one's heart towards Mao's portrait, so expressing absolute loyalty and boundless love. The Loyalty Dance was popular among students, workers and peasants, and could be performed anywhere – in classrooms, factories or even in a shop at the start of the business day. It could be a part of a mass performance or even danced by passengers on a moving train or at various stops along the line (pp. 232–5). A grand Loyalty Dance could be presented by thousands. In one example, 'the performers filled a very wide street for a length of nearly half a mile, following a truck with a huge portrait of Mao on it and two loudspeakers singing songs praising Mao. All the performers danced seriously, and people on sidewalks watched them with respect.'[97] Both performers and spectators were transformed. The cult of Mao lifted individuals beyond themselves and

their ordinary lives. At every moment of the performance they really were mass artists, expressing passion within the conformity of red art.

70 China National Art Museum (ed.), *Zhongguo meishu nianjian (The Chinese Art Almanac)*. Guangxi: Guangxi yishu chubanshe, 1993.
71 Wang Mingxian, 'From Red Guard Art to Contemporary Art', in Jiang (ed.) (2007), op. cit., pp. 36–40.
72 Cited in Wang, ibid., p. 41.
73 The sculpture was destroyed after the exhibition at the China National Art Museum in 1967, with no surviving literary record on the exact size of the entire work, or on the number of the figures. However, based on the available photographic evidence, collected by Wang Mingxian, more than 70 different figures can be found in those particular shots.
74 Cai Qing, '*Yongyuan genzhe Mao zhuxi nao geming: ping nisu* Hong weibing zan (Always Follow Chairman Mao to Carry out the Revolution: on the Clay Sculpture *Ode to the Red Guards*)', *Xin Meishu (New Art)*, No. 2, December 1967.
75 Evans, Harriet and Donald, Stephanie, 'Introducing Posters of China's Cultural Revolution', in Evans and Donald (eds), op. cit., 1999, p. 3.
76 Barmé (1996), op. cit., p. 100.
77 See details in Wang Mingxian (2007), op. cit., pp. 42–3. However, it has been impossible to estimate the total number of Red Guard publications.
78 Interview with Yü Youhan on October 9, 2000, Shanghai.
79 Interview with Zhu Xiaoming on February 19, 2001, Shanghai.
80 Interview with Wang Mingxian on February 25, 2000, Beijing.
81 Interview with Fan Xuede on January 15, 2001, Birmingham.
82 Macfarquhar and Schoenhals (2006), op. cit., p. 67.
83 Chang Tsong-zung (2007), op. cit., p. 61.
84 Xu Bing, 'The Living Word', in Britta Erickson (ed.), *Words without Meaning, Meaning without Words: The Art of Xu Bing*. London: University of Washington Press, 2001, p. 16.
85 Interview with Zhu Xiaoming on February 19, 2001, Shanghai.
86 Interview with Cai Xiaoming on June 6, 2001, Birmingham.
87 Wang Yi, *Yihetuan yundong mengmeixing de wenhua genyuan jiqi dui wenhua da geming de yingxiang* (The Cultural Origin of the Barbarism of Yihetuan Movement and Its Influence on the Cultural Revolution), Vol. 2, in *Huaxia wenzhai (China News Digest)*, Supplement Issue 239, November 8, 2000. Available from: http://www.cnd.org/CR/ZK00/cr81.hz8.html#1 [accessed on February, 1 2009].
88 Mao Zedong, *Mao Tse-Tung on Literature and Art*. Beijing: Foreign Languages Press, 1967, p. 19.
89 '*Cujin meishu da puji ji da fanrong* (To Accelerate the Great Popularisation and Flourish of Fine Art)', *Meishu (Fine Art)*, 1958, Vol. 9, p. 1.
90 Jiang Jiehong, 'The Extermination or Prosperity of Artists? Mass Art in Mid-twentieth Century China', *Third Text*, Vol. 18, Issue 2, 2004, p. 182.
91 '*Geming wenyi de youxiu yangban* (Excellent Models for Revolutionary Literature and Art)', *Renmin ribao*, May 31, 1967, p. 1.
92 Yan and Gao (1996), op. cit., p. 401.
93 Clark, Paul, *The Chinese Cultural Revolution: A History*. New York: Cambridge University Press, 2008, p. 54.
94 Interview with Wang Yongji on November 12, 2008, Shanghai.
95 Clark (2008), op. cit., pp. 56–7.
96 Lu Xing (2004), op. cit., p. 138.
97 Huang, Shaorong, *To Rebel Is Justified: A Rhetorical Study of China's Cultural Revolution Movement 1966–1969*. Lanham, Md.: University Press of America, 1996, p. 146.

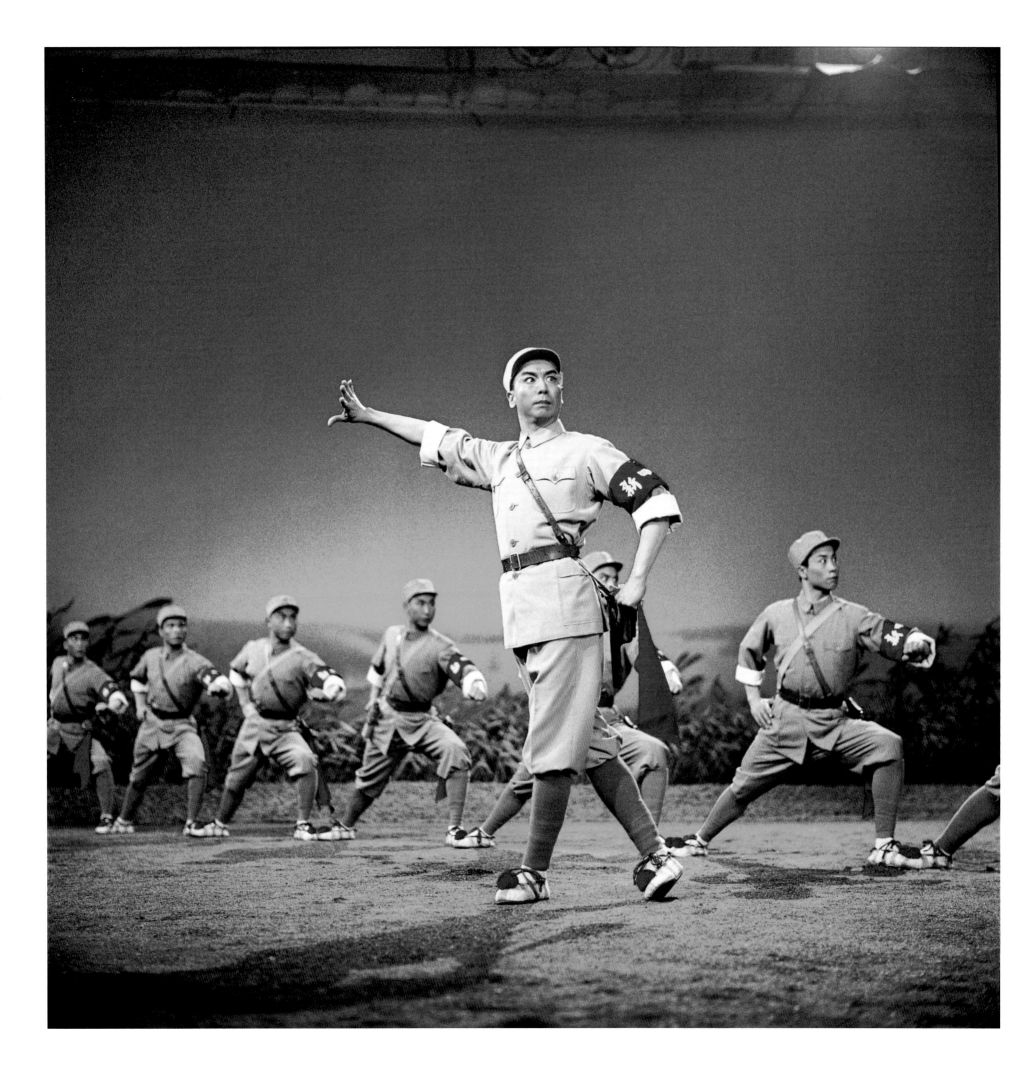

Zhang Yaxin,
Opera *Azalea Mountain (Dujuan shan)*, Beijing, 1974.

Zhang Yaxin,
Ballet *Red Detachment of Women (Hongse niangzijun)*, Beijing, 1973.

Zhang Yaxin,
Opera *Ode to Yimeng (Yimeng song),* Beijing, 1975.

Weng Naiqiang,
Performance at the People's Cultural Palace on 1 May, Beijing, 1966.

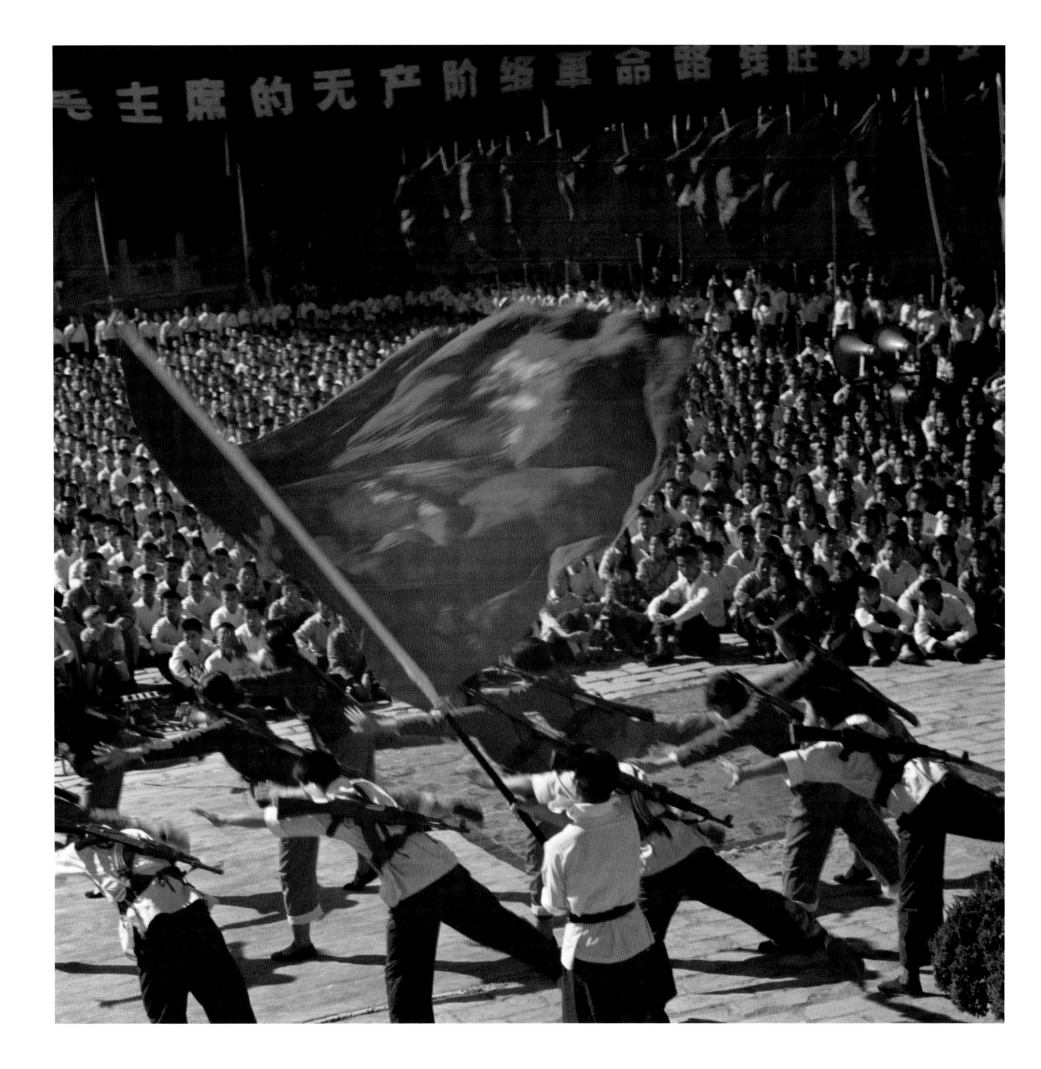

Anonymous photograph,
'Performers of the worker-peasant-soldier propaganda team performance and commune members sing
together in a village' (Shanghai, 1967), *China Pictorial*, Vol. 230, August 1967.

Zhang Yaxin,
The Red Guard Performance in the People's Square, Shanghai, 1966.

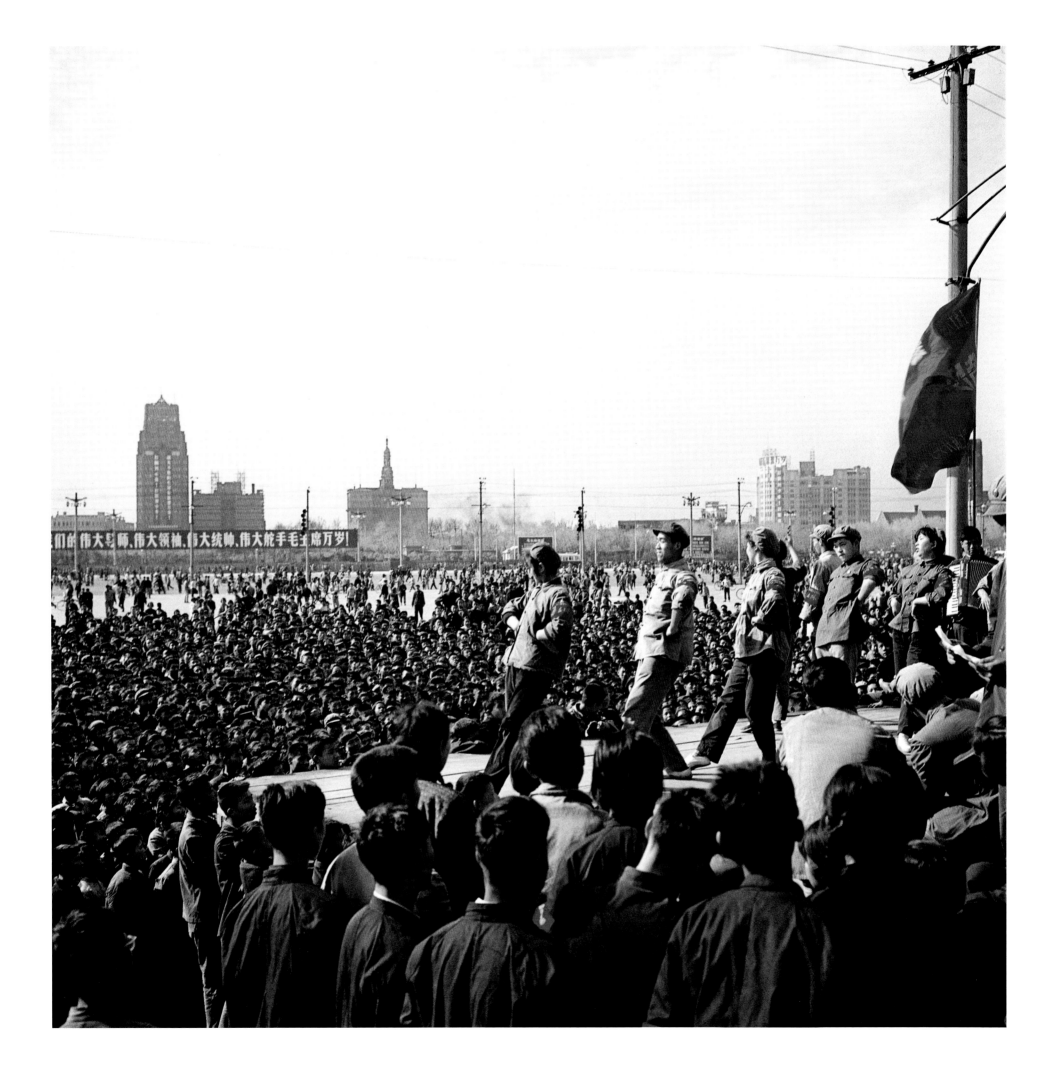

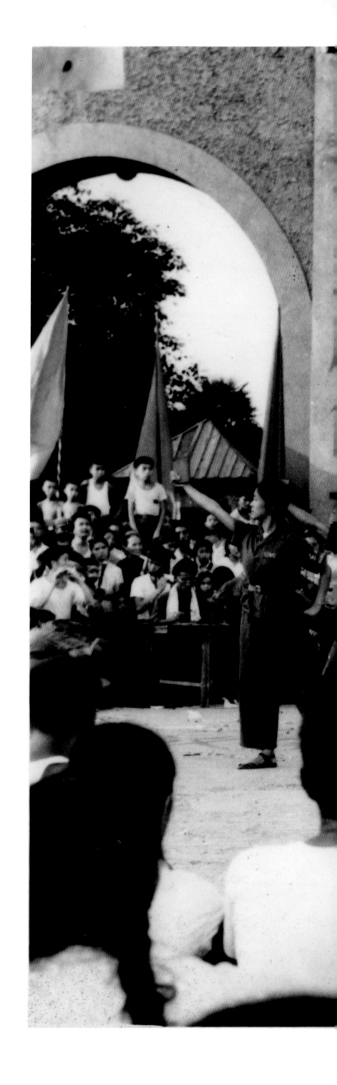

Chen Ke,
Sichuan University and College Students Promoting Mao's Thought, Chengdu, Sichuan province, 1967.

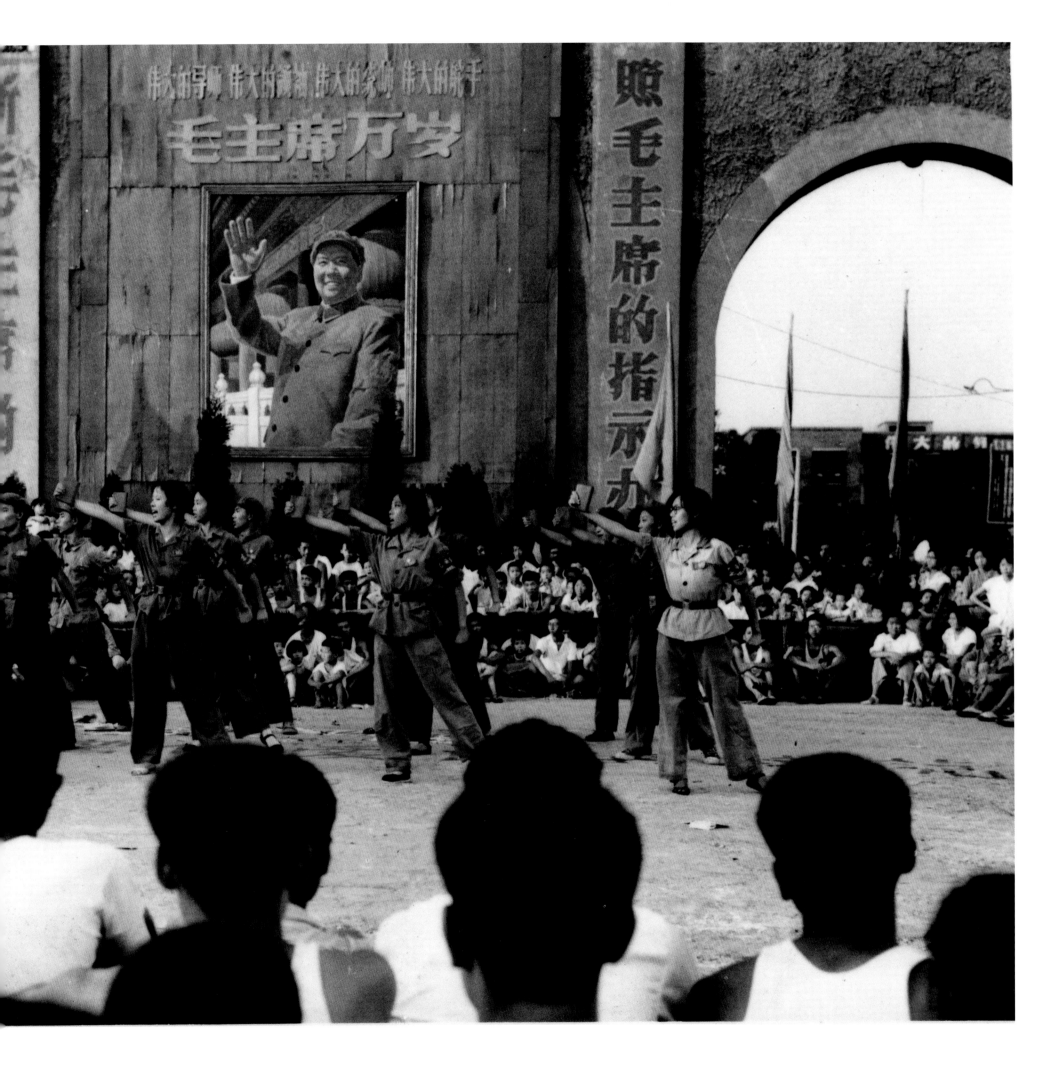

Weng Naiqiang,
Red Guard Performance on Jinggang Mountain, Jiangxi province, 1966.

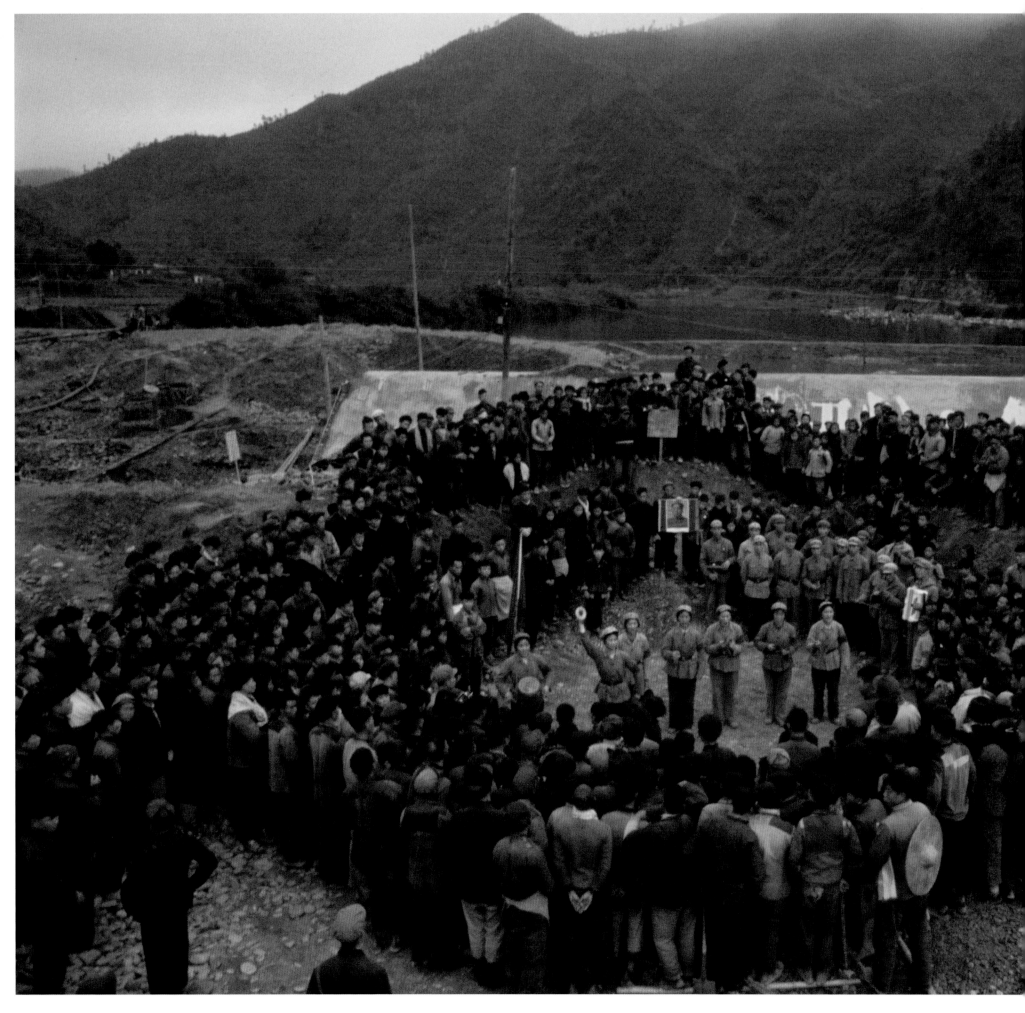

Weng Naiqiang,
Red Guard Performance on Jinggang Mountain, Jiangxi province, 1966.

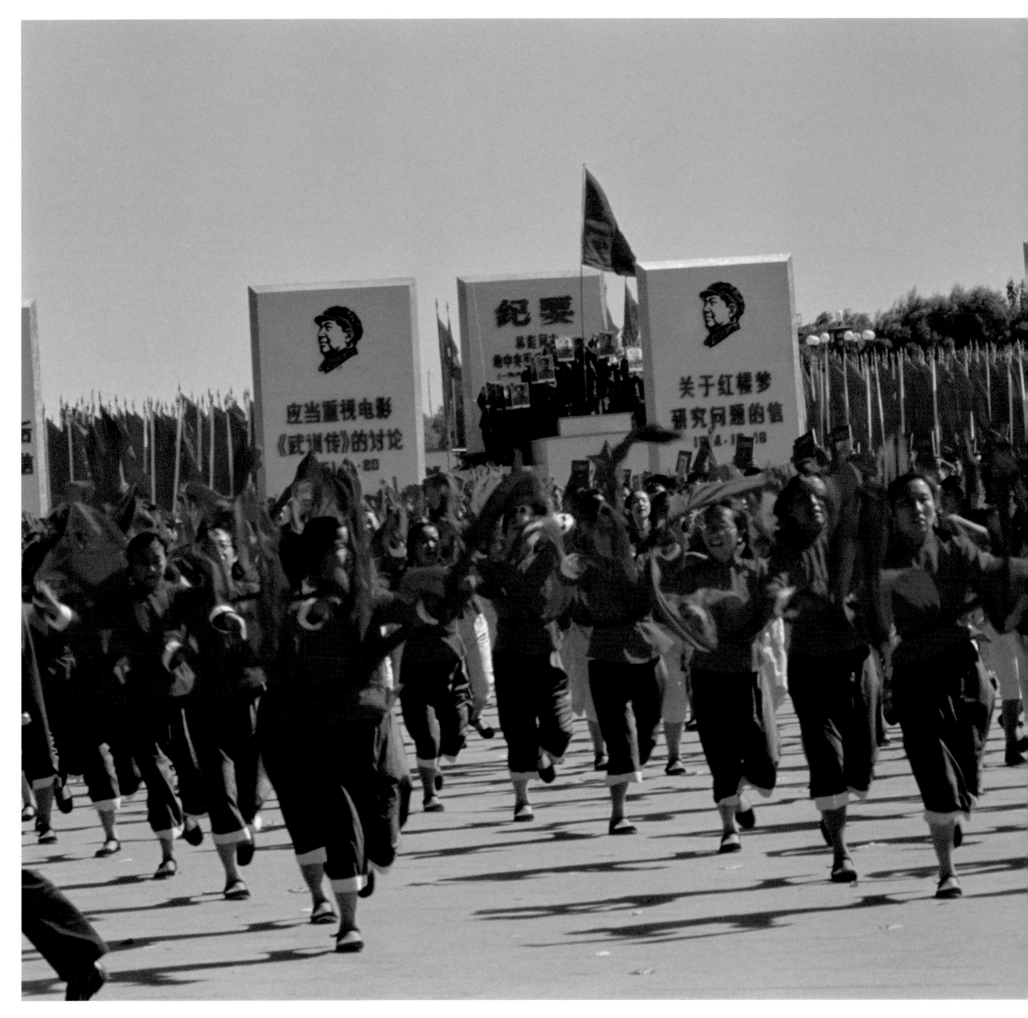

Weng Naiqiang,
Parade Performance on National Day, Beijing, 1967.

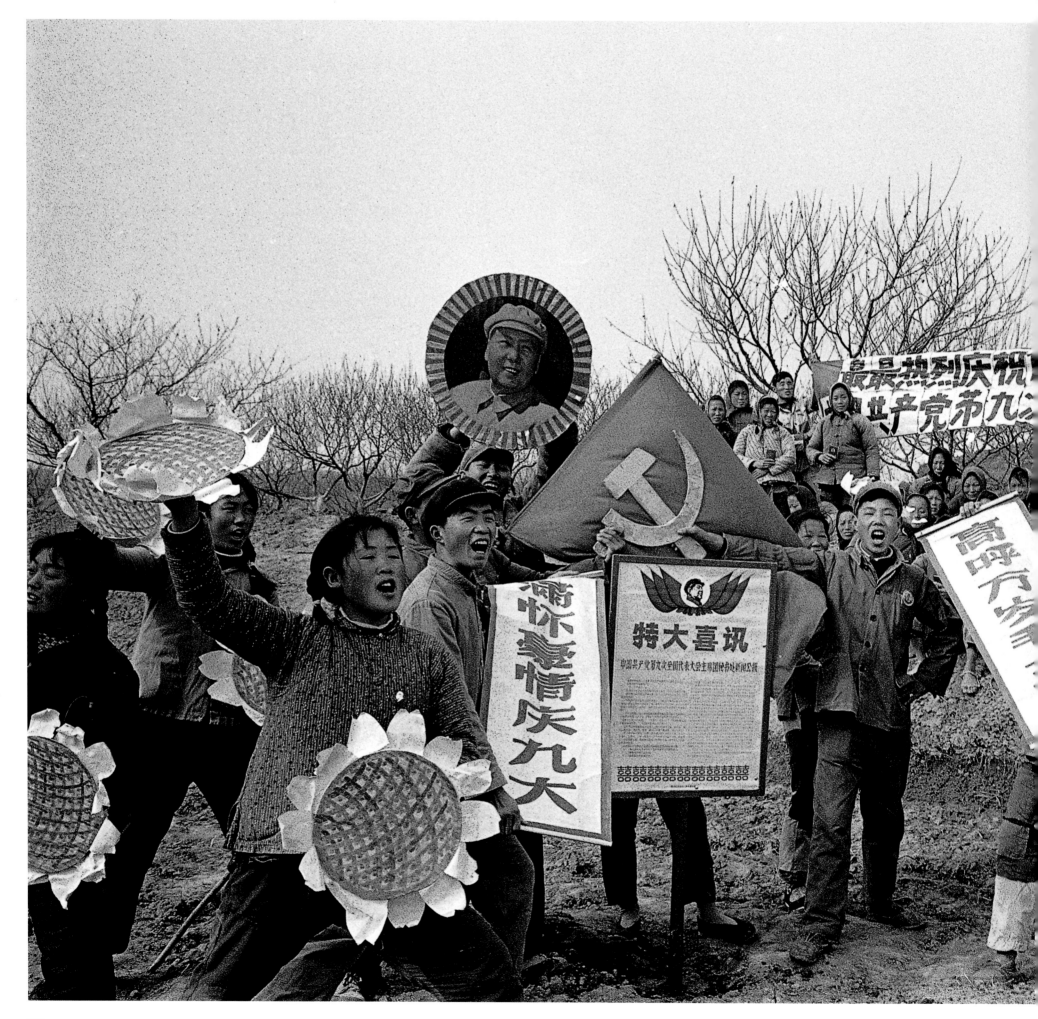

228

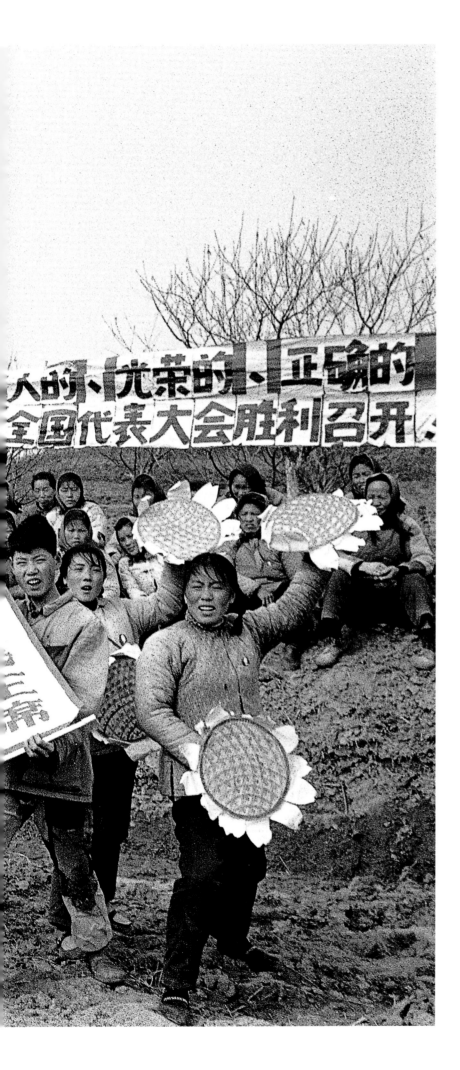

Xiao Zhuang,
Zijinshan Commune Members Celebrating the Success of the Ninth National Congress of the Communist Party of China,
Nanjing, Jiangsu province, 1969.

Li Zhensheng,
'Marchers carrying a statue of Mao on a float adorned with sunflowers symbolising the Chinese people following Mao the way flowers follow the sun'
(Harbin, 1968), *Red-Colour News Soldier*, p. 222.

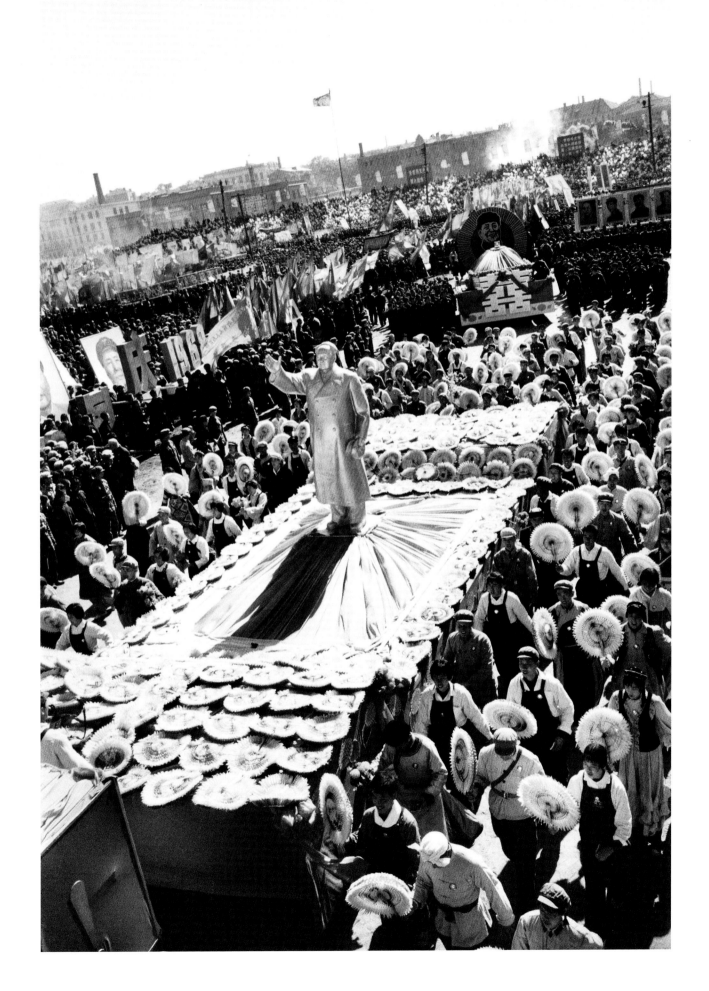

Jiang Shaowu,
The Passengers' Loyalty Dance at the Yingkou Stop, Yingkou, Liaoning province, 1967.

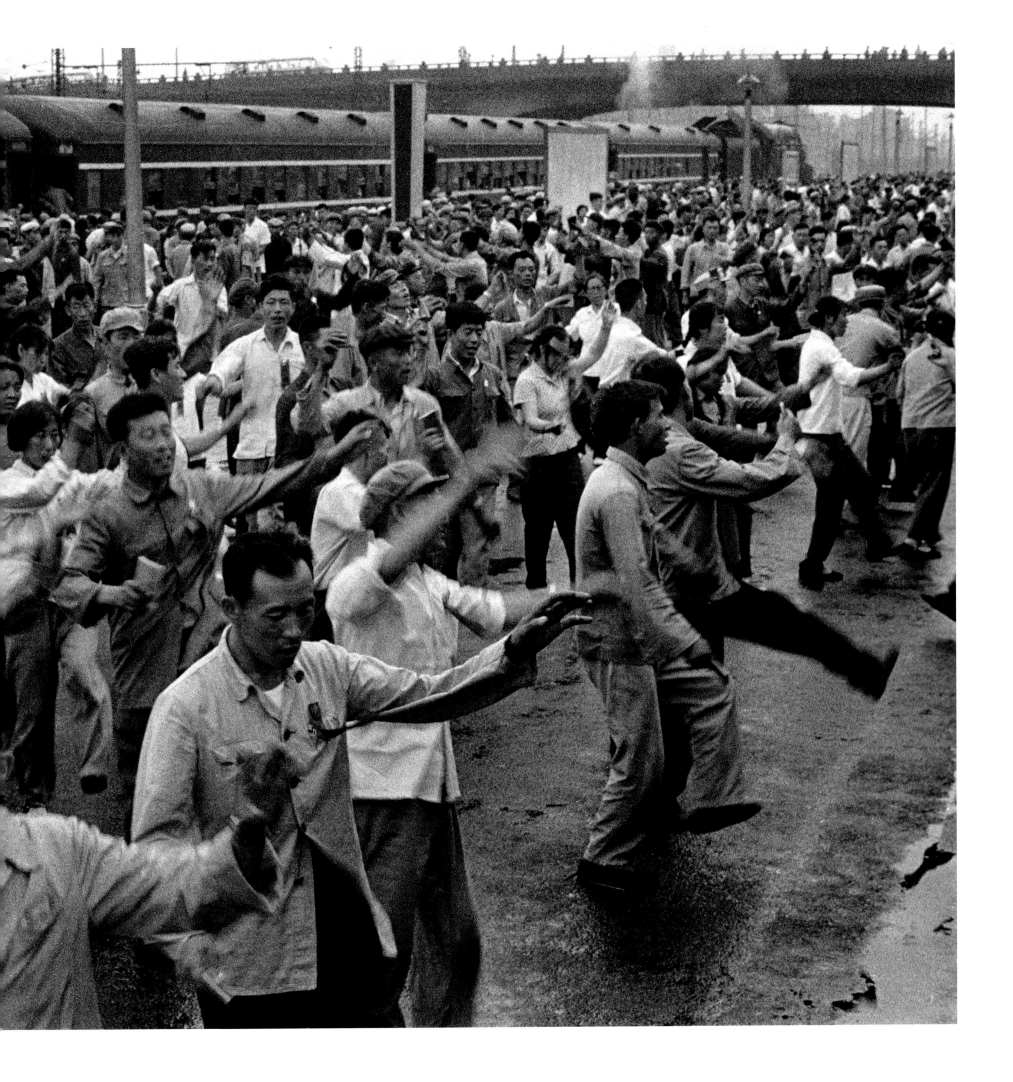

Jiang Shaowu,
The Loyalty Dance on a Train, 1967.

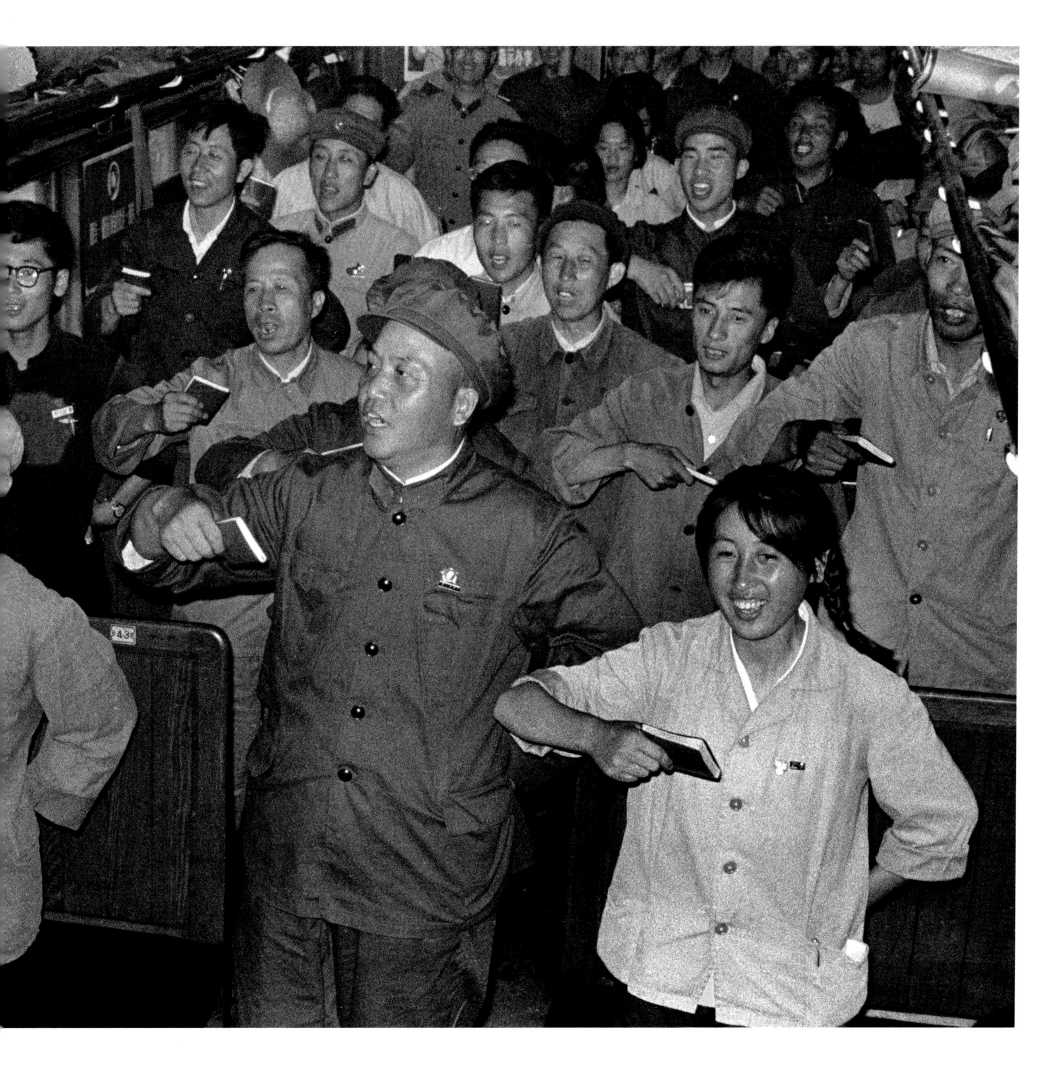

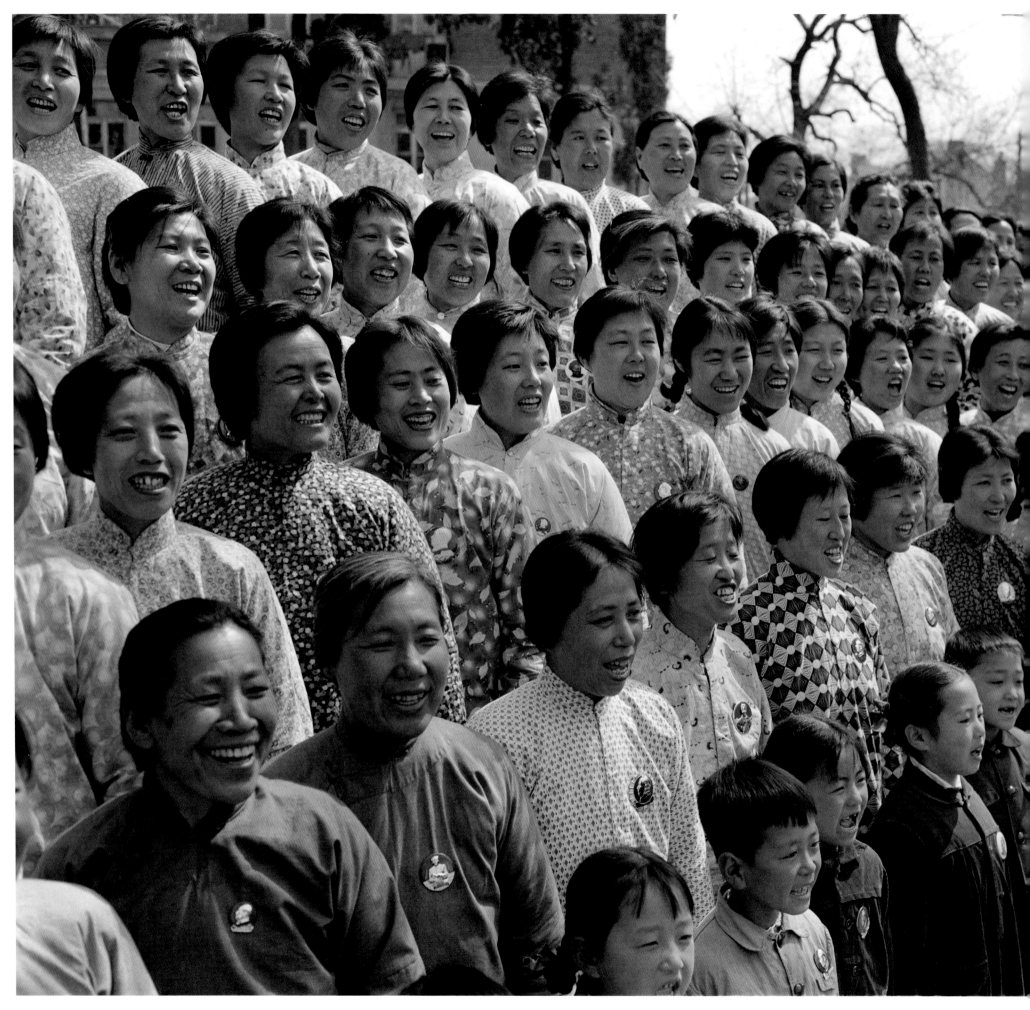

Jiang Shaowu,
Shenyang Granny Choir, Shenyang, Liaoning province, 1967.

Xiao Zhuang,
Little Red Guards Singing Chairman Mao's Quotations, Nanjing, Jiangsu province, 1966.

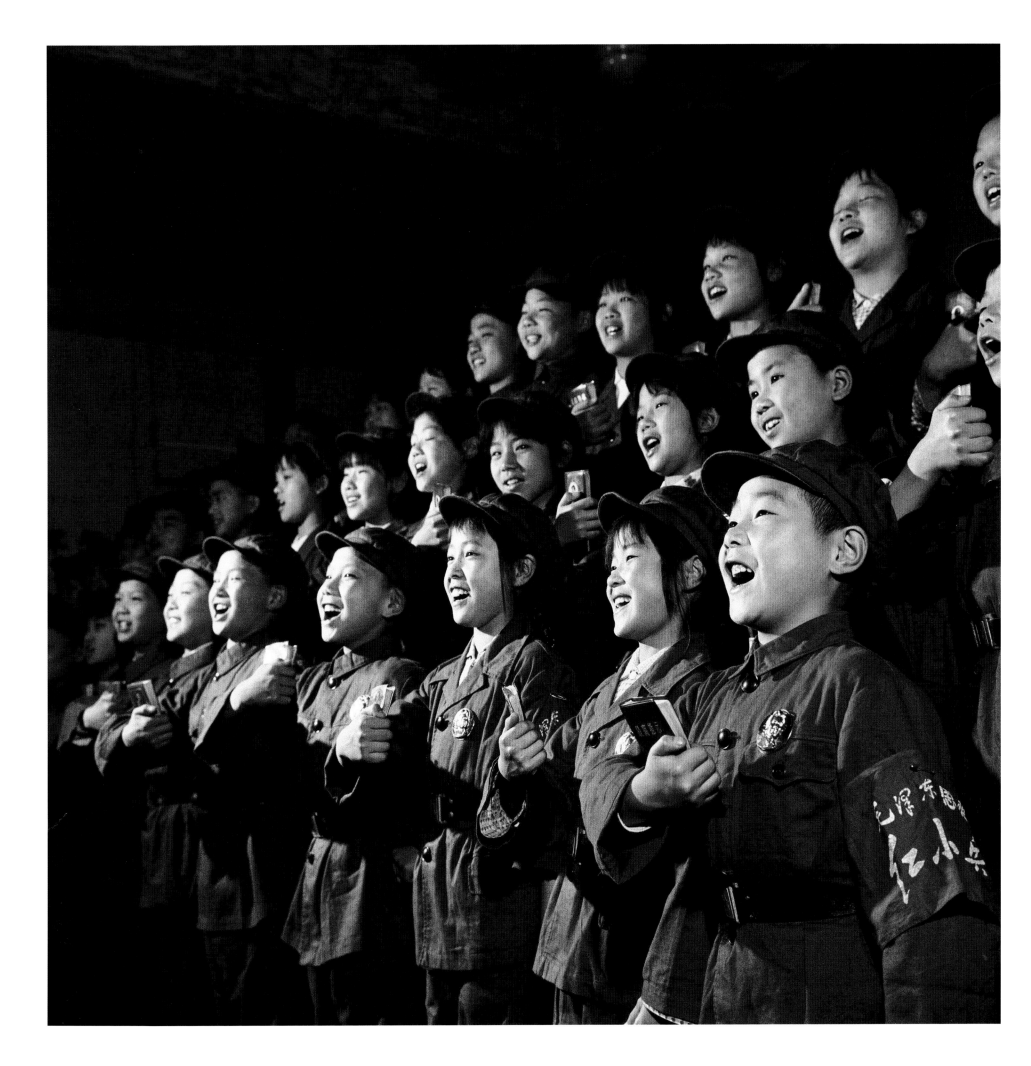

CONCLUSION

In 1976, Mao valued only two things of importance in his life. One was the struggle against Jiang Jieshi and the Japanese during the War of Resistance, which led him to the Forbidden City. The other was his Cultural Revolution. Whether he regarded the latter as a success or a failure was never specified.[98] The Cultural Revolution did not turn 'tianxia daluan (great disorder under heaven)' into 'tianxia dazhi (great order under heaven)', as originally intended. In the wake of unprecedented destruction, it did, however, impose an unparalleled visual experience on China's 800 million people. The extraordinary mass movement concentrated in the first two and a half years of the Revolution would not have happened without such extreme centralisation through the personality cult of one man. The visual phenomenon of the mass movement offers a means to reassess the Cultural Revolution, particularly in a contemporary context, for a better understanding of today's China.

The colour red has specific connotations in China, based on a play between tradition and modern political significance. This enables it to permeate deeply into people's lives. Both old and new uses of the colour harness a sense of national strength. In the turbulent years, when much traditional culture was eliminated, red survived as the dominant visual legacy. In an environment loaded with irrational fanaticism, the colour offered a kind of spiritual continuity.

Since the early twentieth century, Chinese art has been reformed ideologically to become a component in a revolutionary machine. It operated 'as a weapon for uniting and educating the people, and for attacking and destroying the enemy.'[99] Respectfully regarded as the foundation for the reform of the arts, the Yan'an Talks brought earlier revolutionary art to a conclusion. The talks firmly supported the popularisation of art as the primary means for spreading Communist ideas and tempering the will of the masses. The red art of the Cultural Revolution finally eliminated the distinction between artists and masses. The most obvious identifiable image of China remains one of a country 'awash with red'. Viewed as a whole, the Cultural Revolution could even be considered as an art project – one that involved the greatest number of participants in history. After this baptism, red has been inherited, reinterpreted and reborn in China, not as a static image occupying limited space, but as a reflection both of past experience and of changing national aspirations.

Three decades after Mao's death it is generally acknowledged that the Cultural Revolution was a tragedy. Ironically, the decade of the revolution has been described as a 'cultural desert (wenhua shamo)' in Chinese intellectual history. The cultural production of the period has been disregarded. Yet without the visual experience of the Cultural Revolution, China would present another kind of modernity entirely. The visual impact of this strange 'new world' has also fostered the cultural complexity of post-Mao China and, indeed, continues to contribute to the power of contemporary Chinese art in the international arena.[100] Although Mao's portrait is much less evident, the colour red is a constant. The big-character slogans in the celebratory events of today are the signals of commerce in an accelerated economy. Mass assemblies, public performances and street dancing are still the popular entertainments of urban life. Red, the visual language of Mao, has shaped the collective memory.

98. Mao Zedong, 'Seal the Coffin and Pass the Final Verdict', in Schoenhals (ed.) (1996), op. cit., p. 293.
99. Mao (1967), op. cit., p. 2.
100. See Jiang Jiehong, 'The Revolution Continues', in Mark Holborn (ed.), The Revolution Continues: New Art from China. London: Jonathan Cape and the Saatchi Gallery, 2008.

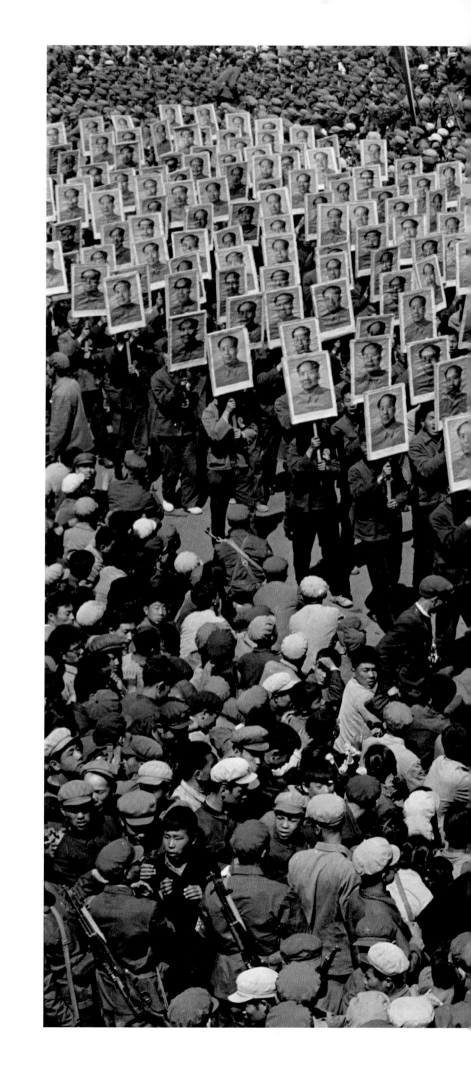

Jiang Shaowu,
Mass Parade in Celebration of the Seventeenth Anniversary of the People's Republic of China,
Shenyang, Liaoning province, 1966.

Weng Naiqiang,
Red Guards in Tiananmen Square

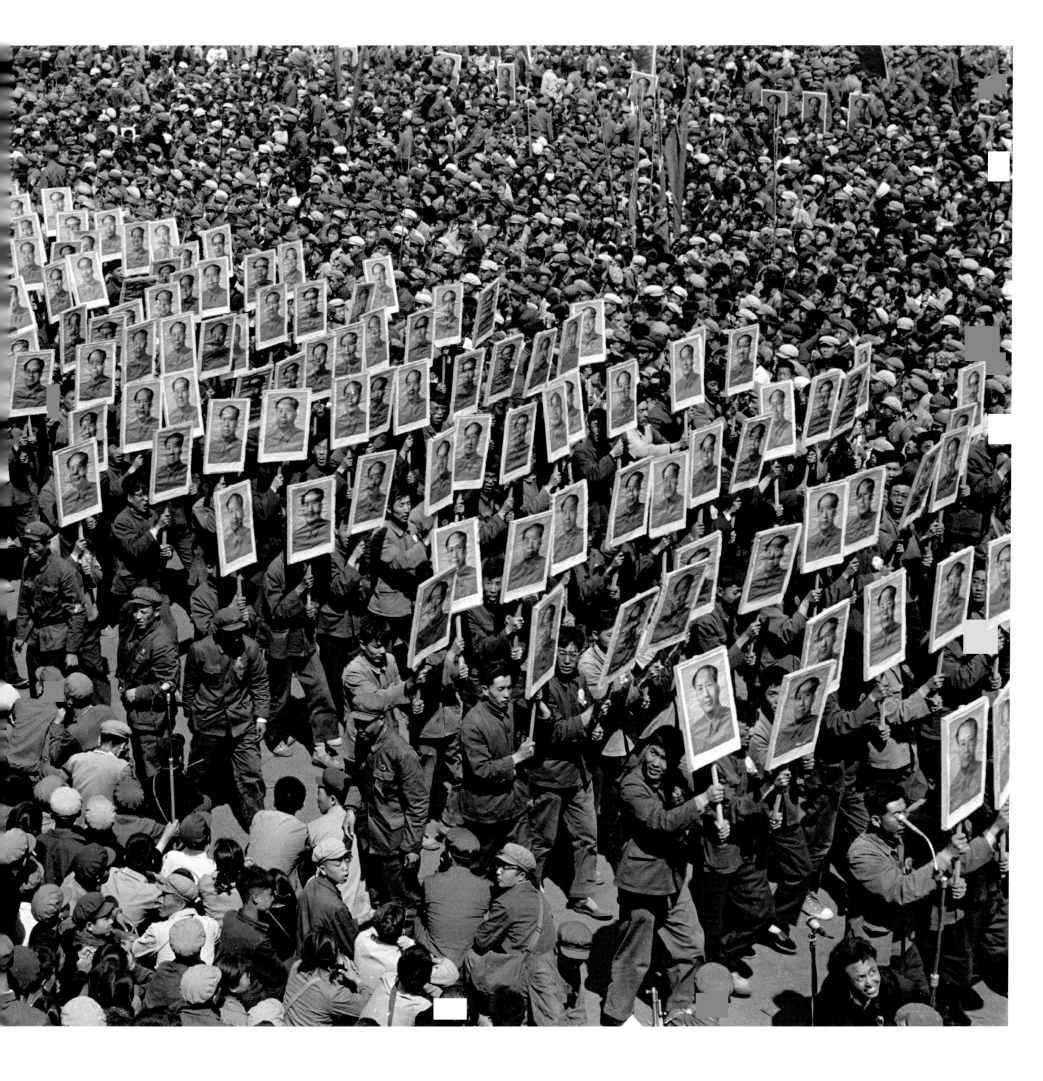

LIST OF CHINESE NAMES

Cai Xiaoming	蔡晓鸣	1956–
Chen Boda	陈伯达	1905–1989
Deng Xiaoping	邓小平	1904–1997
Hai Rui	海瑞	1514–1585
Han Fei	韩非	c. 280–233 BC
Hua Guofeng	华国锋	1921–2008
Jiang Jieshi	蒋介石	1887–1975
Jiang Qing	江青	1914–1991
Kang Sheng	康生	1898–1975
Li Xianting	栗宪庭	1949–
Lin Biao	林彪	1907–1971
Liu Chunhua	刘春华	1944–
Liu Shaoqi	刘少奇	1898–1969
Lu Ping	陆平	1914–2002
Mao Zedong	毛泽东	1893–1976
Nie Yuanzi	聂元梓	1921–
Peng Peiyun	彭佩云	1929–
Qin Shihuang	秦始皇	r. 221–206 BC
Shen Yaoyi	沈尧伊	1943–
Song Binbin	宋彬彬	1947–
Song Shuo	宋硕	dates unknown
Sun Zhongshan	孙中山	1866–1925
Tan Houlan	谭厚兰	1937–1982
Wang Hongwen	王洪文	1935–1992
Wang Mingxian	王明贤	1954–
Wang Yongji	王永吉	1947–
Xu Bing	徐冰	1955–
Yao Wenyuan	姚文元	1932–2005
Yü Youhan	余有涵	1943–
Yue Fei	岳飞	1103–1142
Zhang Chengzhi	张承志	1948–
Zhang Chunqiao	张春桥	1917–2005
Zhou Enlai	周恩來	1898–1976
Zhu De	朱德	1886–1976
Zhu Xiaoming	朱小明	1957–

LIST OF CHINESE TERMS

An'yuan	安源	Handan	邯郸
Baimao nü	白毛女	Hangzhou	杭州
Baita	白塔	Hei wulei	黑五类
Baofeng	宝峰	heiti	黑体
Baotou tu'an ziliao	报头图案资料	Hong baoshu	红宝书
baoxi	报喜	hong baoxiang	红宝像
bayi ren kan batai xi	八亿人看八台戏	hong guang liang	红光亮
Beijing	北京	hong haiyang	红海洋
Beijing kaoya dian	北京烤鸭店	Hong huabing	红画兵
benming nian	本命年	hong taiyang	红太阳
biaozhun xiang	标准像	Hong weibing	红卫兵
Biyun	碧云	Hong weibing zan	红卫兵赞
bupo buli	不破不立	hong wenyi	红文艺
Chang'an	长安	Hong wulei	红五类
Changzheng	长征	Hongdeng ji	红灯记
chedi daohui kongjia dian	彻底捣毁孔家店	Hongjun	红军
Chuanju	川剧	Hongqi	红旗
Da chuanlian	大串联	hongse kongbu	红色恐怖
Da yuejin	大跃进	Hongse niangzi jun	红色娘子军
danwei	单位	Hongyan	红岩
dazi bao	大字报	Huaiju	淮剧
Dong'an	东安	Huhehot	呼和浩特
Dongfang hong	东方红	Jiangxi	江西
Dongfang shengdi	东方圣地	Jietai	戒台
Dongfeng	东风	Jihong	继红
Dujuan shan	杜鹃山	Jile	极乐
duilian	对联	Jing'an	静安
Fandi	反帝	Jinggangshan	井冈山
Feng zi xiu	封资修	jingshen jiangli	精神奖励
gao-da-quan	高大全	Jinsha	金沙
geming shengdi	革命圣地	Kuomintang	国民党
genhong miaozheng	根红苗正	lao zihao	老字号
geren chongbai	个人崇拜	Lazi Kou	腊子口
Gong nong bing	工农兵	Lhasa	拉萨
Guizhou	贵州	Liupan	六盘
Haigang	海港	Longjiang song	龙江颂
Haikou	海口	Luding	泸定

Manjiang hong	满江红	tianxia dazhi	天下大治
Mao zhuxi jiaodao women	毛主席教导我们	Tongren	同仁
Mao zhuxi qu anyuan	毛主席去安源	Urumchi	乌鲁木齐
Mao zhuxi wansui	毛主席万岁	wanshi shibiao	万世师表
Mao zhuxi yülu	毛主席语录	wansui	万岁
Meishu fenglei	美术风雷	weibei	魏碑
Meishu zhanbao	美术战报	weida	伟大
Ming	明	Weidong	卫东
nianhua	年画	wei renmin fuwu	为人民服务
Ningbo	宁波	wenhua shamo	文化沙漠
niugui sheshen	牛鬼蛇神	Wenhui bao	文汇报
nongmin hua	农民画	Wofo	卧佛
Ping xinbian lishiju 'Hairui baguan'	评新编历史剧海瑞罢官	Wu yiliu tongzhi	五一六通知
Po sijiu	破四旧	wuchan jieji wenhua dageming	无产阶级文化大革命
Qing	清	Wuhan	武汉
Qingdao	青岛	Wutai	五台
Qinghua	清华	Xiehe	协和
Qixi baihu tuan	奇袭白虎团	Xikai	西开
quanguo shangxia yipian hong	全国上下一片红	Xuetong lun	血统论
Quanjude	全聚德	Yan'an	延安
Qufu	曲阜	yangban xi	样板戏
Renmin ribao	人民日报	Yimeng song	沂蒙颂
Ruijin	瑞金	yinyang tou	阴阳头
San zhongyü	三忠于	Yongge	永革
Shajiabang	沙家浜	youhong youzhuan	又红又专
Shanbei	陕北	Yuanmingyuan	圆明园
Shanghai	上海	zao qingshi wan huibao	早请示晚汇报
Shanxi	山西	Zaofan pai	造反派
Shaoshan	韶山	zaofan youli	造反有理
shinian dongluan	十年动乱	Zhejiang meishu xueyuan	浙江美术学院
Sichuan meishu xueyuan	四川美术学院	Zhi'qu weihu shan	智取威虎山
Sige weida	四个伟大	zhong	忠
Siren bang	四人帮	zhongbuzhong kan xingdong	忠不忠看行动
Tiananmen	天安门	Zhongyang gongyi meishu xueyuan	中央工艺美术学院
Tianjin	天津	Zhongyang meishu xueyuan	中央美术学院
Tiantian du	天天读	Zhongzi wu	忠字舞
tianxia daluan	天下大乱	zuigao zhishi	最高指示
		Zunyi	遵义

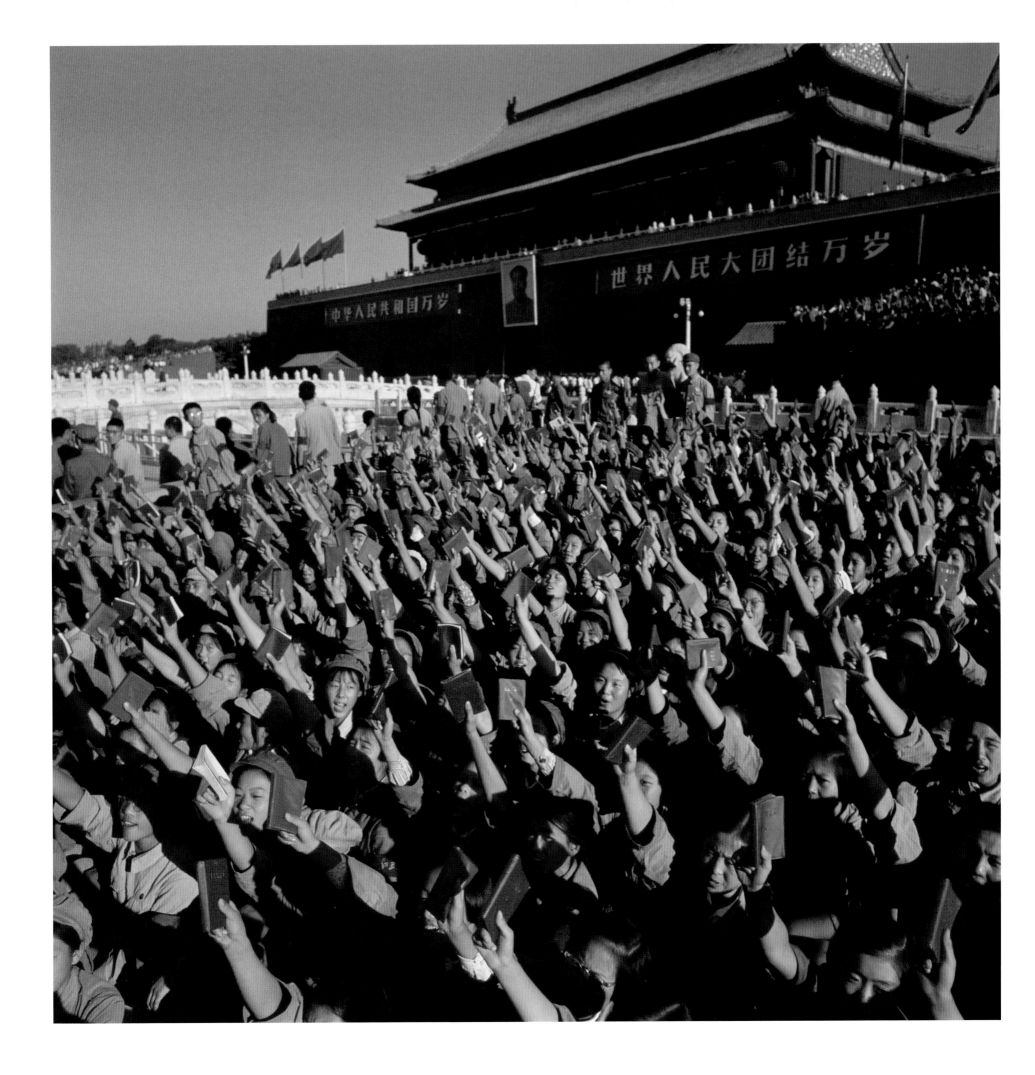

ACKNOWLEDGEMENTS

The development and realisation of this book would not have been possible without the help of many people. First, I am most grateful to Wang Mingxian, who provided me with access to his scholarship on the Cultural Revolution, which inspired me to see the 'ten-year turbulence' from a different perspective. I have benefited greatly from discussions with the following scholars and artists: Cai Xiaoming, Craig Clunas, Li Xianting, Darren Newbury, Steve Smith, Nick Stanley, Wang Yi, Wang Yongji, Xu Bing, Yin Hongbiao, Yü Youhan, Zhu Xiaoming and Zhu Xueqin. I am extremely grateful to Mark Holborn at Jonathan Cape for his enthusiastic support and editorial input, which have made this book possible.

Furthermore I should thank the photographers who contributed to this publication, especially including Chen Ke, Jiang Shaowu, Li Zhensheng, Lü Xiangyou, Sun Yifu, Wang Duanyang, Wang Shilong, Weng Naiqiang, Yu Jianying, Xiao Zhuang, Zhang Yaxin and those who remain anonymous. My sincere thanks goes to Robert Pledge and Jeffery Smith at Contact Press Images, Kong Hongyan, *China Pictorial* and China Photo Service, who provided me with key visual materials for the research. I am also grateful to the following individuals for their assistance: Jesse Holborn, Yvette Burn, Cai Meng, Jenny Hewings, Huang Jianglian, Huang Mingzhan, Jiang Pei, Liang Wenbin, Rachel Marsden, Sun Xiaotong and in particular, Leng Jian for her unfailing support and help throughout the project.

Finally, I owe a great deal of gratitude to my wife Wang Yanyan, whose encouragement and tolerance has been invaluable during the writing of this book, and to my daughters Julia and Michelle, who always added enjoyment, as my blessings, in good and difficult times.

Published in 2010 by Jonathan Cape

9 8 7 6 5 4 3 2 1

First published in Great Britain by Jonathan Cape, Random House,
20 Vauxhall Bridge Road, London SW1V 2SA

The Random House Group Limited Reg. No. 954009

A CIP catalogue record for this book is available from the British Library

ISBN 978-0224-08781-0

The Publisher and the author wish to thank Chen Guangjun at 798 Photo Gallery
and Na Risong at Inter Art Centre and Gallery for providing image permissions
of the photographs by Chen Ke, Wang Duanyang, Wang Shilong, Weng Naiqiang,
Yu Jianying, Xiao Zhuang and Zhang Yaxin.
All photographs by Li Zhensheng are reproduced courtesy of Contact Press
Images Inc.

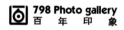 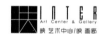

Editor: Mark Holborn
Design: Design Holborn
Production Controller: Simon Rhodes
Printed and bound by Tien Wah Press Ltd., Singapore

Chapter headings taken from the writing of Mao Zedong

Boards: Detail from Anonymous, *Untitled*, print reproduction of oil painting,
1967, personal collection of Wang Mingxian